DRAWING FANTASTIC
MANGA
FEMALE FIGHTERS

THE COMPLETE GUIDE TO DRAWING FEMALE ACTION CHARACTERS

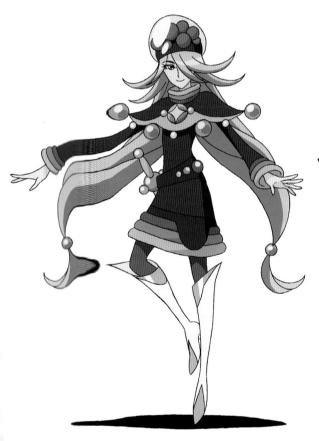

Hisashi Kagawa &
Yoshihiko Umakoshi

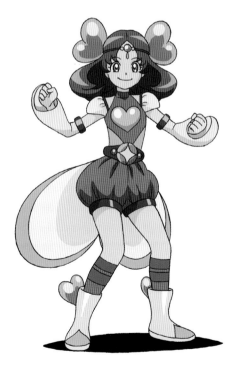

TUTTLE Publishing

Tokyo | Rutland, Vermont | Singapore

Contents

From Hisashi Kagawa's Portfolio 4

From Yoshihiko Umakoshi's Portfolio 16

An Interview with the Masters of Manga
Hisashi Kagawa & Yoshihiko Umakoshi 30

How to Draw Characters:
Basic Tips, Tools and Techniques 36

 Be Aware of Body Lines 38

 Exaggerate Your Poses 40

 Finding Balance in the Face 42

 Capturing Emotion 44

 Adding Details to Express Your
 Character's Individuality 46

Creating Characters to Tell an Original
Story 48

PART 1 A Tutorial with Hisashi Kagawa 49

Storyboard Overview 50

Character 1
Outrageous Orange 55

Expert Advice:
Bringing Your Character to Completion 64

Character 2
Grappling Grape 65

Character 3
Powerful Peach 73

Character 4
Pontoon 81

Expert Advice:
Let's Talk About Tracing 84

Character 5
Twin Female Villains: Aspar and Tame 85

Expert Advice:
Expressing Characters' Individuality Even in
the Extremities 90

Character 6
A Male Villain: Sucrose 91

Character Scale Chart 94

Expert Advice:
Drawing Exaggerated Movements, Anime-
Style 96

Design Variations 97

Semi-Realistic Character Designs 98

Chibi-Style Character Designs 100

Expert Advice:
Creating Character Designs for an Original
Story 102

Interview with Hisashi Kagawa 104

Hisashi Kagawa's Rough Sketches 106

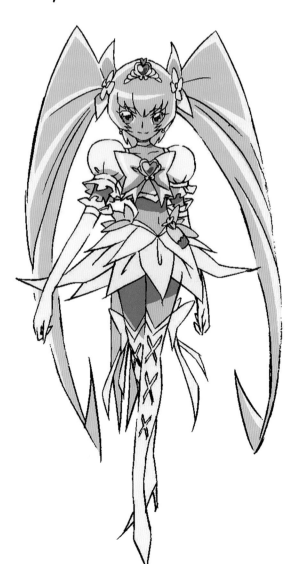

PART 2 A Tutorial with Yoshihiko Umakoshi 109

Yoshihiko Umakoshi's Original Character Designs 110

Character 1
Martial Mandarin 111

Expert Advice:
Developing Character, Story and Setting 118

Character 2
Mighty Melon 119

Character 3
Pure Mango 127

Expert Advice:
Drawing Skirts 134

Character 4
Sidekicks and Mascots 135

Expert Advice:
Rough Sketches 138

Character 5
Sasha 139

Expert Advice:
Chibi-Style Facial Expressions 142

Character 6
Stevia 143

Expert Advice:
Veritable Villains 146

Character 7
Sweet-n-Low 147

Expert Advice:
Designing a Neutral Character 150

Illustration Meets Animation 151

Image Boards 152

Copyright Illustrations 156

Concept Art 160

Drawing an Action Sequence 162

Expert Advice:
Women's Hand Gestures 164

Interview with Yoshihiko Umakoshi 166

Yoshihiko Umakoshi's Rough Sketches 168

Hisashi Kagawa's Studio 172

Yoshihiko Umakoshi's Studio 173

Message and Profile 174

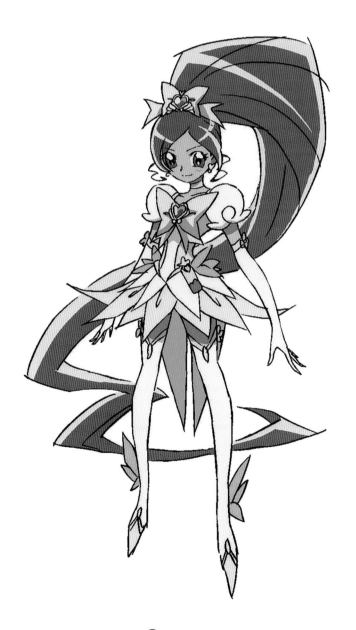

香 indicates a comment by Kagawa 馬 indicates a comment by Umakoshi

From Hisashi Kagawa's Portfolio
Fresh Pretty Cure!

CHARACTER DESIGNS

In order to distinguish this from previous Pretty Cures series, we've made the characters taller and adjusted proportions accordingly. Three characters—Peach, Berry, Pine—have been created.

Fresh Pretty Cure!
Original: Toudou Izumi
Series Director: Shimizu Junji, Zako Akifumi (Episode 16 onwards)
Series Writer: Maekawa Atsushi

Animation Production: Toei Animation The sixth 'Pretty Cure' series. Along with a distinct new look, the series features more close-ups of the 'Pretty Cure family' and a villain general who becomes a Pretty Cure herself, among several other fresh concepts.
ABC A Toei Animation

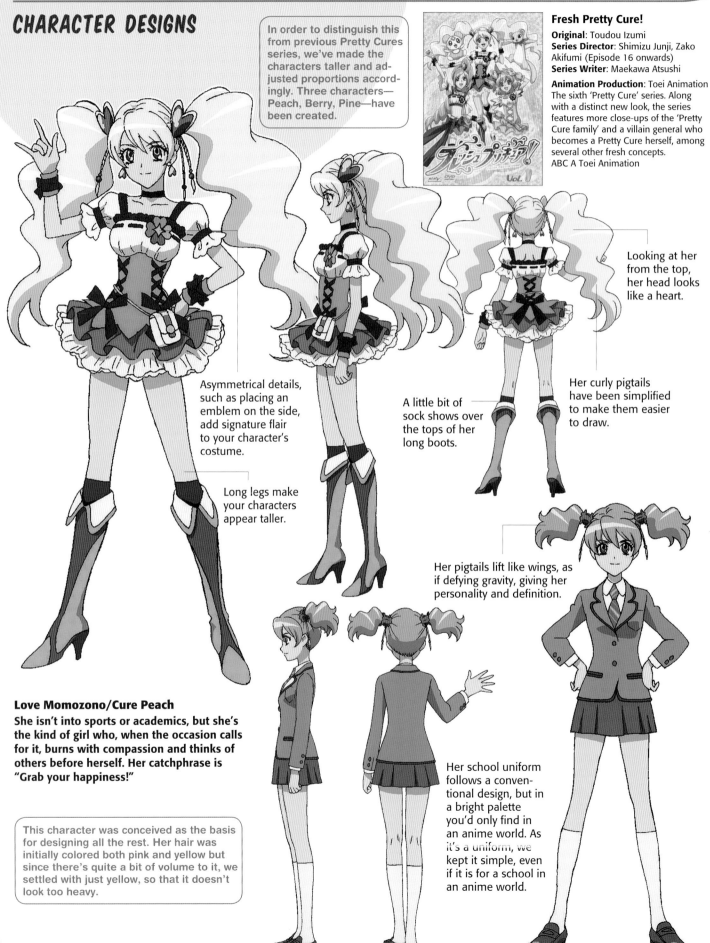

Looking at her from the top, her head looks like a heart.

Asymmetrical details, such as placing an emblem on the side, add signature flair to your character's costume.

Her curly pigtails have been simplified to make them easier to draw.

A little bit of sock shows over the tops of her long boots.

Long legs make your characters appear taller.

Her pigtails lift like wings, as if defying gravity, giving her personality and definition.

Love Momozono/Cure Peach
She isn't into sports or academics, but she's the kind of girl who, when the occasion calls for it, burns with compassion and thinks of others before herself. Her catchphrase is "Grab your happiness!"

This character was conceived as the basis for designing all the rest. Her hair was initially colored both pink and yellow but since there's quite a bit of volume to it, we settled with just yellow, so that it doesn't look too heavy.

Her school uniform follows a conventional design, but in a bright palette you'd only find in an anime world. As it's a uniform, we kept it simple, even if it is for a school in an anime world.

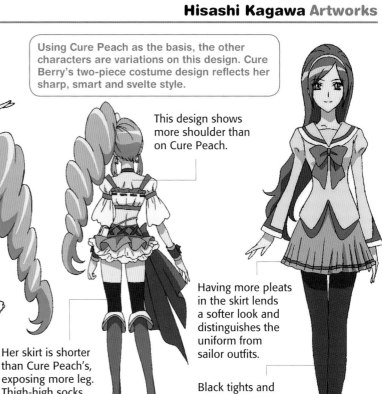

Using Cure Peach as the basis, the other characters are variations on this design. Cure Berry's two-piece costume design reflects her sharp, smart and svelte style.

This design shows more shoulder than on Cure Peach.

Having more pleats in the skirt lends a softer look and distinguishes the uniform from sailor outfits.

Black tights and silver shoes offer an appealing contrast to the tall boots and thigh-high socks.

We put a large ribbon on her right hip to offset her long, swirling side-pony and to maintain the balance of the overall design.

Cure Berry's midriff is exposed, a way of distinguishing her from her more buttoned-down alter ego.

Her skirt is shorter than Cure Peach's, exposing more leg. Thigh-high socks complement her image of sharp smartness.

Miki Aono/Cure Berry
A stylish and perceptive second-year junior-high student at a private academy, she also models for magazines. With her catchphrase—"The power of perfection"—she's driven, a hard worker with her goals always in sight. She lives with her mother who runs a hair and nail salon.

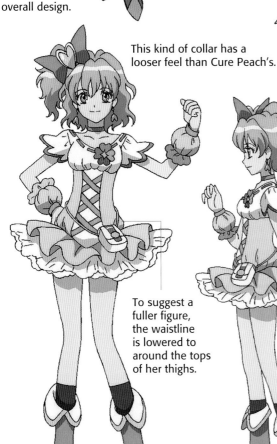

This kind of collar has a looser feel than Cure Peach's.

The feathery, floaty sleeve design suggests angel wings.

To suggest a fuller figure, the waistline is lowered to around the tops of her thighs.

The skirt spreads outward to empha-size the design's soft, airy feel.

Here we're going for a softer, rounder image with the looser lines around her hips.

So that the skirt didn't become too complicated, we opted for a simpler plaid pattern to make the design easier to draw.

Rounded cuffs on the wrists complement the boots, leading to a more rounded drawing that keeps the feel of the design consistent.

As the uniform of an all-girl's school, the blazer-and-kilt combination evoke the image of a well-mannered young lady.

Inori Yamabuki/Cure Pine
A student at an academy. She joins Cure Peach's dance group in an effort to transform herself.

At first we had a
design that was stiff,
more mechanical, but
we settled on a more
angelic look
with white
wing shapes.

At first we dressed her in the same type of
costume as Cure Peach, but then she didn't
stand out enough as an individual, so we mixed
things up. It didn't seem right for this one to be
seen in anything skimpy, so we favored a more
conservative design.

**From antagonist
to the fourth
fierce fighter**

Her pouch is on
the opposite hip as
Cure Peach's, so the
characters will stand
out in contrast to
each other.

The skirt layers feature
shifting shades of red,
giving the costume
decadence and detail.

To make her stand
out, we've made
the costume design
less revealing than
Cure Peach's.

Setsuna Higashi/Cure Passion
The fourth fantastic female fighter was born in a
labyrinth when a great general made a wish for
happiness from the very bottom of her heart. She
can be awkward, but she's always earnest. Her
catchphrase is "I'll do my best!"

Her hair is pink, but
notice she gets her
own shade.

The costume
suggests a dancer,
and again with a
heavy emphasis
on red.

A character designed to be a
red herring and mislead view-
ers into thinking, "Could she
be a Pretty Cure?" She shares
a lot of similarities with Cure
Passion, such as their color
schemes. She's modeled after
the singer Amuro Namie.

Miyuki Chinen
She gets to know the others and
becomes their dance tutor, at
first mistakenly thought to be
the fourth member.

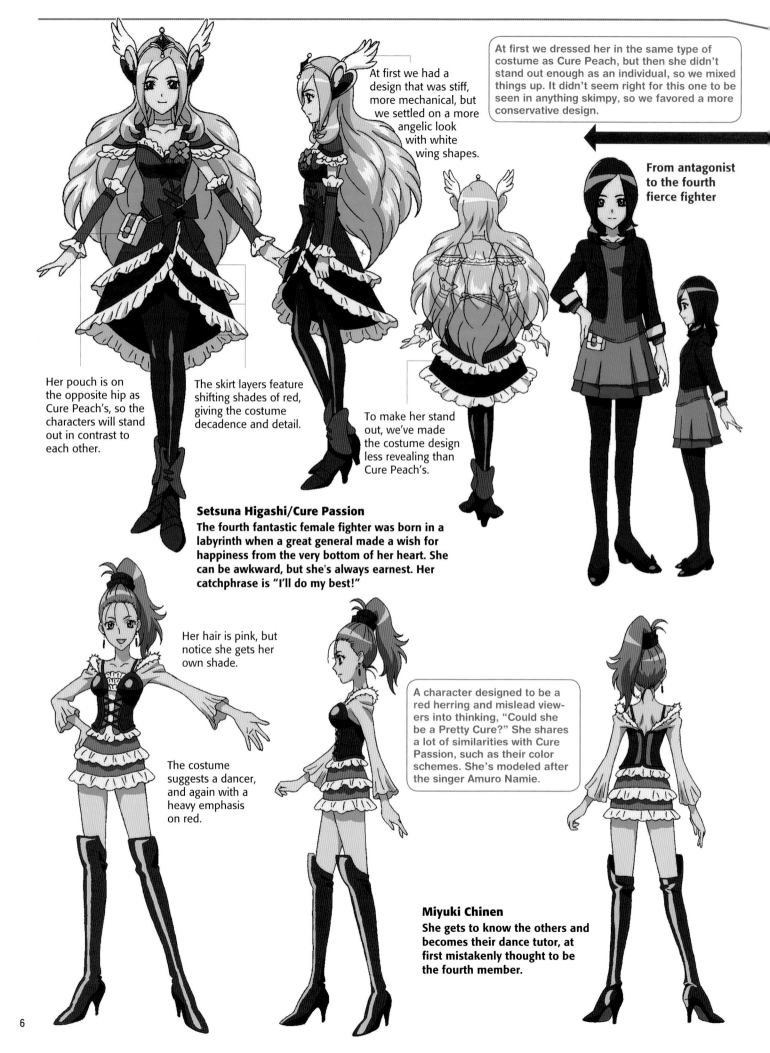

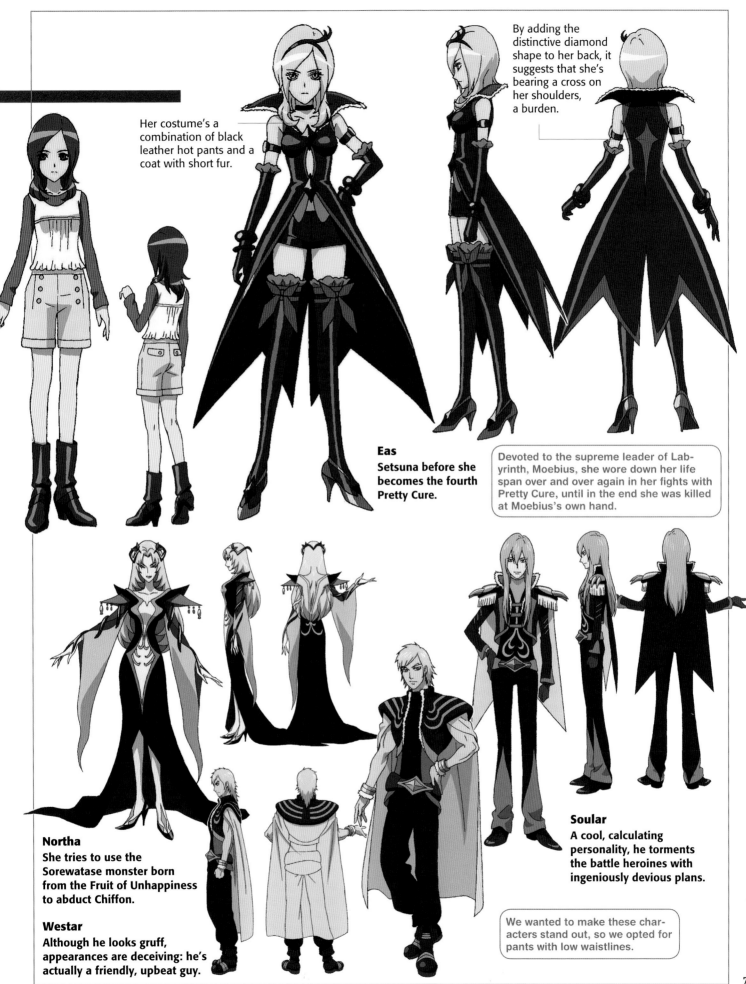

Her costume's a combination of black leather hot pants and a coat with short fur.

By adding the distinctive diamond shape to her back, it suggests that she's bearing a cross on her shoulders, a burden.

Eas
Setsuna before she becomes the fourth Pretty Cure.

Devoted to the supreme leader of Labyrinth, Moebius, she wore down her life span over and over again in her fights with Pretty Cure, until in the end she was killed at Moebius's own hand.

Northa
She tries to use the Sorewatase monster born from the Fruit of Unhappiness to abduct Chiffon.

Westar
Although he looks gruff, appearances are deceiving: he's actually a friendly, upbeat guy.

Soular
A cool, calculating personality, he torments the battle heroines with ingeniously devious plans.

We wanted to make these characters stand out, so we opted for pants with low waistlines.

USING DETAILS IN DESIGN

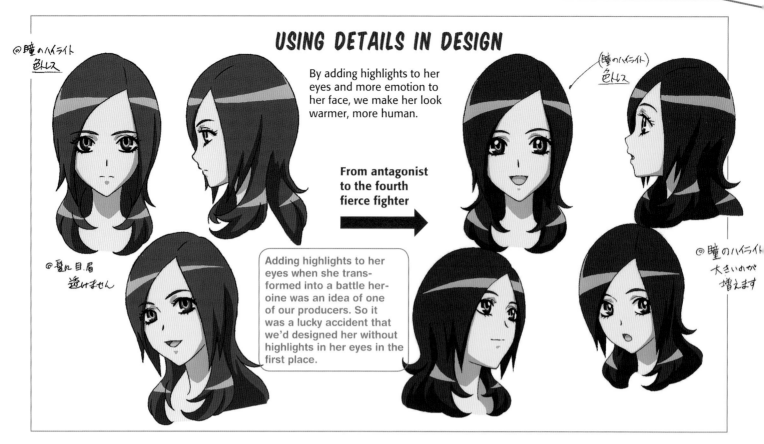

By adding highlights to her eyes and more emotion to her face, we make her look warmer, more human.

From antagonist to the fourth fierce fighter

Adding highlights to her eyes when she transformed into a battle heroine was an idea of one of our producers. So it was a lucky accident that we'd designed her without highlights in her eyes in the first place.

Chiffon
A mysterious little fairy who becomes the subject of repeat abduction attempts.

This character was originally meant to be a rabbit, but we thought it was supposed to look like a panda or a bear.

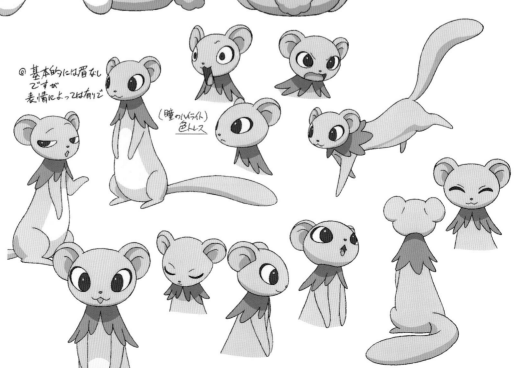

Tart
He hangs in the background —he can't fight to save his life!—acting as our heroines' emotional pillar.

Tart was also created with merchandise in mind, so from many possible designs we settled on a ferret-like look for him.

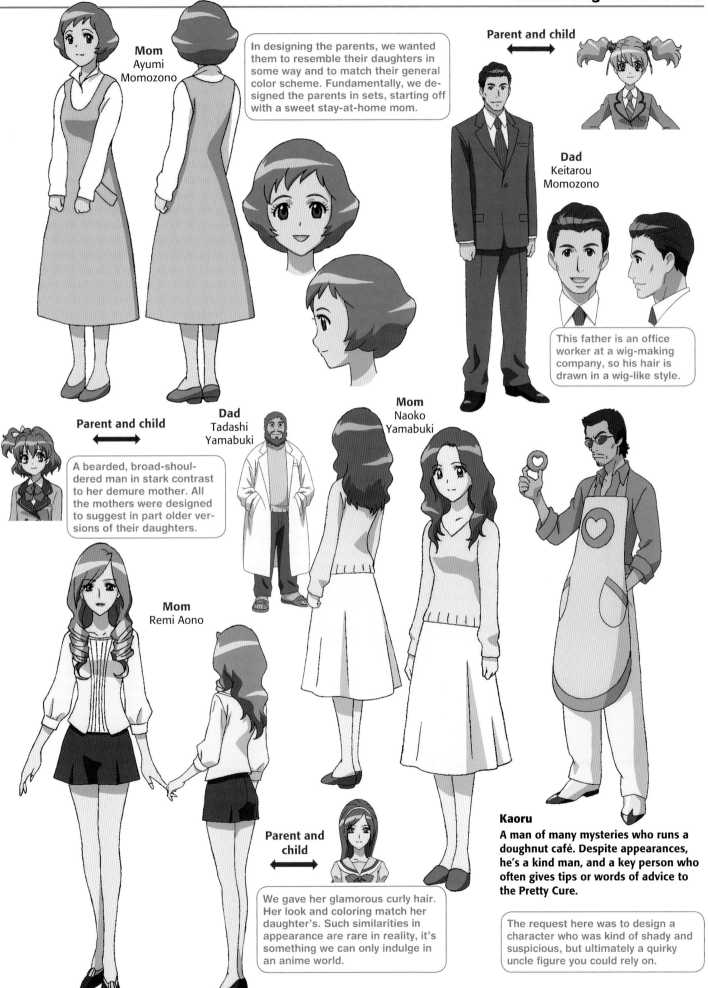

Mom
Ayumi Momozono

In designing the parents, we wanted them to resemble their daughters in some way and to match their general color scheme. Fundamentally, we designed the parents in sets, starting off with a sweet stay-at-home mom.

Parent and child

Dad
Keitarou Momozono

This father is an office worker at a wig-making company, so his hair is drawn in a wig-like style.

Parent and child

Dad
Tadashi Yamabuki

A bearded, broad-shouldered man in stark contrast to her demure mother. All the mothers were designed to suggest in part older versions of their daughters.

Mom
Naoko Yamabuki

Mom
Remi Aono

Parent and child

We gave her glamorous curly hair. Her look and coloring match her daughter's. Such similarities in appearance are rare in reality, it's something we can only indulge in an anime world.

Kaoru
A man of many mysteries who runs a doughnut café. Despite appearances, he's a kind man, and a key person who often gives tips or words of advice to the Pretty Cure.

The request here was to design a character who was kind of shady and suspicious, but ultimately a quirky uncle figure you could rely on.

VARYING THE DESIGN

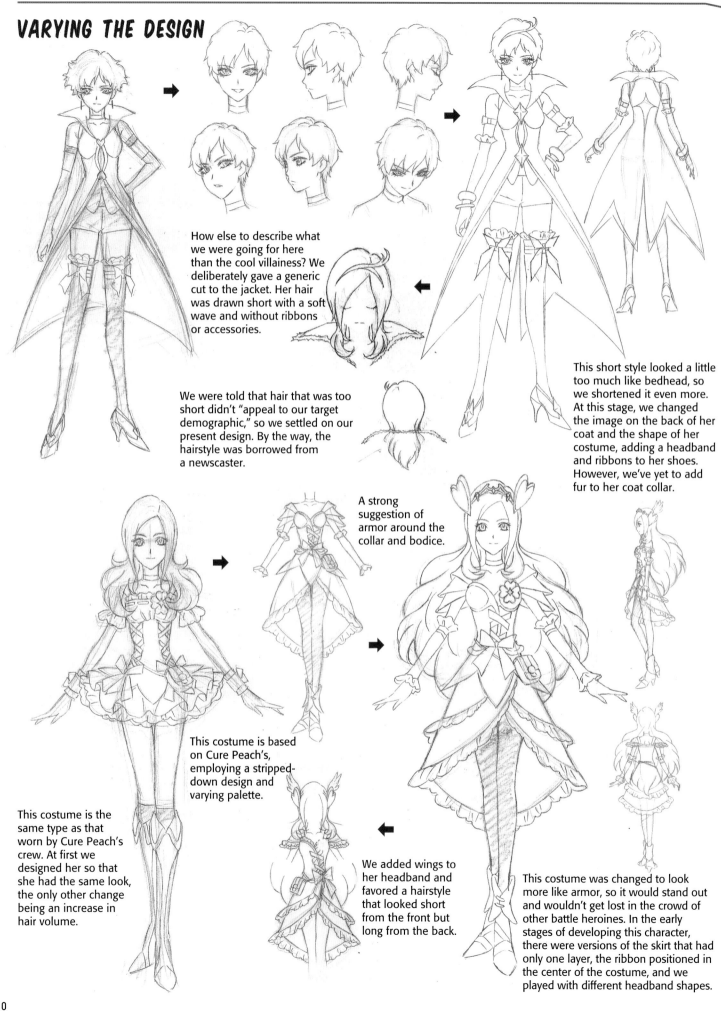

How else to describe what we were going for here than the cool villainess? We deliberately gave a generic cut to the jacket. Her hair was drawn short with a soft wave and without ribbons or accessories.

We were told that hair that was too short didn't "appeal to our target demographic," so we settled on our present design. By the way, the hairstyle was borrowed from a newscaster.

This short style looked a little too much like bedhead, so we shortened it even more. At this stage, we changed the image on the back of her coat and the shape of her costume, adding a headband and ribbons to her shoes. However, we've yet to add fur to her coat collar.

A strong suggestion of armor around the collar and bodice.

This costume is based on Cure Peach's, employing a stripped-down design and varying palette.

This costume is the same type as that worn by Cure Peach's crew. At first we designed her so that she had the same look, the only other change being an increase in hair volume.

We added wings to her headband and favored a hairstyle that looked short from the front but long from the back.

This costume was changed to look more like armor, so it would stand out and wouldn't get lost in the crowd of other battle heroines. In the early stages of developing this character, there were versions of the skirt that had only one layer, the ribbon positioned in the center of the costume, and we played with different headband shapes.

For the first two monsters, we used an amplifier and a vending machine as their main motifs, and added diamonds to the center. These two would serve as the models for all future monsters in the series.

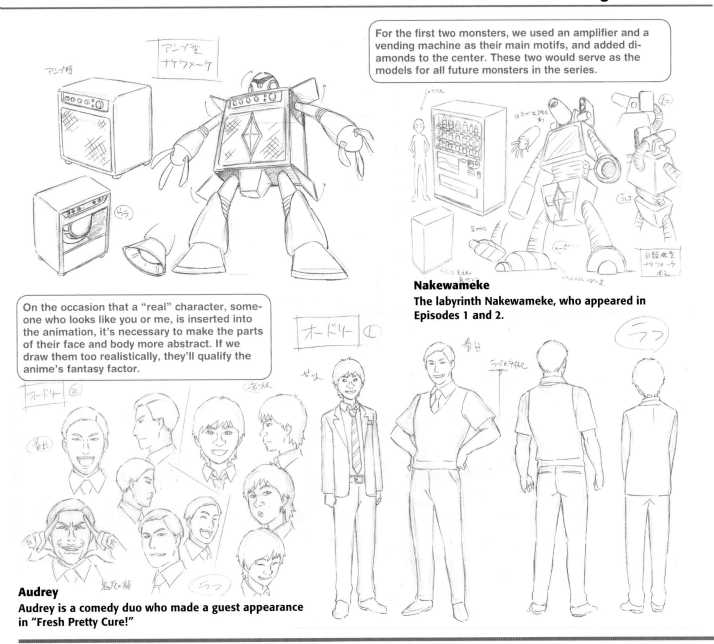

Nakewameke
The labyrinth Nakewameke, who appeared in Episodes 1 and 2.

On the occasion that a "real" character, someone who looks like you or me, is inserted into the animation, it's necessary to make the parts of their face and body more abstract. If we draw them too realistically, they'll qualify the anime's fantasy factor.

Audrey
Audrey is a comedy duo who made a guest appearance in "Fresh Pretty Cure!"

MULTIPLE FORMATS

It's important to think ahead, just in case your images need to be used someday for blue-ray or DVD packages, advertising posters, calendars or any commercial product. In the case of these characters, their distinctively large hairstyles make deciding the layouts of illustrations for alternate formats difficult.

For posters, think about which character you want to emphasize when deciding the illustration's layout. It's important to pose your characters in ways that show off their individual personalities, with dynamic and appealing gestures and expressions.

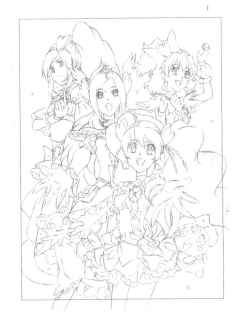

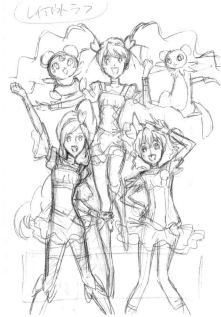

SKETCHES

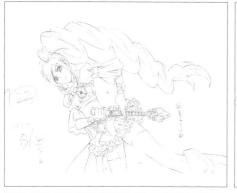

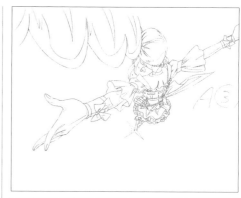

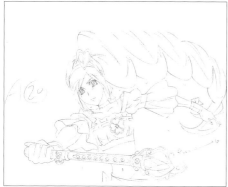

Using Objects in a Scene

Since we're using Cure Peach's signature sword sequence as the basis for the others, until she lands her blow, the movement is roughly the same for the other two. Consider also the other distinctive movements associated with swordfighting, such as drawing the weapon from the hip or slashing it from side to side.

Creating Action and Movements

The sword comes to the foreground, closest to the viewer, further highlighting its presence in the frame. Also, at the point where she readies her stance, she holds the weapon in an underhand grip, so we add an indication of movement to suggest that she's changed her grip position "off-screen." This technique adds variation to the movements actually pictured and also reduces the time and effort involved in drawing trickier scenes where a character's movement changes direction.

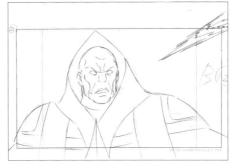

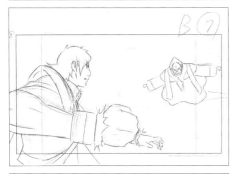

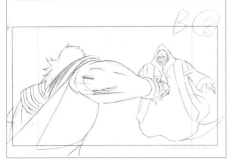

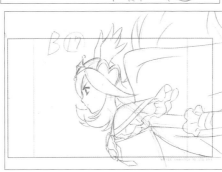

Using Intermediary Frames

We use a time sheet that includes directions, such as how many intermediaries are needed and where they're positioned, so that the people who make the frames will understand.

↓ The time sheet allows the animators to set out directions for intermediary frames.

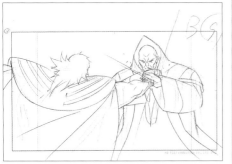

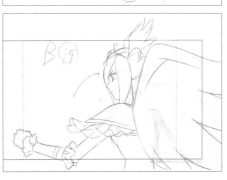

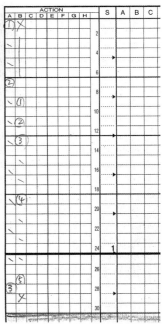

Drawings That Seem 3-Dimensional

From the viewer's vantage point, we shifted the characters back and forth from foreground to background. Here we created a sense of movement and action by changing how the foreground and background are drawn and the sizes of the objects included.

Essential to All Action Scenes: The "It Moment"

In an action sequence, it's important to show the blow land, when the sword strikes its target.

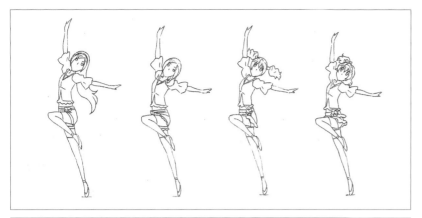

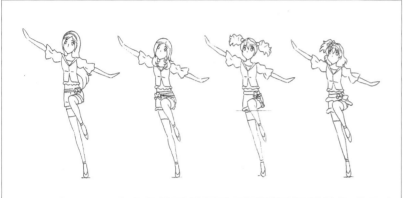

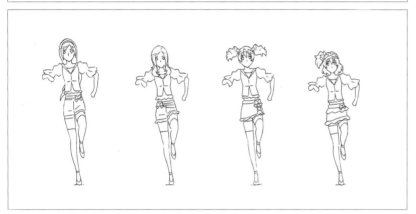

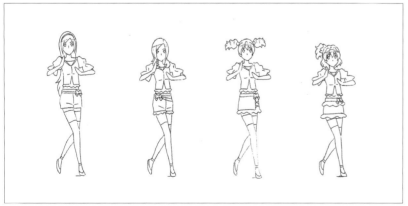

Movements in a Dance Sequence
The choreography is expressed in the swaying motion of their skirts and hair.

At the time, there was no CG modeling for the pre-transformation appearances, so it was a scene we had to draw out. As it was for the final episode, we had a lot to do in a very tight schedule, so it was quite difficult. It was fine when the characters were dancing apart, but the cuts in which they held hands to dance were very challenging.

Vary the scene with closeups of your individual characters, showing different angles and attitudes and of course highlighting their particular features and expressions.

SEEMINGLY HUMAN

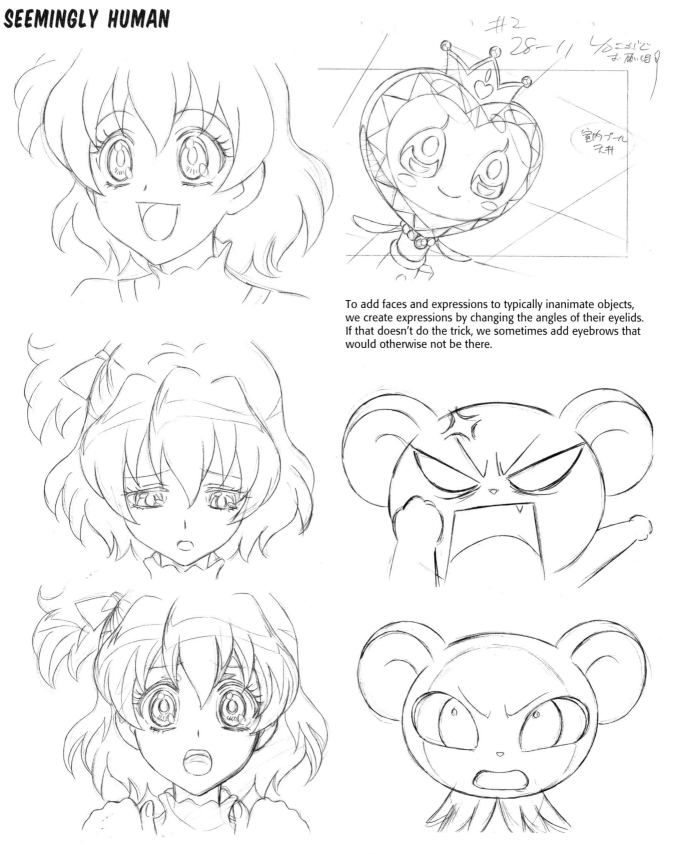

To add faces and expressions to typically inanimate objects, we create expressions by changing the angles of their eyelids. If that doesn't do the trick, we sometimes add eyebrows that would otherwise not be there.

A Human Character's Expressions
Drawing the eyebrows in an arch shape '/\' makes for an anxious expression. Whether they're droopy or narrow, large eyes also make it easier to telegraph your character's emotions.

A Nonhuman Character's Expressions
Sometimes it's helpful to use giant droplets of sweat or popping veins in depicting a character's emotions. On the other hand, if you wanted to draw a more realistic animal expression, you'd have to consult photos and reference works to do so.

CHARACTER DESIGNS

Heart Catch Pretty Cure!
Original: Toudou Izumi
Series Director: Nagamine Tatsuya
Series Writer: Yamada Takashi

Animation: Toei Animation
The seventh 'Pretty Cure' series. 'Heart Catch' included many plot and direction choices that were novel departures from previous series and revolutionary for the franchise, such as including Cure characters from previous series and having a Cure appear on the villain's side.
ABC-A Toei Animation

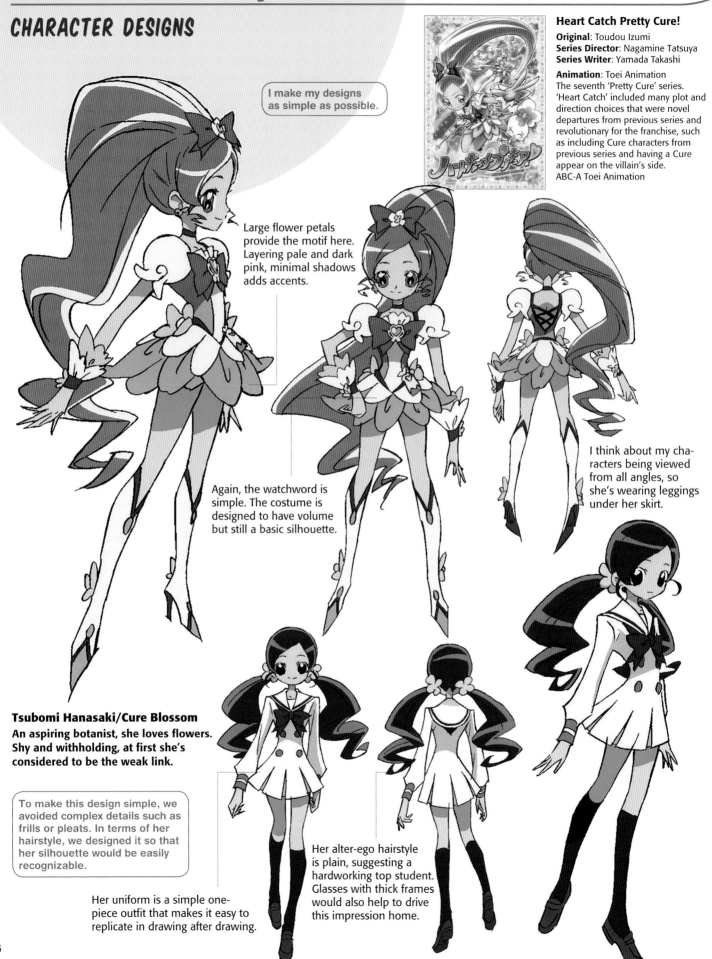

I make my designs as simple as possible.

Large flower petals provide the motif here. Layering pale and dark pink, minimal shadows adds accents.

Again, the watchword is simple. The costume is designed to have volume but still a basic silhouette.

I think about my characters being viewed from all angles, so she's wearing leggings under her skirt.

Tsubomi Hanasaki/Cure Blossom
An aspiring botanist, she loves flowers. Shy and withholding, at first she's considered to be the weak link.

To make this design simple, we avoided complex details such as frills or pleats. In terms of her hairstyle, we designed it so that her silhouette would be easily recognizable.

Her uniform is a simple one-piece outfit that makes it easy to replicate in drawing after drawing.

Her alter-ego hairstyle is plain, suggesting a hardworking top student. Glasses with thick frames would also help to drive this impression home.

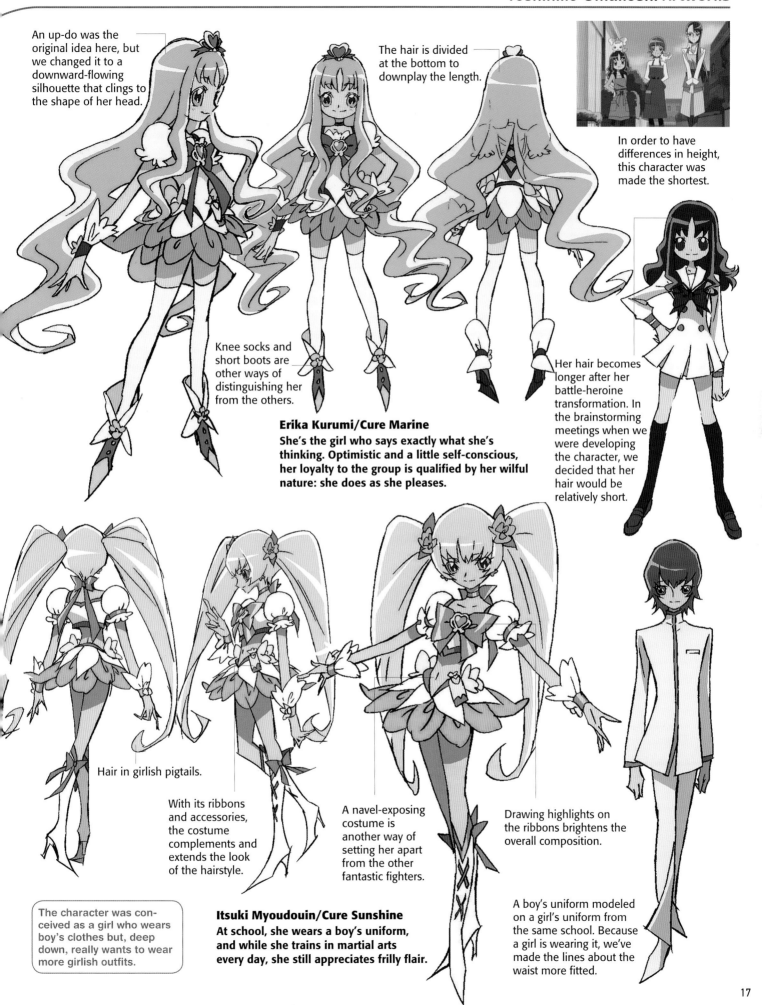

An up-do was the original idea here, but we changed it to a downward-flowing silhouette that clings to the shape of her head.

The hair is divided at the bottom to downplay the length.

In order to have differences in height, this character was made the shortest.

Knee socks and short boots are other ways of distinguishing her from the others.

Erika Kurumi/Cure Marine
She's the girl who says exactly what she's thinking. Optimistic and a little self-conscious, her loyalty to the group is qualified by her wilful nature: she does as she pleases.

Her hair becomes longer after her battle-heroine transformation. In the brainstorming meetings when we were developing the character, we decided that her hair would be relatively short.

Hair in girlish pigtails.

With its ribbons and accessories, the costume complements and extends the look of the hairstyle.

A navel-exposing costume is another way of setting her apart from the other fantastic fighters.

Drawing highlights on the ribbons brightens the overall composition.

The character was conceived as a girl who wears boy's clothes but, deep down, really wants to wear more girlish outfits.

Itsuki Myoudouin/Cure Sunshine
At school, she wears a boy's uniform, and while she trains in martial arts every day, she still appreciates frilly flair.

A boy's uniform modeled on a girl's uniform from the same school. Because a girl is wearing it, we've made the lines about the waist more fitted.

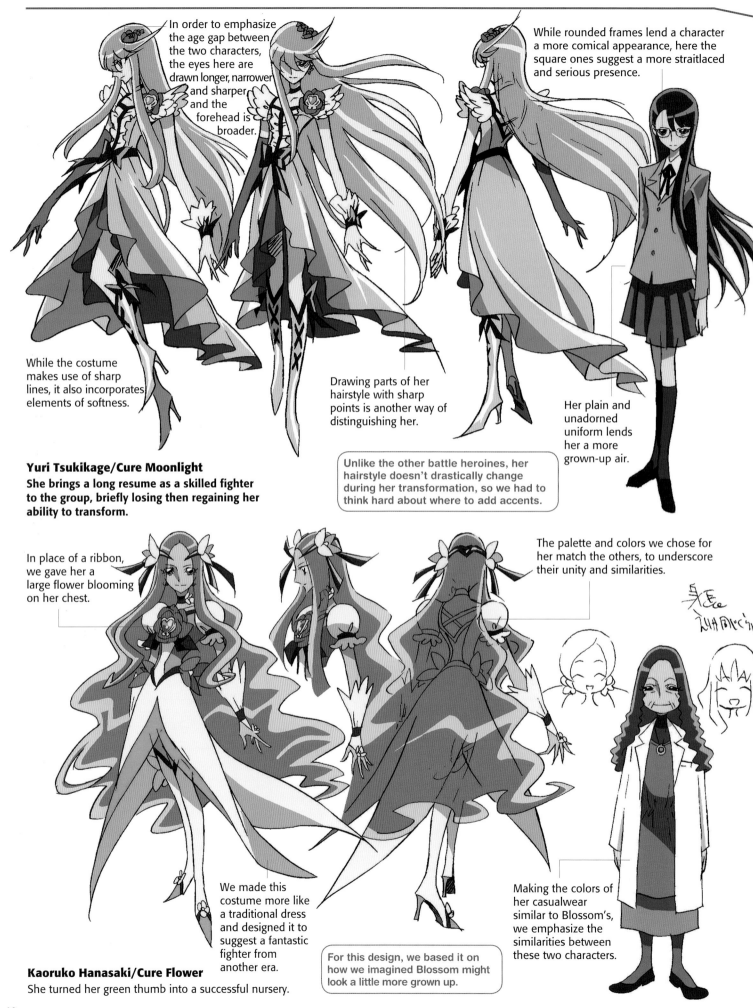

In order to emphasize the age gap between the two characters, the eyes here are drawn longer, narrower and sharper and the forehead is broader.

While rounded frames lend a character a more comical appearance, here the square ones suggest a more straitlaced and serious presence.

While the costume makes use of sharp lines, it also incorporates elements of softness.

Drawing parts of her hairstyle with sharp points is another way of distinguishing her.

Yuri Tsukikage/Cure Moonlight
She brings a long resume as a skilled fighter to the group, briefly losing then regaining her ability to transform.

Her plain and unadorned uniform lends her a more grown-up air.

Unlike the other battle heroines, her hairstyle doesn't drastically change during her transformation, so we had to think hard about where to add accents.

In place of a ribbon, we gave her a large flower blooming on her chest.

The palette and colors we chose for her match the others, to underscore their unity and similarities.

We made this costume more like a traditional dress and designed it to suggest a fantastic fighter from another era.

Making the colors of her casualwear similar to Blossom's, we emphasize the similarities between these two characters.

Kaoruko Hanasaki/Cure Flower
She turned her green thumb into a successful nursery.

For this design, we based it on how we imagined Blossom might look a little more grown up.

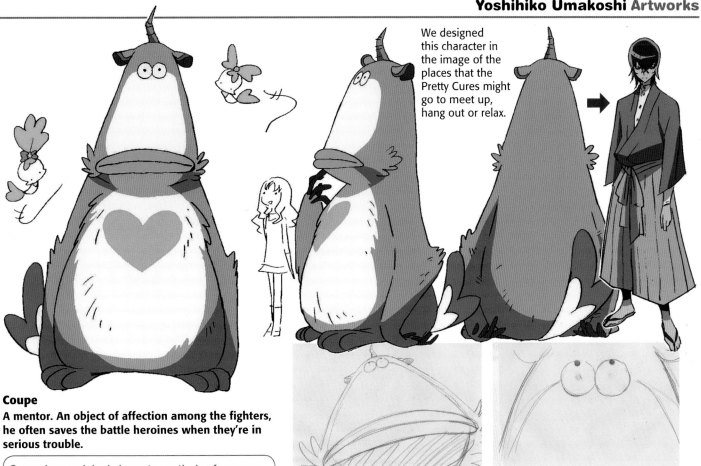

We designed this character in the image of the places that the Pretty Cures might go to meet up, hang out or relax.

Coupe

A mentor. An object of affection among the fighters, he often saves the battle heroines when they're in serious trouble.

Coupe is an original character entirely of my own invention. I like to think that Coupe had a time, once, when he looked more like Shipure and Kofure (ha ha). There were no plans for merchandise with this character, but with the good will of the toy makers, we were able to have some made.

This character stares blankly, unmoving, showing absolutely no sign of emotion.

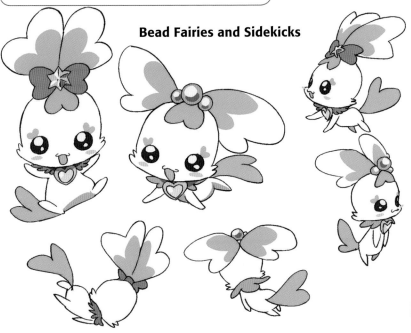

Bead Fairies and Sidekicks

These fairies produce the 'Pretty Cure Seeds' that enable the Pretty Cure to transform. They're important presences in the show.

The initial designs for these fairies, mascots and sidekicks were somewhat off. Once we adjusted the volume above the eyes to better balance the image, that did the trick: too cute!

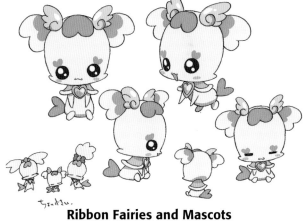

Ribbon Fairies and Mascots

There was no intention to make merchandise of Cologne, so he's been designed in line with Moonlight's 'sharp' image.

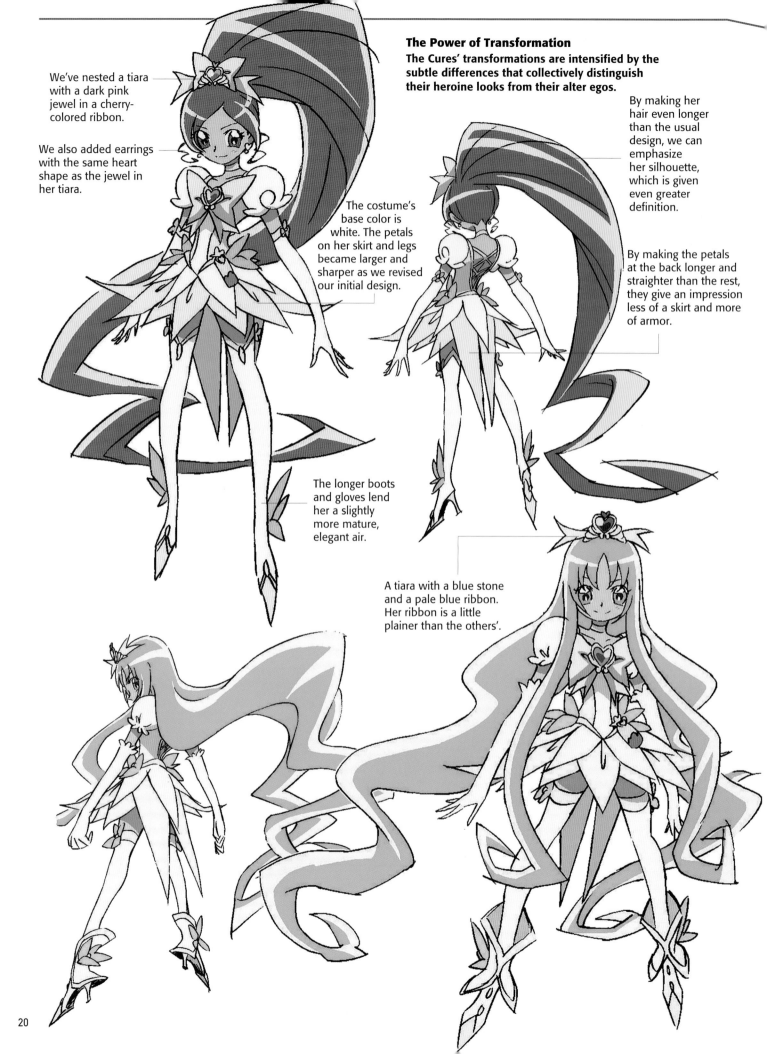

We've nested a tiara with a dark pink jewel in a cherry-colored ribbon.

We also added earrings with the same heart shape as the jewel in her tiara.

The costume's base color is white. The petals on her skirt and legs became larger and sharper as we revised our initial design.

The longer boots and gloves lend her a slightly more mature, elegant air.

The Power of Transformation
The Cures' transformations are intensified by the subtle differences that collectively distinguish their heroine looks from their alter egos.

By making her hair even longer than the usual design, we can emphasize her silhouette, which is given even greater definition.

By making the petals at the back longer and straighter than the rest, they give an impression less of a skirt and more of armor.

A tiara with a blue stone and a pale blue ribbon. Her ribbon is a little plainer than the others'.

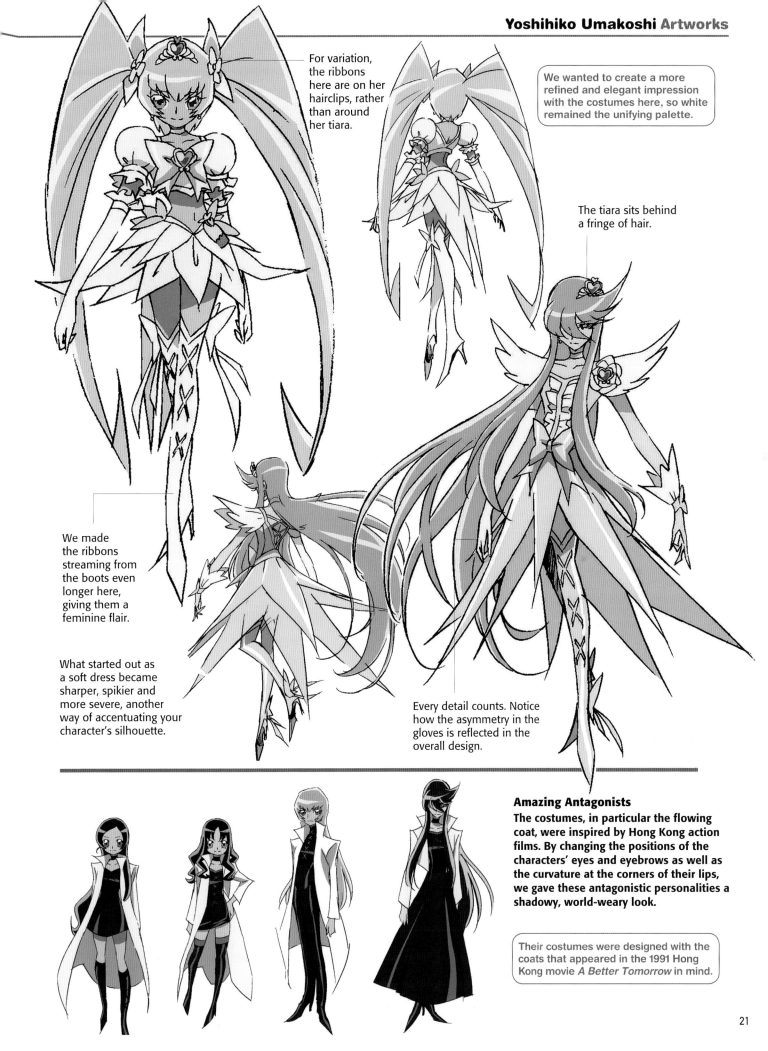

For variation, the ribbons here are on her hairclips, rather than around her tiara.

We wanted to create a more refined and elegant impression with the costumes here, so white remained the unifying palette.

The tiara sits behind a fringe of hair.

We made the ribbons streaming from the boots even longer here, giving them a feminine flair.

What started out as a soft dress became sharper, spikier and more severe, another way of accentuating your character's silhouette.

Every detail counts. Notice how the asymmetry in the gloves is reflected in the overall design.

Amazing Antagonists

The costumes, in particular the flowing coat, were inspired by Hong Kong action films. By changing the positions of the characters' eyes and eyebrows as well as the curvature at the corners of their lips, we gave these antagonistic personalities a shadowy, world-weary look.

Their costumes were designed with the coats that appeared in the 1991 Hong Kong movie *A Better Tomorrow* in mind.

21

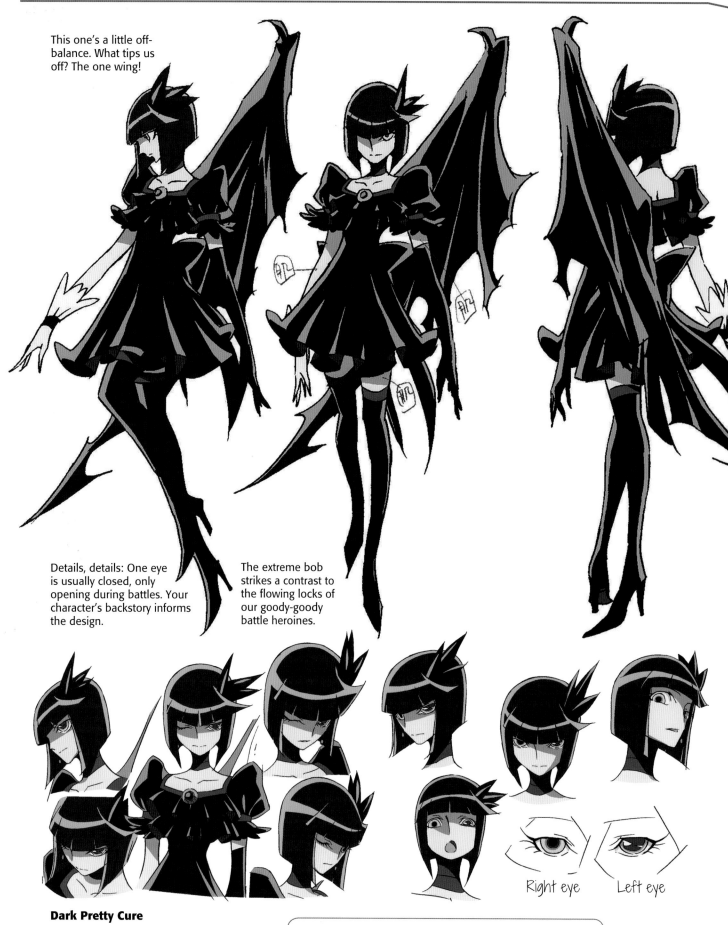

This one's a little off-balance. What tips us off? The one wing!

Details, details: One eye is usually closed, only opening during battles. Your character's backstory informs the design.

The extreme bob strikes a contrast to the flowing locks of our goody-goody battle heroines.

Right eye Left eye

Dark Pretty Cure

An aggressive and destructive force, she isn't easily defeated, coming back at her enemies with even more punishing power.

The shadows on top of her head and the extreme line of the bob accentuate the sleek lines of the figure. And do you see what we did to the eyes to finish off the look?

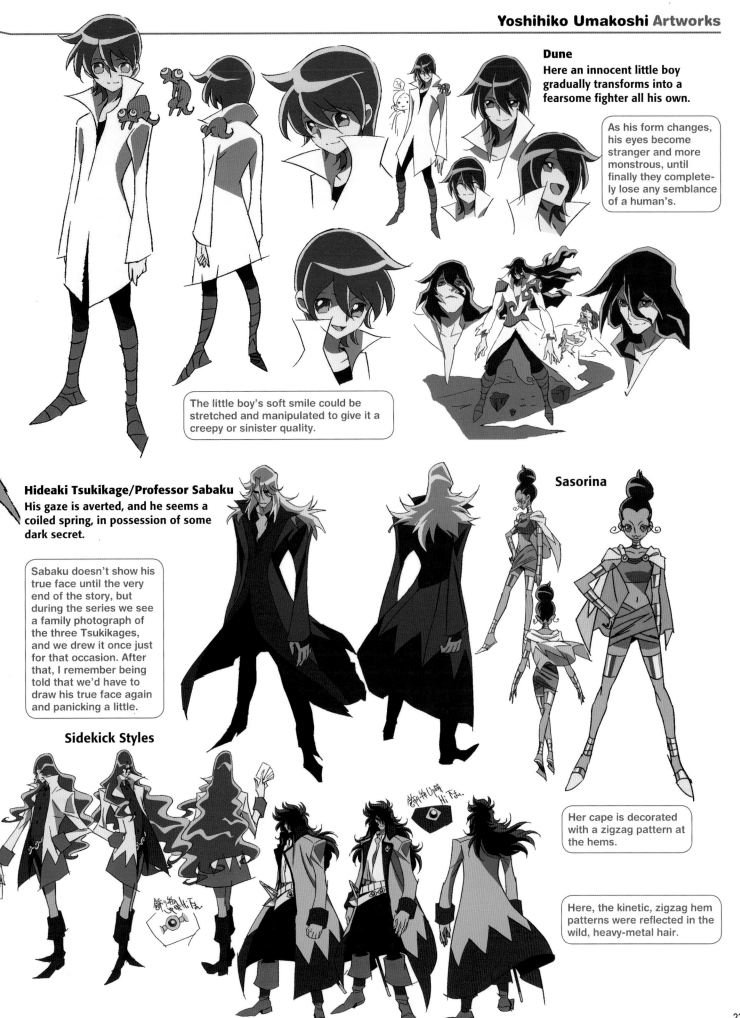

Dune
Here an innocent little boy gradually transforms into a fearsome fighter all his own.

As his form changes, his eyes become stranger and more monstrous, until finally they completely lose any semblance of a human's.

The little boy's soft smile could be stretched and manipulated to give it a creepy or sinister quality.

Hideaki Tsukikage/Professor Sabaku
His gaze is averted, and he seems a coiled spring, in possession of some dark secret.

Sabaku doesn't show his true face until the very end of the story, but during the series we see a family photograph of the three Tsukikages, and we drew it once just for that occasion. After that, I remember being told that we'd have to draw his true face again and panicking a little.

Sidekick Styles

Sasorina

Her cape is decorated with a zigzag pattern at the hems.

Here, the kinetic, zigzag hem patterns were reflected in the wild, heavy-metal hair.

SKETCHES

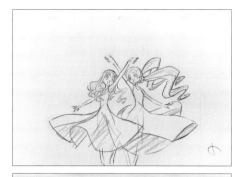

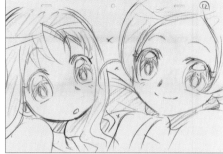

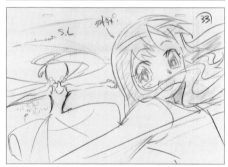

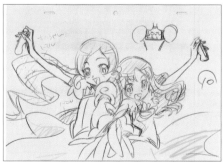

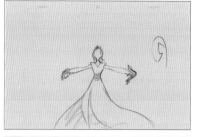

One Frame at a Time: Capturing Subtle Transformations

The transformation sequence is an important scene that draws even more attention to your character's distinctive features. By simplifying the design, the characters become easier to transition, so you can add distinctive poses and signature action poses to further highlight their individual personalities.

Time-Lapse Tresses: Transforming from Short to Long Hair

Here we take a cool, smart-looking short cut and, amid an eruption of hair, turn it into a long, luxurious mane. At the same time her hairdo transforms, we were able to showcase the character's martial arts skills by adding in a rousing roundhouse kick.

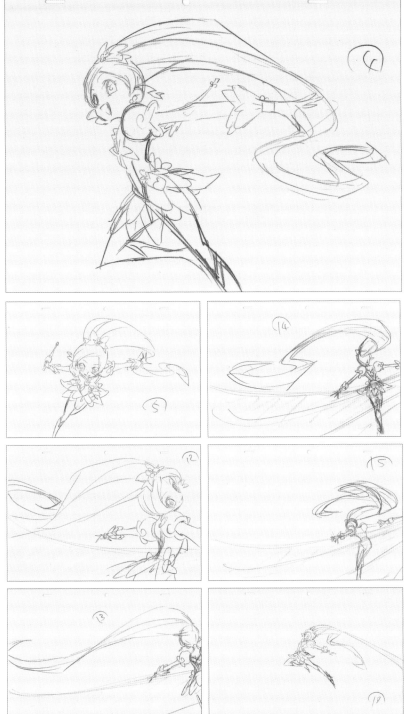

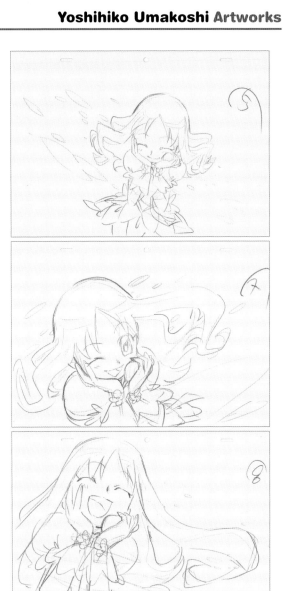

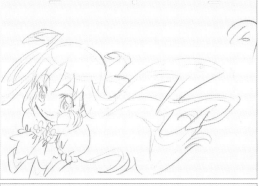

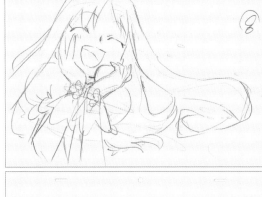

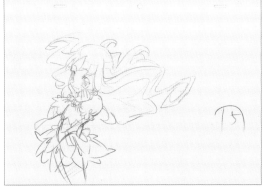

Even Hair Needs a Sharp Silhouette

A change in hairstyle is one of the most effective ways of signaling your battle heroine's transformation. But always keep the character silhouette in mind. A sharply defined silhouette adds dynamism to the transformation sequences and the dramatically sweeping movements featured in fight scenes. Notice also the rippling effect on the hair as the characters turn or spin.

A Fine-Toothed Comb: Finishing Your Heroine's Hair

Here a character smiles and sways her body as she transforms. Her hair lengthens, twisting and twining to match the curvature of her body.

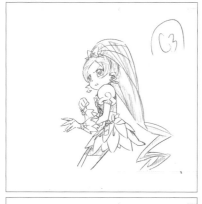

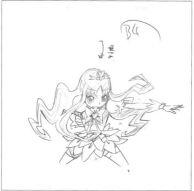

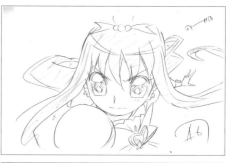

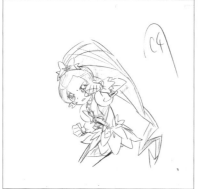

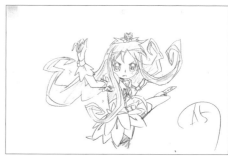

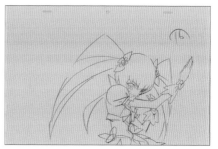

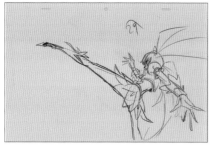

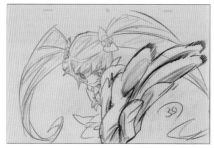

In Your Face

Rather than moving a character side to side, shifting the action instead from background to foreground ratchets up the tension and the physicality of the fight. This trick also gives your drawing a greater sense of dimension.

Making Use of Action Poses

If you keep your character designs simple, in a battle scene, you're able to discover more riveting action and more dynamic poses. Here the characters fight back to back against their enemy.

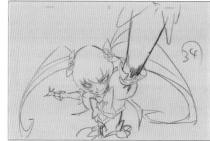

Another high-kicking signature pose signals a completed transformation. It's a reminder to keep your character's distinctive qualities on display as the story unfolds.

The hand moving from background to foreground offers a sense of depth.

By thickening the lines of her chopping hand in the foreground, an even more dynamic and expressive sense of motion is suggested.

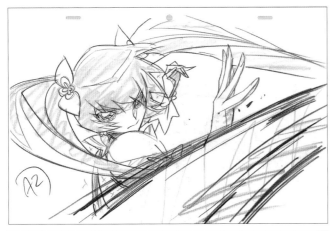

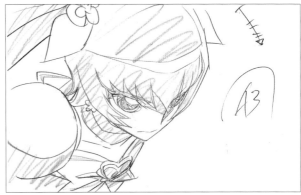

Glaring down at her enemy with a sharp, serious gaze and slowly leaning forward, she's locking on her target and preparing her attack.

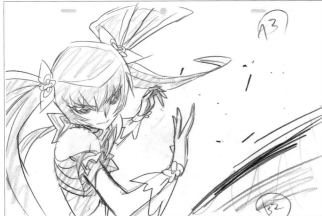

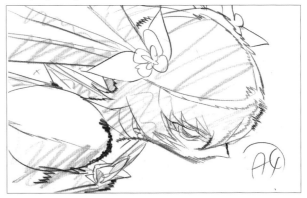

She lunges forward, her face twisted and her hair floating up. By distorting her face and adding shaky, wavering lines, we loosen or open up the scene.

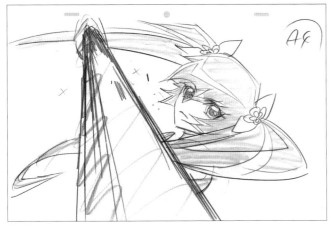

In contrast to the more intricately drawn transformation sequence, the fight scenes are simpler and pared down. Streamlining the action helps create a sense of speed.

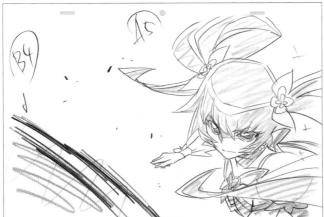

Deflecting an Attack
The hair ripples and floats as the character deflects a glancing blow. Changing the point of view to the attacker's perspective is a good way to add dimension, dynamism and perspective.

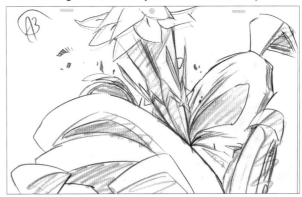

Or cut to the chase: Jump to the end of the fight sequence, as your battle heroine lands her blow. She's made her point, and her fists have done the talking.

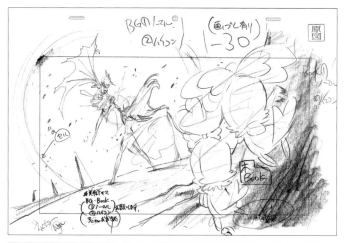

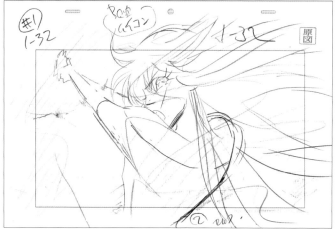

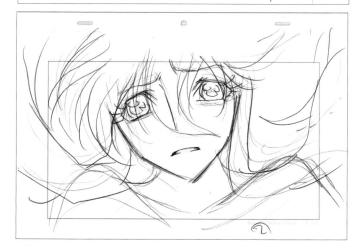

The Attraction of Action
Switching back and forth between opposing
points of view is another simple way of
introducing complexity and depth to your story.

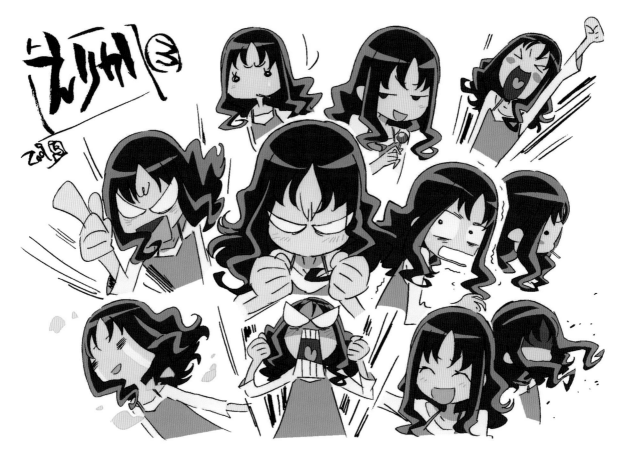

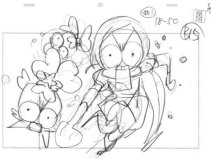

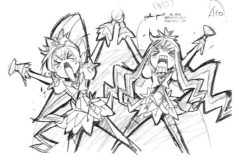
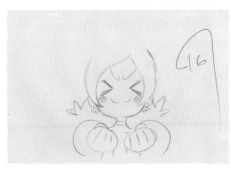

Drawing Chibi Characters

The faces of chibi characters often have thicker lines to emphasize or exaggerate their "cuteness." The contrast between the tense poses found in the serious scenes and the expressions in looser daily-life scenarios adds an essential variety that keeps your readers or viewers hooked.

AN INTERVIEW WITH THE MASTERS OF MANGA

We ask these two, who've been both animators and character designers for a long time now, what inspired them to enter the worlds of manga and animation. And then we took it from there:

To start off, we'd like to hear what inspired you both to become animators in the first place.

Kagawa: It was the animation boom on television that triggered my interest. Influenced by the imagery, I started drawing and copying pictures. I ended up copying largely a lot of the anime works. Then I showed those pictures to my sister and my friends and thought, "This makes them happy, which makes me happy."

Umakoshi: I was inspired to become an artist and animator by manga too, and the layouts and frames created by the true pioneers, drawn with color pencils, were just too cool!

Gundam had a huge influence, didn't it? Now, in this book, we're asking the two of you, who actually became animators and practiced your craft in the industry, to go all out in demonstrating your skills.

Umakoshi: It's the drawing and design techniques for battle heroines, isn't it? It's interesting, seeing as neither I nor Kagawa drew female characters to start with.

Kagawa: As an animator I was heavily influenced by Junichi Hayama, so I'd learned how to draw bone structure and the like from series featuring very manly men. But I'm applying what I learned from them to female characters as well.

Are your methods and thoughs processes behind designing female characters different from other animators?

Umakoshi: Oh, yes, they're very different.

Kagawa: We've been drawing from a time before the current moe boom, so it's difficult to understand some of the more recent methodologies.

Umakoshi: Yes, they're incomprehensible, aren't they?

Kagawa: But they say that the start of moe was "Sailor Moon." Having said that, the girls in "Sailor Moon" that I drew had quite masculine personalities and mannish poses. I drew them with the thought that I wasn't one of those moe-type animators and was reacting against all that. Apparently drawing those young girls with such physicality worked for the people who liked that sort of thing.

In the Pretty Cure series that you've both worked on, Kagawa's design have smaller faces and a more realistic feel, don't they?

Kagawa: That was from a request to make them taller looking over all. But there was also a wish to put in more jokes and gags, so there are humorous expressions, "funny faces" in it that hadn't been used previously in the Pretty Cure series. It's pretty reminiscent of early "Sailor Moon" actually.

You can see a lot of differences just from studying the design of a single eye.

Umakoshi: Because I can't do any of that stuff where you add lots of lines and shadows to a young girl's eyes to make them sparkle.

Kagawa: I can't either. It's just so difficult. I only draw the pupils and highlights.

Umakoshi: I can understand that, as our characters have to see, right? Those complicated eyes.

How do you make a character appear cute without drawing over-the-top eyes?

Kagawa: Through their poses and movements.

Umakoshi: We're artists, after all. We look at the situation, the context and adapt and mold their mannerisms and their movements accordingly.

Kagawa: Even the way a character sits, her pose, can be revealing, the off moments when a character's in a contemplative mood.

Umakoshi: The way a small child sits is different from how a high-school-age character sits and so on. The details reveal the character.

How do you realistically depict gestures and mannerisms?

Umakoshi: I don't have children, nor can I really spend much time going out into the streets to observe people, so I tend to use movies and televisions shows as references.

Kagawa: Watching actresses on screen, you can work out what they do in their performances that catch your attention and captivate you.

Are there any things to pay special attention to during a character's transformation?

Kagawa: We figure out each character's post-transformation/fighter look first then work back from that to develop her alter ego or student avatar, her point of origin. Making her hair shorter, drawing her as close to a simple junior high schooler as possible, designing an original costume or uniform.

Umakoshi: It is easier to work backward, but remember it's a free-flowing, two-way process, each persona is reflected in the other, the battle heroine shows in her everyday persona and vice versa. Oh, and one last thing: have fun with it. It will show in your drawings and the stories they tell!

Do you take special note of those movie scenes?

Kagawa: It's not that I actively try to make any special note of them.

Umakoshi: At the end of the day, our work is to replicate what it was that we found especially good about them. We don't remember the scenes totally in their details, but we try to replicate what we felt it was like. We've had times where afterward we might

go back to the original and find it was completely different. But it does come down to wanting to replicate the impressions those scenes evoked.

Do you often have directives as to how character poses should be drawn?

Umakoshi: It's different on each occasion. Sometimes we're given total free rein. With Pretty Cure, didn't we decide things after a discussion with the director and producers?

Kagawa: We did. We had notes from the director about the positions of characters in scenes and who or what to put in the center. In the copyrighted official illustrations, there were seated poses, as well as standing, and there were some very specific requests about those poses.

Are costume designs decided from the very start?

Umakoshi: Template patterns tend to be decided from the start quite often. It was decided for Ojamajo Doremi.

Kagawa: Costumes tend to be redesigned by the merchandise department to make them more suited for toys after the animation side has decided on its designs. Also, fairy-character designs tend to be decided before they come to us, and we draw proposals of what they might look like moving in the animation.

Are the antagonists' character and costume designs decided from the start?

Kagawa: The antagonists aren't decided at all—for toys or costumes—so there's an element of freedom with them. For one of the additional Cures, there's one who changes sides from the antagonists to the protagonists (Eas becomes Cure Passion), and in her case nothing about her design was fixed, so we proposed all her designs. There was input that they wanted to make a toy from part of that design, so then we adjusted accordingly.

Are the magic items' designs already decided with toys in mind?

Kagawa: The items they carry are already designed by toymakers. In Pretty Cure, the costumes were also designed by the toymakers to be changeable in lots of way. Considering that, we made changes to the silhouettes and some of the positions of the costume parts.

Are there any things to pay special attention to from pre- to post-transformation?

Kagawa: In "Fresh Pretty Cure," we decided the main girl's post-transformation design first, then worked back from that to her pre-design. Making her hair shorter, drawing her as close to a simple junior-high schooler as possible, designing an original school uniform. The first three girls all came from different schools, so we designed their uniforms with the image of their respective schools in mind, such as, "This girl goes to a private school and is a little lady" or "This girl goes to an ordinary public school."

We discussed copyrighted official illustrations earlier, but are there any particular points to be concerned about when drawing those?

Umakoshi: I draw them with the feeling of being able to represent the series with a drawing that says: "This is it!"

Kagawa: "Fresh Pretty Cure" had dancing as a main concept, so I drew the characters in poses that were similar to dancing.

For dance scenes and the like, what do you use for your references?

Kagawa: There's nothing that I specifically use. I go more for images or feelings, like female kung fu motions. Maybe I've drawn some influences from Chinese martial arts, which can look quite balletic. Umakoshi is probably similar to me, since we're both of the Jackie Chan kung fu generation.

Umakoshi: We had a lot of influence from Daisuke Nishio to start with too.

Kagawa: Nishio was a big kung fu fan, wasn't he? Pretty Cure's concept was based on the premise, "What if pretty young girls like in 'Sailor Moon' were to engage in 'Dragon Ball'-like action?" That's why we went for a more refined and elegant style of action over the brawly stuff.

Do you have any particularly memorable moments from your times working on Pretty Cure?

Kagawa: The call to work for "Fresh Pretty Cure" came to me when I'd left Toei Animation to work at another company, so it was the first time in a while that I'd worked with them. I didn't know why they were calling me (ha ha). It was probably because they wanted to expand the age of their viewing audience, so decided they wanted more adult-looking characters, and they called me in because I'd done "Sailor Moon." Because I'd left Toei, I was quite scared to work with them again, but there was the nostalgic feeling of returning to an old roost too. As "Fresh" was the first series that I worked on in a Toei production as both animation director and character designer, it had a big impact for me afterward. At the time, I was a complete novice when it came to the Pretty Cure series, so by taking on board and digesting lots of different people's opinions, I think I was able to get a favorable result.

Umakoshi: The memory that's stuck with me is how happy I was when the character that I just came up with on a whim, Coupe, got used in the show. Even though there was some chaos at the studio because of it, at the point of discussing whether to include or not to include the character in the cast, the director approved it. To me, it was a character I'd created because it was fun to "Just have it there," but then it could turn into a beautiful young man, and then it had a mysterious connection with the main character's grandmother. In the end, it became quite an important character (ha ha). Probably the only person who was happy about it was me, but I really was so happy. And the toymakers actually made a model of him. Having said that, when it came to the opening credits and the climax scene and he's rampaging about in them, I took responsibility and drew all the principal frames for his sequences myself (ha ha). My other fond memory is that I was able to be animation director for the last two episodes. The final and penultimate episodes were really tough, but I am so glad that I did them.

Drawing Your Own Fantastic Fighters

So this is what you came for! You're about to draw along with two masters as they explain the drawing and design techniques you'll need to produce your own battle heroines. From there, they'll walk you through the character designs used in the original story created for this book. From character setting to method of design to fine-tuned facial expressions, you'll get to see the individual approach of two expert artists and see the choices and approaches that lead to their signature styles. Then it's time to come up with a signature style all your own!

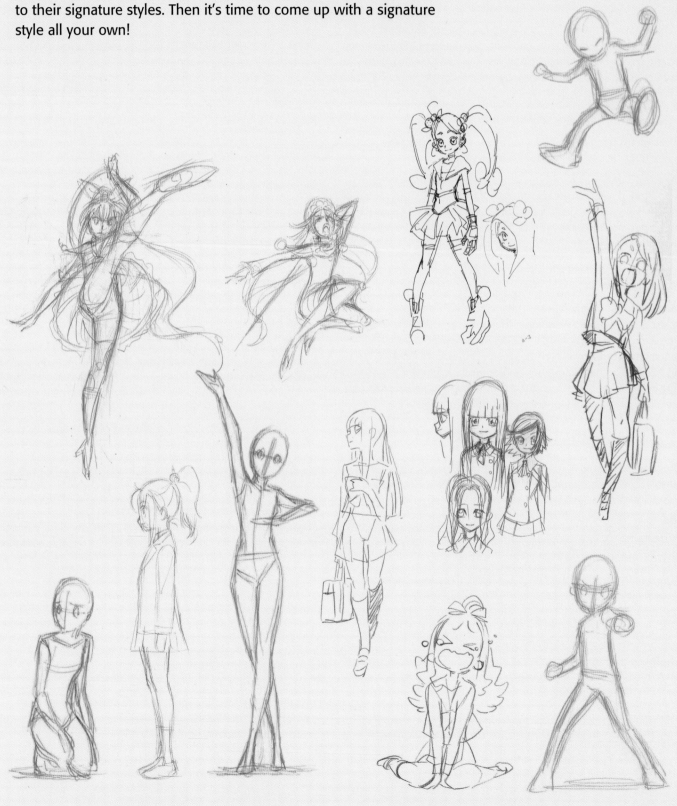

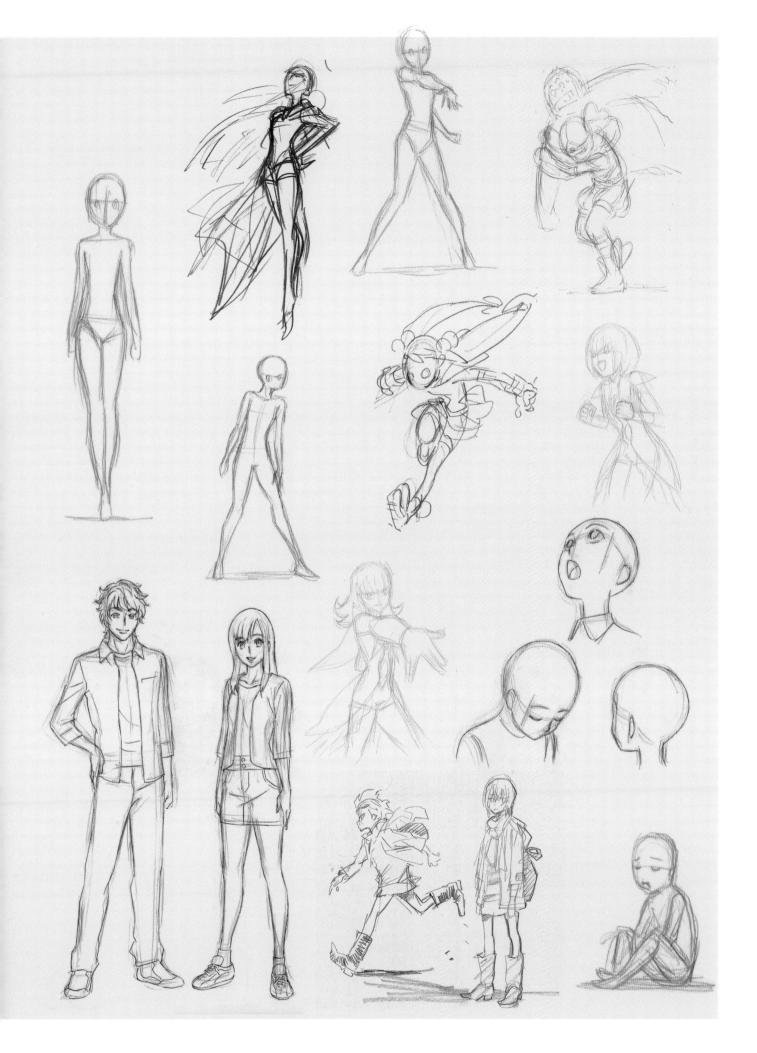

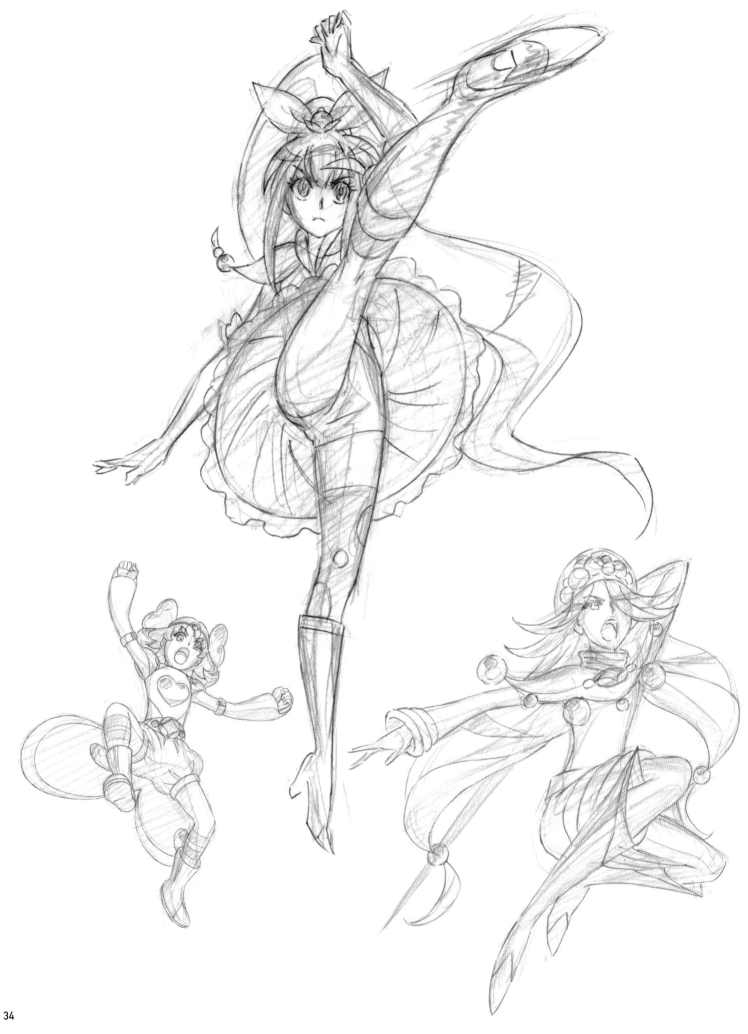

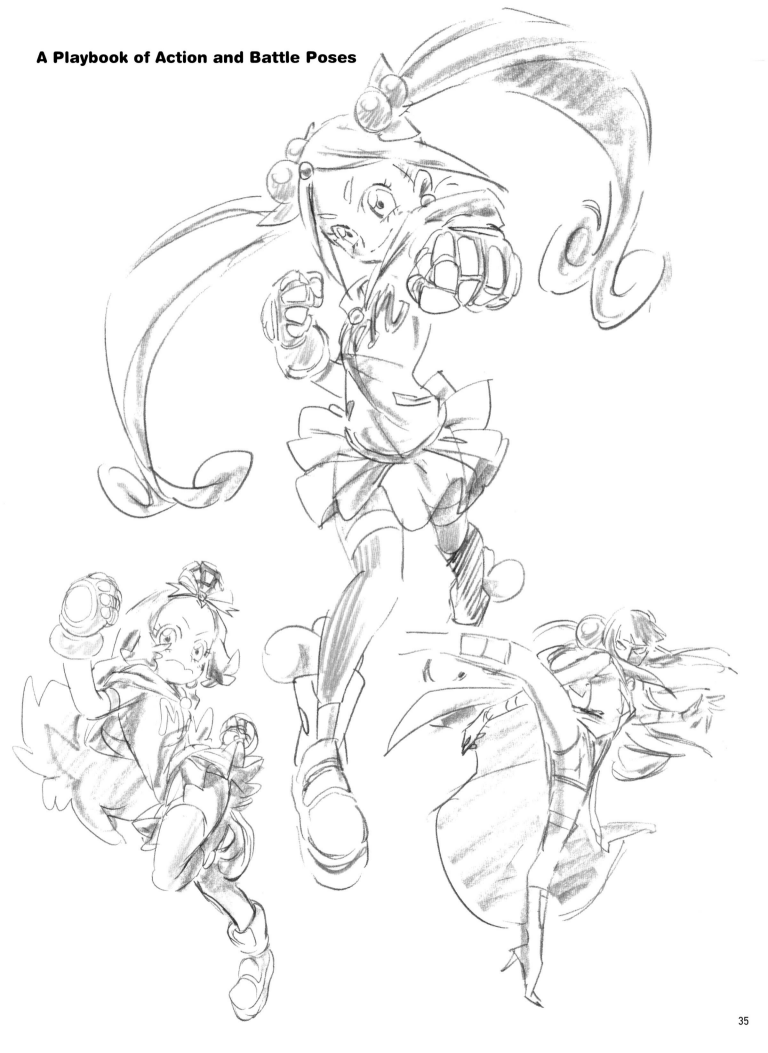

How to Draw Characters: Basic Tips, Tools and Techniques

Here, we'll introduce the basic techniques for drawing human characters, including the body, poses, facial expressions and the key points to consider when drawing specific parts.

From Outline to Finished Drawing

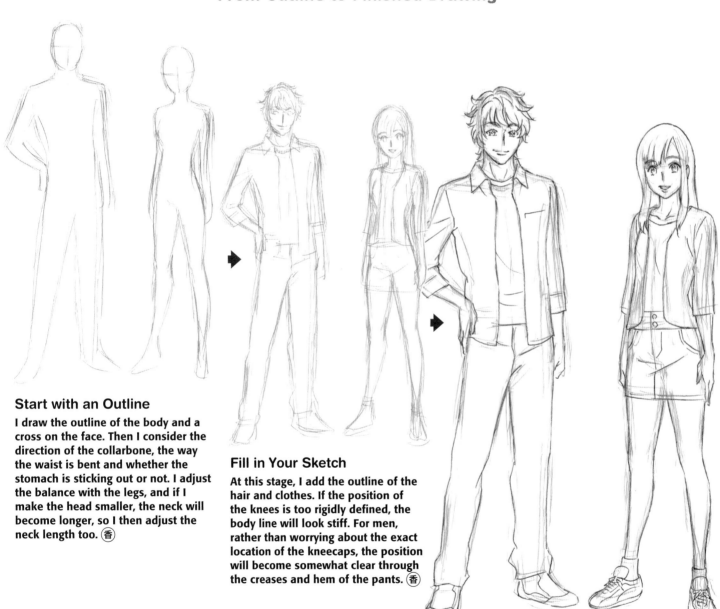

Start with an Outline

I draw the outline of the body and a cross on the face. Then I consider the direction of the collarbone, the way the waist is bent and whether the stomach is sticking out or not. I adjust the balance with the legs, and if I make the head smaller, the neck will become longer, so I then adjust the neck length too. 香

Fill in Your Sketch

At this stage, I add the outline of the hair and clothes. If the position of the knees is too rigidly defined, the body line will look stiff. For men, rather than worrying about the exact location of the kneecaps, the position will become somewhat clear through the creases and hem of the pants. 香

Wrap It Up

Here, I add even more details. The main difference between men and women is in how you draw the thickness of the neck, the shoulders and the overall physique. For women, I am conscious of the curves and I create a pose that accentuates the belly and butt. For unathletic men and women, I make sure the chest isn't too defined, and I make the shoulders rounded. 香

Expert Tip

The Basics of Drawing Women
I draw women's joints and fingers with a looseness to them, as though they don't contain too much strength. Be careful not to draw the hands too realistically, or else they'll look mechanical. 香

Drawing Realistic Characters

The details I've chosen to adorn this character with add up to a natural, realistic look. With a denim skirt and sneakers, she's a strong, sporty presence. 香

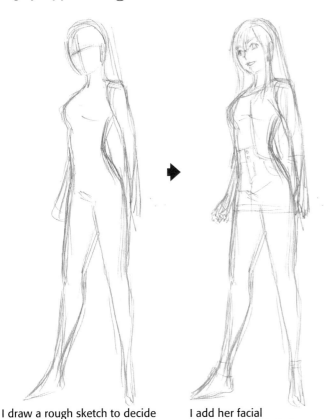

I draw a rough sketch to decide the head-body balance.

I add her facial expressions and clothes.

She looks older by making her chest bigger and adding more volume to the body.

I draw the nose line and even nostrils to be realistic.

With realistic characters, I add a bit of thickness to the thighs and favor thinner ankles.

Drawing Chibi Characters

The head is about 3.5 bigger than usual, in the style of manga. It's my own particular preference and approach, but I omit the joints of the fingers and hands so a more flexible figure is formed and the exaggerated features and look can be supported. 香

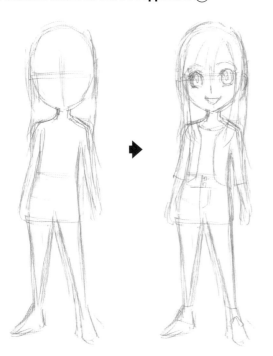

To emphasize the exaggerated and oversized parts and features, rather than getting thinner toward the ankles as you would with a realistic character, draw the ankles slightly thicker.

Expert Tip

Rubbery Chibi
For chibi characters, I draw the joints like rubber, as though they're softly bending. That makes it even easier to give the character that essential blend of cutesy and comical features. 香

A regular joint

A chibi joint

Basic Tips, Tools and Techniques 1
Be Aware of Body Lines

When drawing fantastic fighters and battle heroines, try keeping your lines supple.

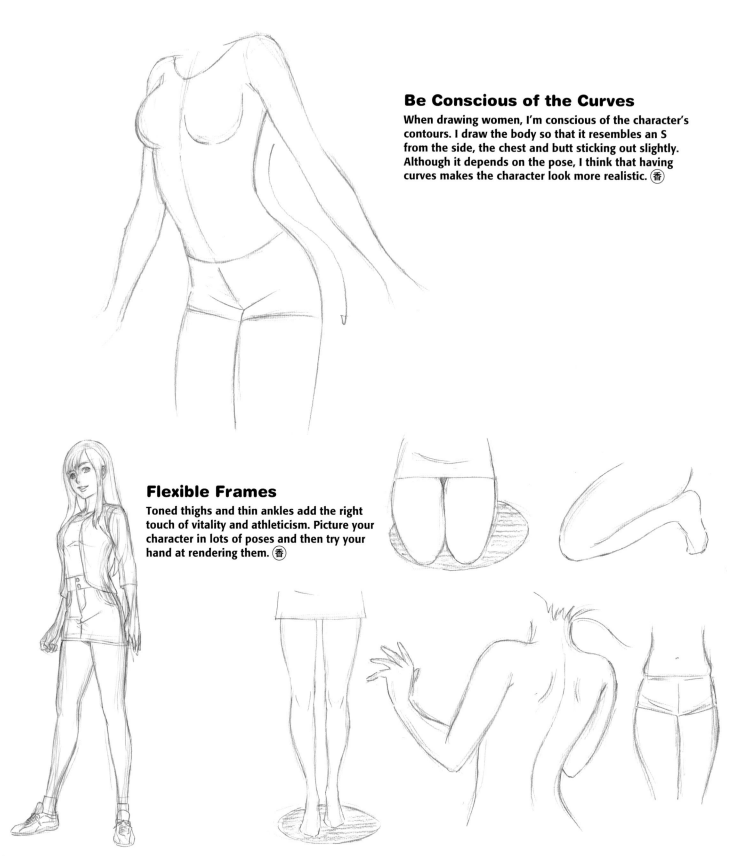

Be Conscious of the Curves
When drawing women, I'm conscious of the character's contours. I draw the body so that it resembles an S from the side, the chest and butt sticking out slightly. Although it depends on the pose, I think that having curves makes the character look more realistic. 香

Flexible Frames
Toned thighs and thin ankles add the right touch of vitality and athleticism. Picture your character in lots of poses and then try your hand at rendering them. 香

Adjust the Shoulder Width and the Neck Length

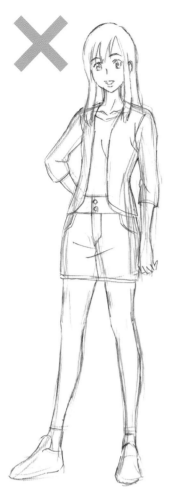

Adjust

In the drawing on the left, the shoulders are too low and the neck is too long. It looks like it's growing out of the chin. So I adjust the height of the shoulders and shorten the neck. The bend in the right arm and shoulder means the hand is turned and concealed behind the back. So I've redrawn the direction of the creases in her top to make the arm and hand look more natural and realistic. Further, in the left drawing, the angle of the waist is too shallow, so it looks as though she's tipping or leaning to the right. I compensate for this by widening the legs and putting emphasis on the right foot. 香

Here the arms are being held more rigidly alongside the body. Notice the slight gap I left between the left arm and the waist.

One More Thing

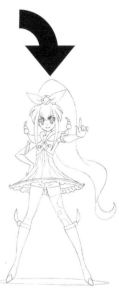

For battle heroines, exaggerating the length of the legs below the knees helps to create an action pose.

How Clothing Affects Body Line
Even when your character's wearing a skirt, it's important to think about how the legs look. If you don't, it'll look as though they're growing from a strange position. 馬

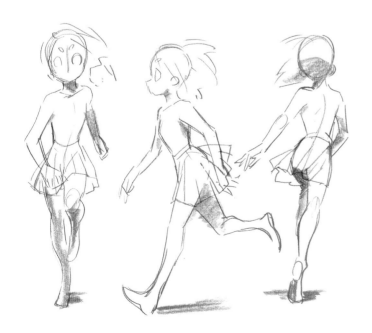

Expert Tip

Think about the difference between men and women by looking at a cross-section of the waist

When drawing men, I think of the cross-section as a rectangle, so I use that shape. For women, an oval or circle works best.

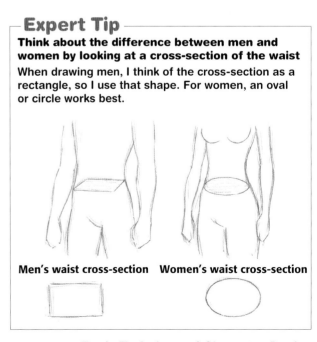

Men's waist cross-section Women's waist cross-section

Basic Tips, Tools and Techniques 2
Exaggerate Your Poses

Once your characters' proportions have been decided, it's time to figure out their poses. Here we'll also show how to express personality through gestures, and what to be careful of when drawing action poses.

Poses That Match the Character

It's possible to express a character's personality just by the way she stands, from a smart, delicate character that stands on one leg to a strong fighter who stands firmly with both feet on the ground. It's important to express these personalities through the details you work into the drawing. 香 馬

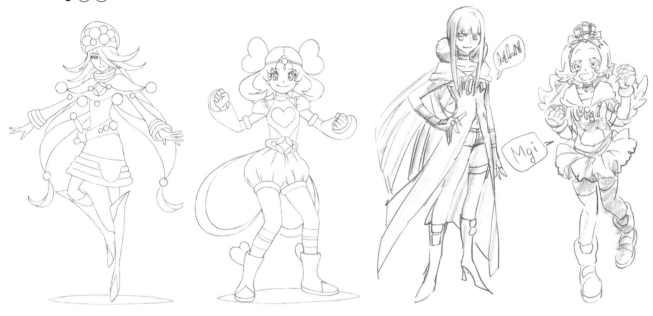

Emphasizing the Gestures

Hand movements are an important part of expressing character, so exaggerating the gestures is an essential technique to master. 香 馬

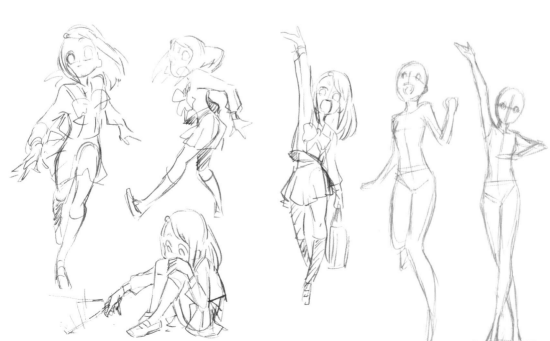

Creating New Poses

Draw a projection line between shoulder, collarbone, chest and waist; then, based on that line, continue filling in so that it's obvious which leg is forward. 香

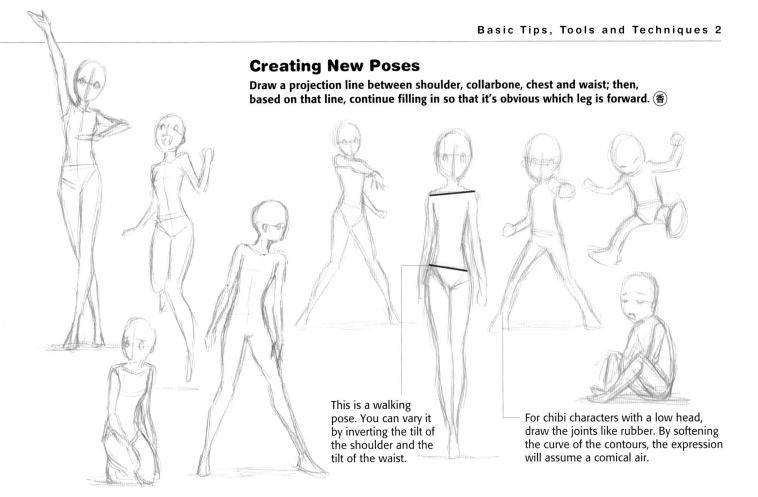

This is a walking pose. You can vary it by inverting the tilt of the shoulder and the tilt of the waist.

For chibi characters with a low head, draw the joints like rubber. By softening the curve of the contours, the expression will assume a comical air.

Expert Tip

Keep the waistline in mind when deciding on the pose

By making the waist higher, emphasizing the neck and lengthening the legs, especially the lower back, the design becomes something that can be used for a battle heroine action pose. 香

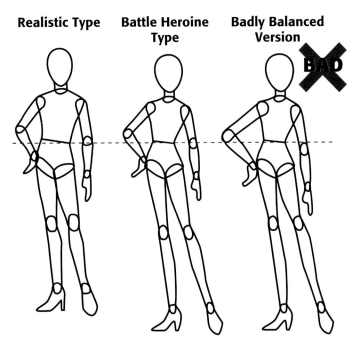

Realistic Type **Battle Heroine Type** **Badly Balanced Version** BAD

If both the legs and arms are lengthened, it looks unnatural, so the arms shouldn't be made longer. Just make sure that the legs and the lower back aren't too long.

In a standing position, the body weight shifts to one leg, the central line shifting with it, the shoulders and pelvis tilting in opposite directions to create an S shape. 香

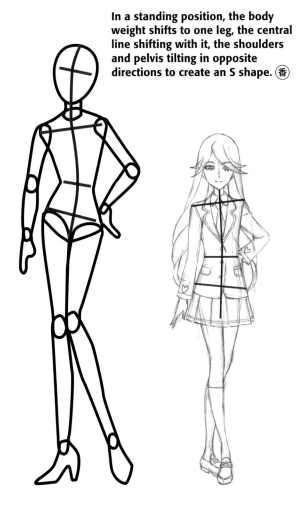

Basic Tips, Tools and Techniques 3
Finding Balance in the Face

It's the face that makes the character, so it's the most important part to master. Right down to drawing the pupils, everyone has his or her own style. This time, focusing on Hisashi Kagawa's technique, we'll introduce the basics of making faces.

From Outline to Completion

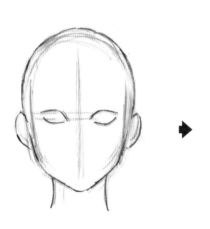

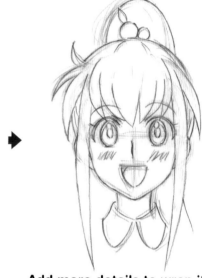

Outline the contours of the face
Draw the front-view outline contours of the face, and decide the position of the eyes by adding a cross-shaped projection line. The ears should be slightly lower than the eyes. 香

Add in the details
Add the rough details of the eyes, nose, mouth and hair. For battle heroines, the eyes can be slightly bigger than in real life. 香

Add more details to wrap it up
Add the finer details, such as the pupils. Once everything has been adjusted with the main outline, the drawing is complete. Look to the next page for help on how to draw the pupils. 香

Tips for Changing Angles

Changing the distance between the eyes and ears depending on the angle of the face is a key technique to master. From a front-facing angle, the eyes and ears look closer together, while from a side-facing angle, they'll be farther apart. To avoid an unnatural or unbalanced appearance, it's important to get the spacing right. Once you know the angle of the face, decide the position of the ears and draw them in. It then becomes easier to draw the rest of the face. 香

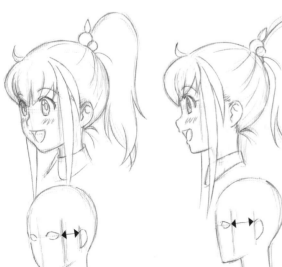

Regardless of the angle of the face, it's easier to draw if you think about the position of the eyes and ears.

All Eyes on Eyes

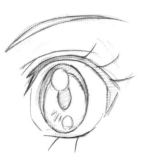

The shimmer of normal pupils

A slightly more enhanced effect

Highlights

The green parts are the darker shadow.

The ring light is a slightly lighter shade than the main pupil.

This is the main color of the pupil, so for blue eyes it'll be blue.

The blue area is shadow.

Adding a ring of a lighter color around the pupil highlights and emphasizes it. (香)

Ring Light Effect

Adding a ring around the pupils, then a lighter color and highlights, makes the eyes especially bright and sparkling. (香)

A pair of perfect pupils

Out of proportion

Draw it in the shape of a mortar or bowl

Seeing in Three Dimensions

When looking at the eyeball from the side, it's possible to see the lens if the pupil retains a bowl-like shape. If one is not conscious of the lens, it looks like the pupil is stuck to the eyeball like a sticker. (香)

Slightly Crosseyed from the Front

By making the irises slightly crossed or off-center, it looks as though the eye is looking straight on. It's easier to pull off on characters that have big eyes, where the effect is exaggerated. (香)

Expert Tip

Kagawa's design

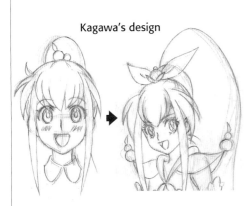

Individuality in face design

If you compare the faces, you notice a big difference in the position of the eyes. In Kagawa's drawing, the eyes are big, and post-transformation, the eyelashes are more voluminous and stiff. In Umakoshi's take on it, the younger the character, the wider the forehead area and the lower the eyes are, to give a sense of youth and vitality.

Umakoshi's design

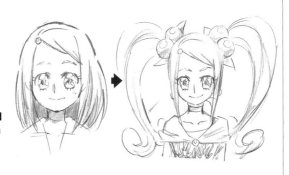

Basic Tips, Tools and Techniques 4
Capturing Emotion

When you're first developing your character, you'll draw it viewed straight on. But in reality, in manga, anime and animation, faces are rarely seen this way. So the character's feelings must be partially revealed through the angle of the face. Here we'll look at the angle of the face and how that affects the expressions you draw.

Laughter Fundamentally, laughter is expressed by raising the corners of the mouth. But there are so many permutations and shades to a smile. Even though it's the same basic shape, it can be a full smile or one that's turned or facing downward, it all depends on the story you're trying to tell and the reaction that's required. 馬

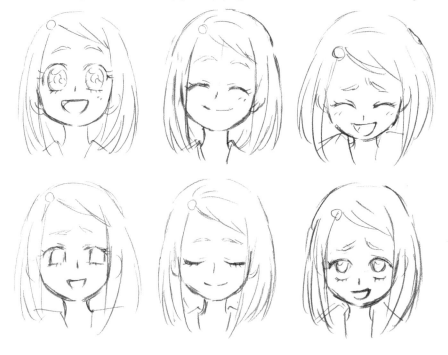

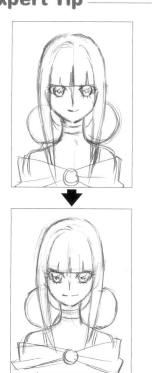

Expert Tip

Expressing Personality Through the Angle of the Face

It's not just in the eyes, eyebrows and mouth that give your character definition and a clarity of expression but also the angle of the face itself that can suggest personality and capture mood and emotion.

Anger The expressions for anger, as with the smile, encompass a range of modes. Eyebrows tilting inward and the corners of the mouth drooping are typical elements highlighted in a face pinched with anger. 馬

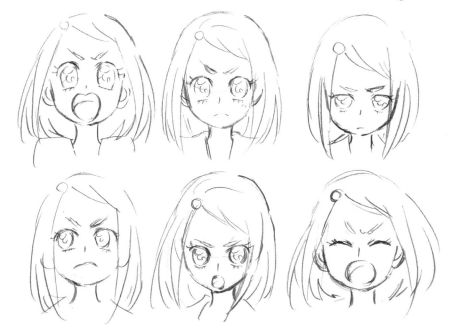

Sadness For a crying face, in contrast to an angry face, drawing the eyebrows outward helps to effectively capture the sense of grief. Settle on the right expression depending on the circumstance. (馬)

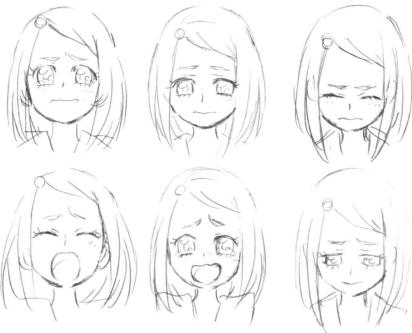

Creating Expression Through the Angle of the Face

Even with the same expression, depending on whether it's seen from below, above or from the side, the impression changes. Consider showing the ears so that it's easier to work out the proper angle and overall proportions. It might be helpful to set down a projection line to guide you before drawing. (馬)

From a slightly lower angle Straight ahead From a slightly higher angle

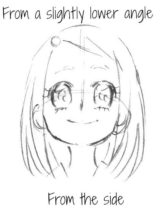
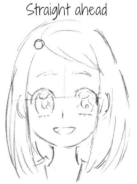

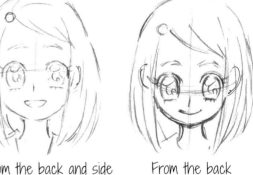

From the side From the back and side From the back

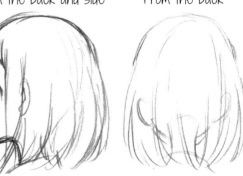

Expert Tip

Depending on the circumstances, there may be expressions or details that you leave out or add in. As in the drawings on the left, the teeth aren't shown, but depending on the circumstances, one might draw the teeth. With the comical drawings on the right, there are times when it's necessary to use a more exaggerated chibi-style expression.

Adding Details to Express Your Character's Individuality

Beyond the unique shape and size of the body, costumes, weapons and decorations all help to differentiate among the personalities of different characters.

Talking with Her Hands

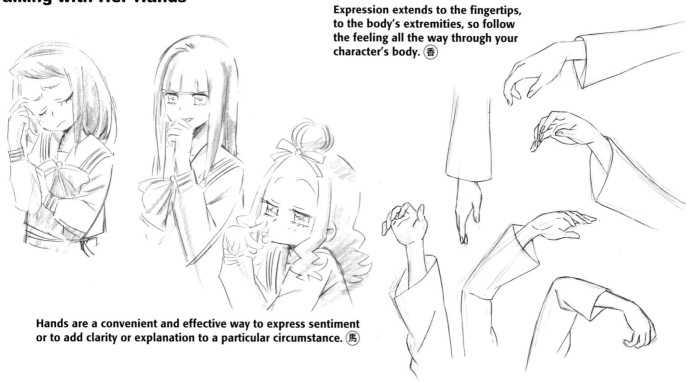

Expression extends to the fingertips, to the body's extremities, so follow the feeling all the way through your character's body. 香

Hands are a convenient and effective way to express sentiment or to add clarity or explanation to a particular circumstance. 馬

The Fabric of Their Lives

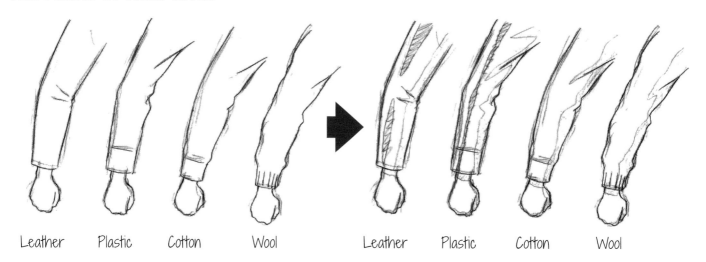

Leather Plastic Cotton Wool Leather Plastic Cotton Wool

As leather doesn't wrinkle much, I add jagged contours for the highlights with a bit of detail. For synthethic fabrics, it's easy for wrinkles to form, so although it depends on the color, I add detailed shiny highlights. For sporty-type cotton material, rather than a highlight, I draw a sharp shadow and subtle wrinkles. For wool, I use contour lines and a soft, contoured shadow. 香

Sock It to Them!

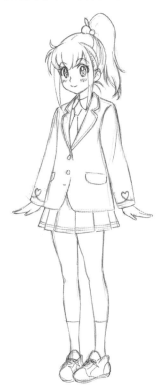

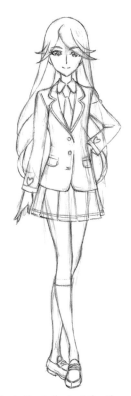

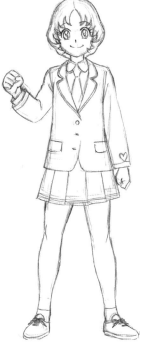

When the characters are wearing the same uniform, it's difficult to differentiate their personalities, so it's necessary to capture their individuality through their socks and shoes. 香

An athletic character, she favors sneakers over pumps or traditional leather shoes.

She's the tallest of the three characters and wears her loafers like a princess.

This character does judo, so she stands squarely. The clenched fists underscore the impression of strength.

Adding Motifs

This character's motif is the grape, so I designed a transparent hat containing grape balls.

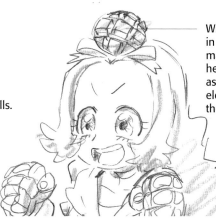

With a hair accessory in the shape of a cut mango, it's clear what her characteristics are, as well as adding an element of humor to the illustration.

Design Elements

The characters' post-transformation costumes are decorated with food motifs, and I drew cheeky little matching scarves around their necks. 馬

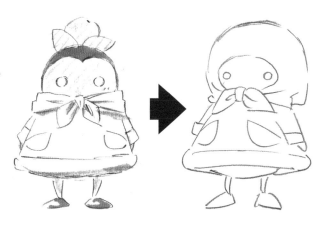

Creating Characters to Tell an Original Story

In this book, using an original story as a basis, we've asked our manga masters to explain how they came up with each character design. Kagawa thinks about the concept of the character's setting before sitting down to draw, while Umakoshi thinks about the concept while working on his rough sketches. Note their different methods and come up with your own!

Common Themes
A battle heroine plotline featuring junior-high students

Part 1

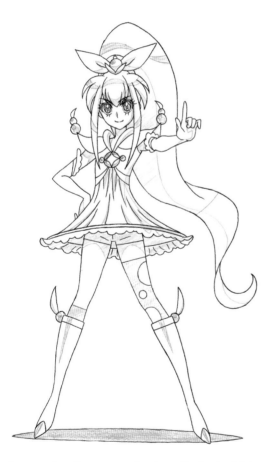

Summoning the power of nature, the junior-high students transform into their fierce-fighting alter egos to fight Pesticide, their nemesis.

▶ page 49

Part 2

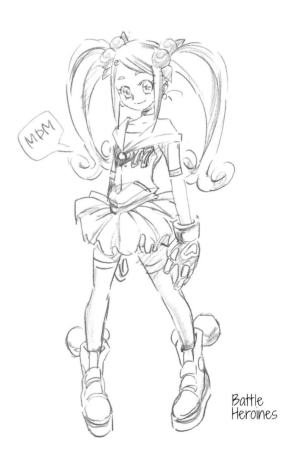

Battle Heroines

With Pesticide hiding in the human world, plotting to turn people into chemical monsters, a junior-high student transforms into a legendary warrior in order to fight her.

▶ page 109

Part 1

A Tutorial with Hisashi Kagawa

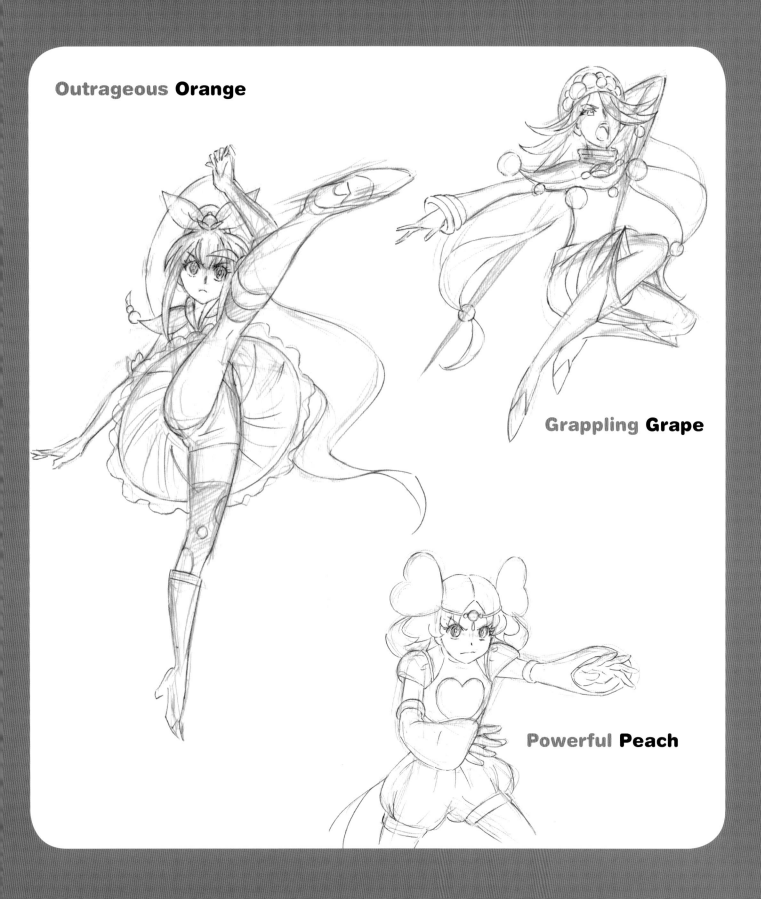

Outrageous **Orange**

Grappling **Grape**

Powerful **Peach**

Part 1 Storyboard Overview

Sasha is in the second year of junior high. She can be a little ditzy, but she's a sweet, kindhearted girl.

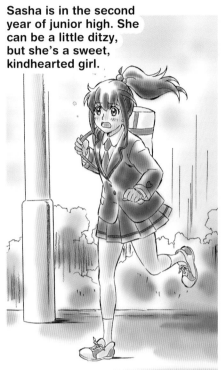

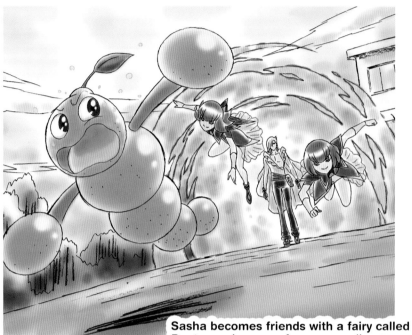

Sasha becomes friends with a fairy called Pontoon who came from a paradise known as Loveacre. But they're attacked by mysterious invaders.

"I want to protect you and the world you live in! If we join forces."

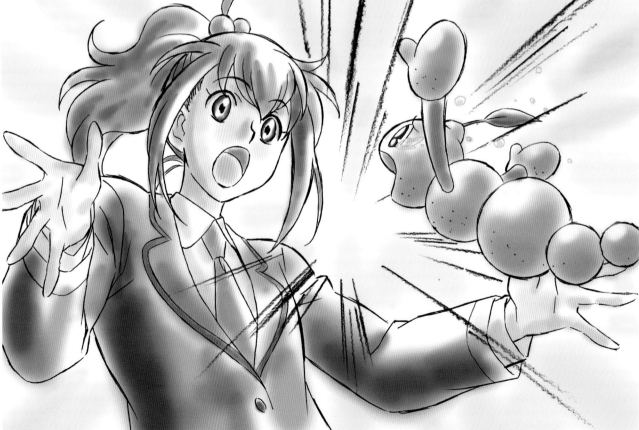

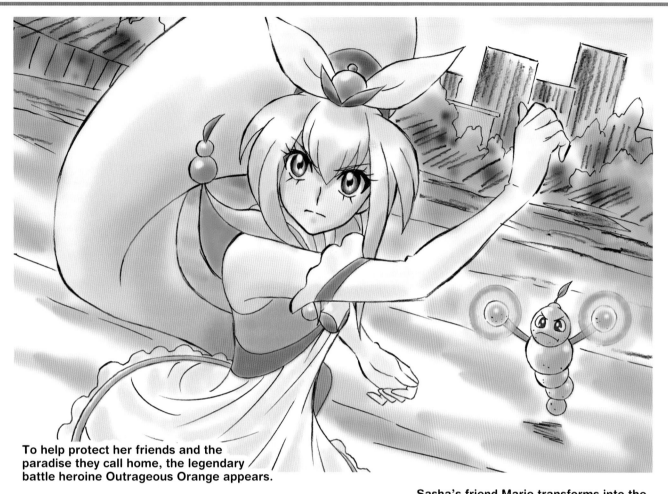

To help protect her friends and the paradise they call home, the legendary battle heroine Outrageous Orange appears.

Sasha's friend Marie transforms into the formidable Grappling Grape.

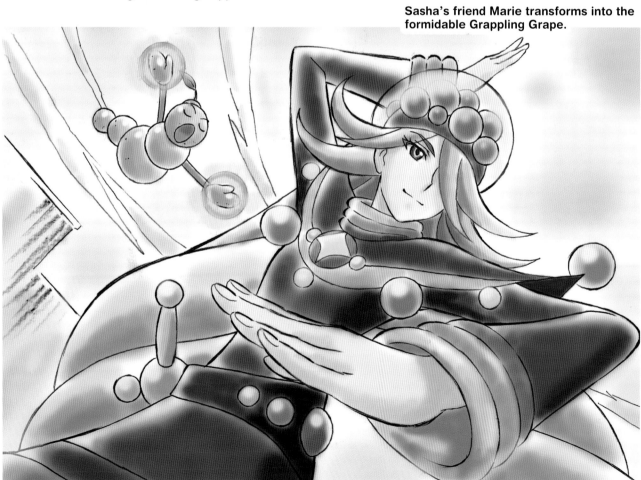

Another friend, Tammi Matsuno, in the guise of Powerful Peach, joins in!

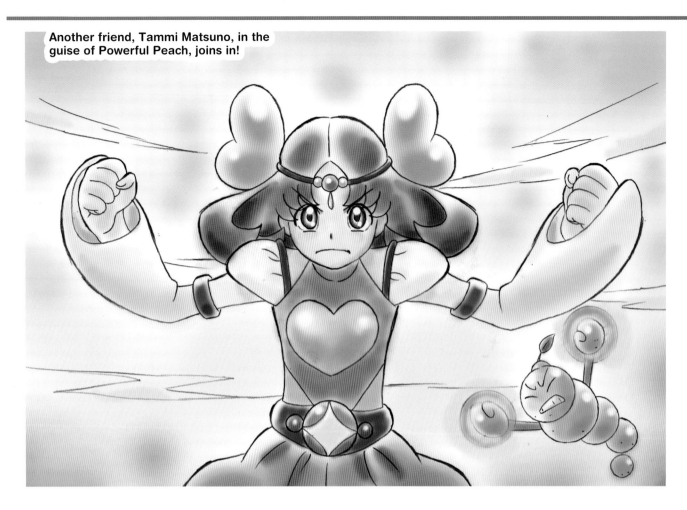

Powerful and poised, ready to protect the peace of Loveacre, the three battle heroines step up to fight!

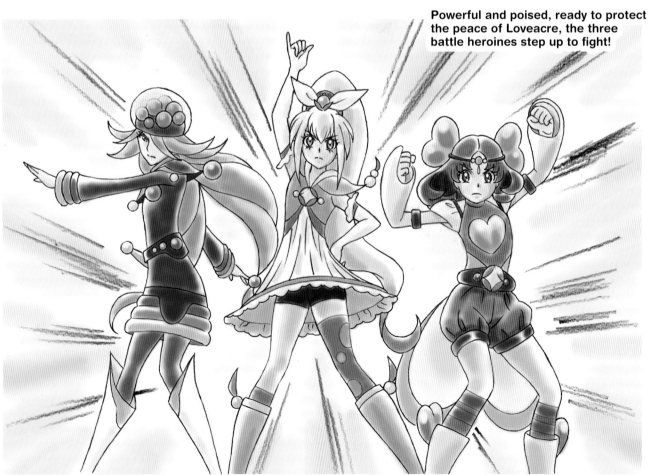

What does Pesticide want anyway?
In the end, can Sasha and her power posse protect Pontoon's world?
The door has opened to a fierce battle!

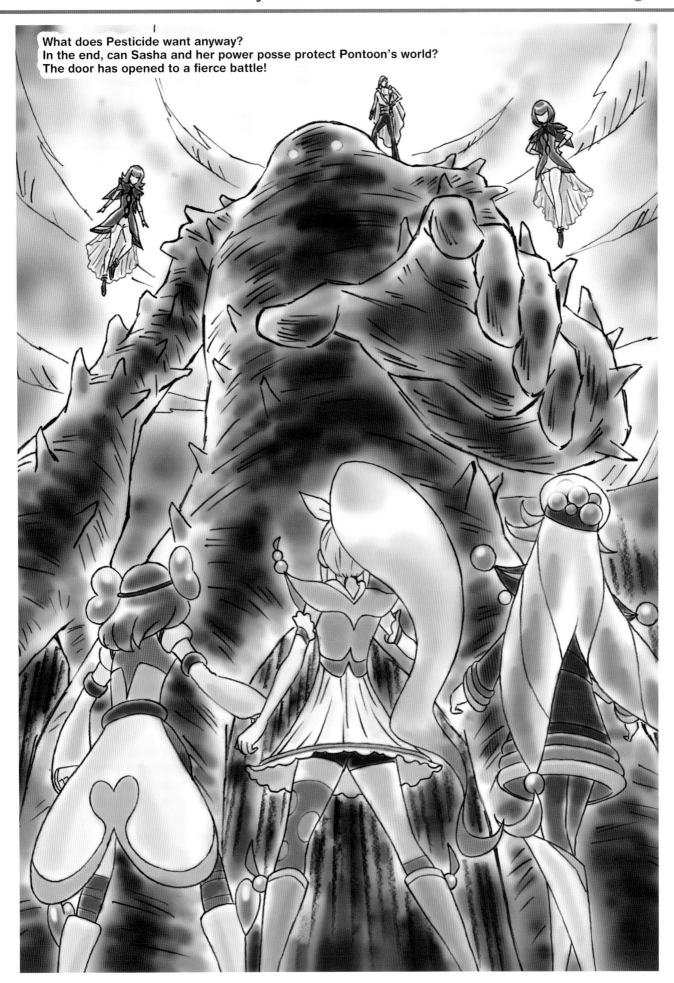

Part 1

Hisashi Kagawa's Character Designs

Subject:

A battle heroine illustration that features a junior-high student.

Setting the scene:

When the parallel world of Loveacre is thrown into chaos, the people ask the fierce fighters to save them, and an epic battle ensues.

Backstory:

The fruit fairies come from Loveacre, where they've been living in natural harmony. However, Pesticide and her minions threaten to undermine this order with their stringent chemical attacks. To find a savior for Loveacre, Pontoon and the fruit fairies barely make it to the human world, where Pontoon and Sasha become fast friends. But, with an eye to target the human world's additives and chemicals, Chemload, the evil warrior who has followed Pontoon, creates a seething, fearsome monster! If it were to enter Loveacre, the fruit fairies would surely be destroyed. As Sasha hugs a weeping Pontoon, she vows to resist. Surrounded by a shining light and with a helping hand from Mother Nature, she transforms into a fierce warrior and battle princess! A fight breaks out between Outrageous Orange and the toxic monster Amakunena. With Pesticide in control, the conflagration is spreading over the dimension that connects the human world and Loveacre. Can't somebody help?

Key points:

♦ A fierce battle between cute costumed heroines and an evil villain who is threatening their world.
♦ The costumes of our battle heroines bear fruit motifs while the evil characters are associated with chemical additives.

Based on this storyboard, we'll now look at how we came up with the characters, developing and designing them.

Part 1
Character
001 Outrageous Orange!

After meeting Pontoon, she's the first to transform, assuming the identity of Outrageous Orange. Although she has a tendency to be flighty and disorganized, she has a strong sense of justice and an upstanding moral code. Inspired by her love of kung fu movies, she's become a student of karate.

Starting Point

She's a bit ditzy, but take that as your cue and make her into a pleasant, cheerful girl.

Kagawa's Inspiration

Out of the three heroines, she's the main character, so I drew her first. As her name suggests, I've added lots of orange motifs as accessories.

Name:
Outrageous Orange aka Sasha

Character Data:

Motif: Orange Warrior

Age/gender: 14 years old/female

Personality: Happy and cheerful, a bit ditzy

Favorite thing: Kung fu movies

Hobby: Collecting movie memorabilia (particularly anything related to Bruce Lee)

Family structure: Family of 4, parents own an organic food shop, brother is a high school student

Skill: Karate (she has been going to the local dojo since she was small)

Framed in fruit: orange motifs decorate her costume.

A hair ornament featuring oranges and orange leaves. Afterward, this can transform into a wild weapon of your own imagining. It's important to include in the design the originating elements that change during the battle heroine's transformation.

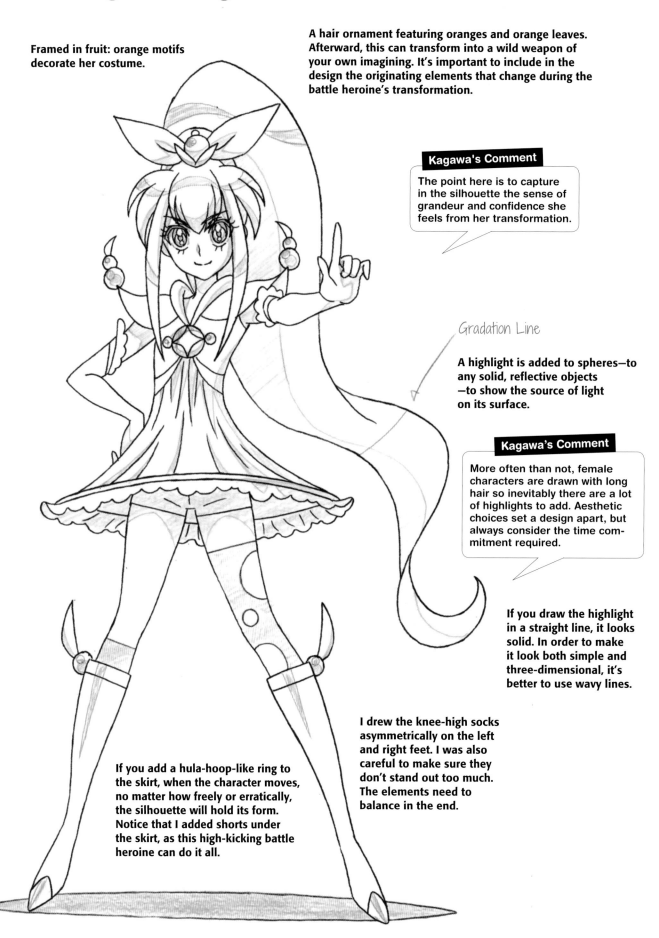

Kagawa's Comment

The point here is to capture in the silhouette the sense of grandeur and confidence she feels from her transformation.

Gradation Line

A highlight is added to spheres—to any solid, reflective objects —to show the source of light on its surface.

Kagawa's Comment

More often than not, female characters are drawn with long hair so inevitably there are a lot of highlights to add. Aesthetic choices set a design apart, but always consider the time commitment required.

If you draw the highlight in a straight line, it looks solid. In order to make it look both simple and three-dimensional, it's better to use wavy lines.

If you add a hula-hoop-like ring to the skirt, when the character moves, no matter how freely or erratically, the silhouette will hold its form. Notice that I added shorts under the skirt, as this high-kicking battle heroine can do it all.

I drew the knee-high socks asymmetrically on the left and right feet. I was also careful to make sure they don't stand out too much. The elements need to balance in the end.

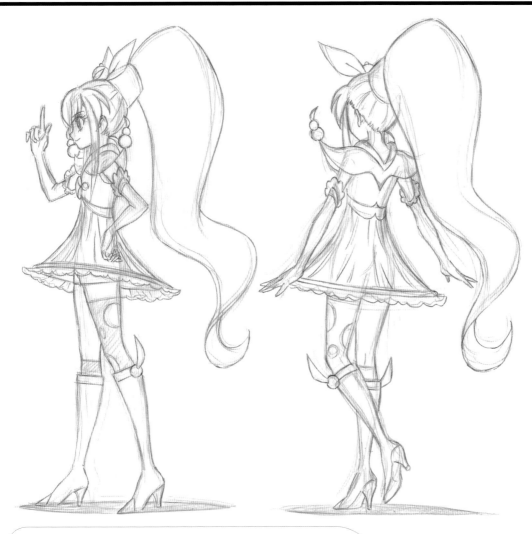

Expert Tips

Don't Overlap Complicated Details

I avoid drawing complicated details that overlap, such as adding hair over the frills on a costume. If the design becomes overly complicated, the main outline gets hidden and it becomes difficult to comprehend. Sometimes, the hair and ornamental features get in the way of the pose. Of course, from a design perspective, it's more interesting to have asymmetrical costumes or erratically complex patterns, but when it comes to animation, these choices can lead to all kinds of problems when creating a moving image. Just something to think about!

Master Class

Basic Design & Drawing Pointers

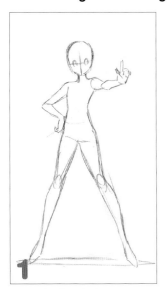

1 From the head, draw a contoured outline and sketch in the collarbone, waist and stomach line. In order to establish the direction of the face, add a cross shape.

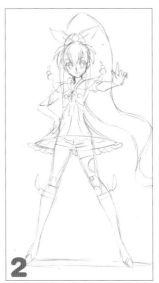

2 Adjust the proportions, and while keeping the costume in mind, add more details.

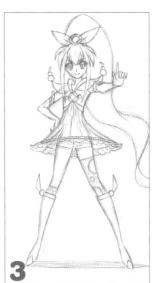

3 With a pencil, define the main outlines. In the process of adjusting the lines, fill in the details.

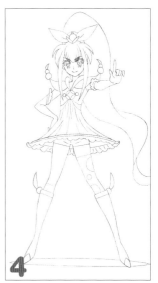

4 Trace the image so that only the main outlines are visible. Afterward, we'll decide the placement of shadows.

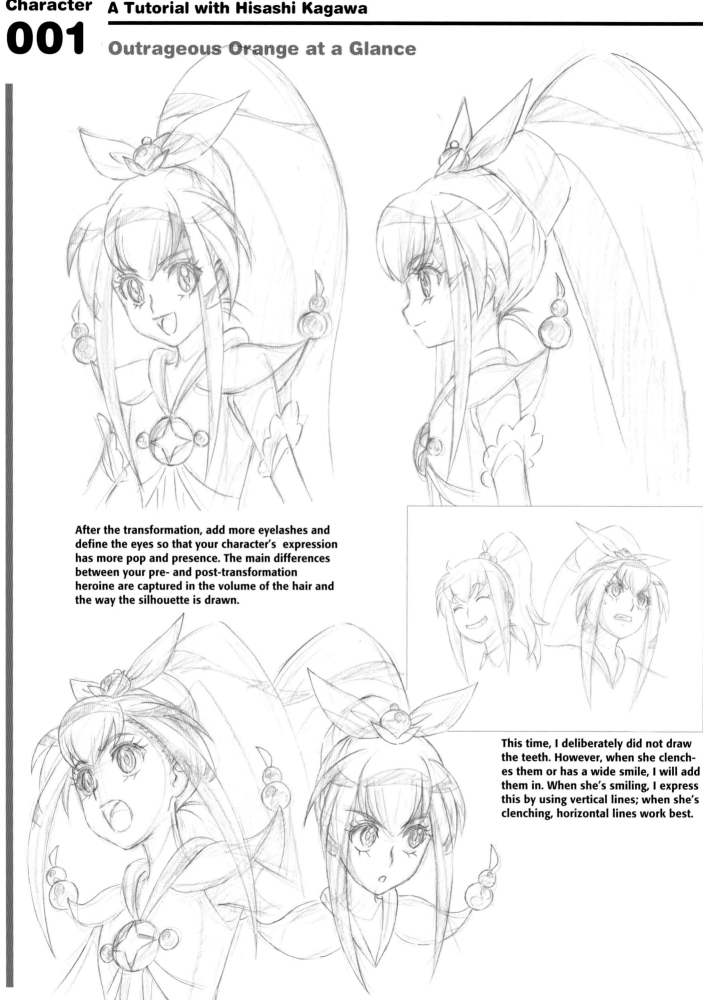

After the transformation, add more eyelashes and define the eyes so that your character's expression has more pop and presence. The main differences between your pre- and post-transformation heroine are captured in the volume of the hair and the way the silhouette is drawn.

This time, I deliberately did not draw the teeth. However, when she clenches them or has a wide smile, I will add them in. When she's smiling, I express this by using vertical lines; when she's clenching, horizontal lines work best.

Master Class
Basic Design & Drawing Pointers

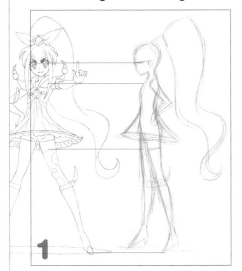

1 When drawing a pose in profile, use the already designed front-view pose as reference. Create the outlines of the head, legs and waist to match.

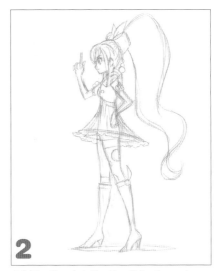

2 Add in the details. For this character, the circle of the skirt is raised at the front, so when it's seen from the side, I've drawn it diagonally.

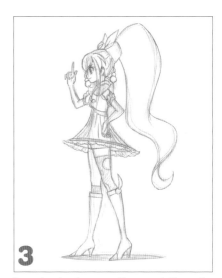

3 In order to clean up the rough lines, I draw the main outlines. And then I'll trace over them.

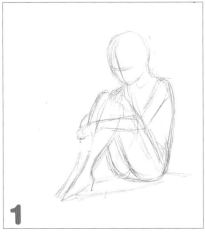

1 For a seated pose, I decide the position of the head and bottom before drawing the legs. To match the character's features, I draw outlines of the back and each body area.

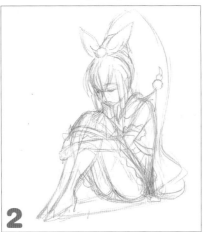

2 In proportion to the size of the head, I then draw a bow or fringe, adjusting the position of the shoulders to the front and so on. Then, I start adding the costume and its details before deciding on the line of the ponytail.

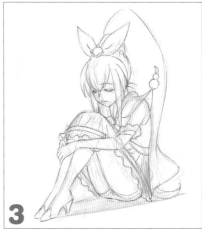

3 Finally, in order to clean up the rough lines, I draw the main outlines to finish.

Drawing a cross over the face helps you more easily decide the direction of the gaze and sketch in the rough outline of the face and position of the eyes.

With a pencil, fill in the main outline to finish.

Expert Tips

Think About the Costume's Movement

The body's flow and motion are expressed in the movement of the character's garment. In order to show that the illustration on the right is rotating, I've adjusted the drape of the skirt, twisting it. In the bottom-left drawing, when she spins at the waist, the hooplike effect at the bottom flares out, twirling afterward. Capturing the fabric's flow this way offers the suggestion of a soft rather than a stiffer, more rigid material.

I draw a tightly clenched fist so that it's inwardly twisting. Effects such as light, bubbles and smoke are drawn on separate pieces of paper when creating the animation.

As this character is a dedicated karate student, her signature poses, the roundhouse kick and the frontal punch, reflect that. Even for a junior high school student setting, I would like to create clearly defined poses.

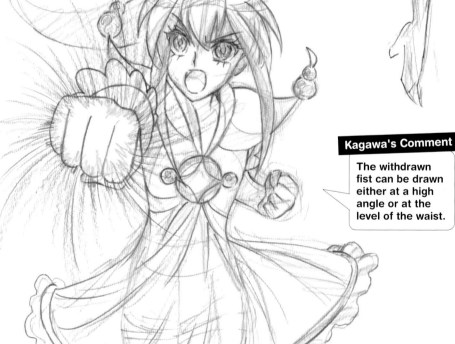

Kagawa's Comment

The withdrawn fist can be drawn either at a high angle or at the level of the waist.

Expert Tips

Be aware of the direction of the effect, its full arc and the range of motion

The above drawing is an example of an effect being drawn incorrectly. The direction of the effect needs to be decided based on the direction that the object is turning.

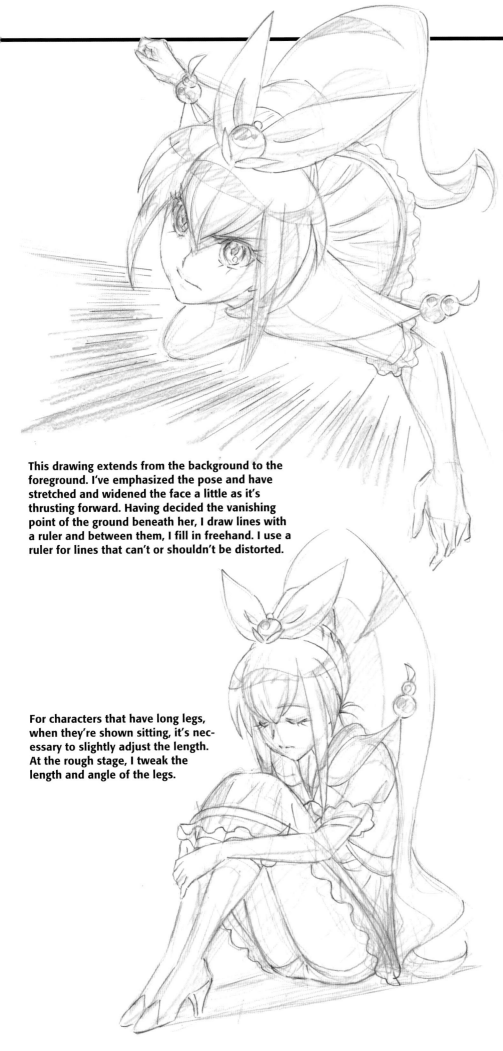

1

Start with drawing the foreground first. The background can be sketched in, while the skirt's appearance needs to be decided here and now.

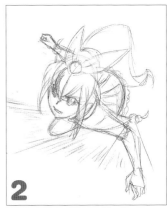

2

While being conscious of its flow and movement, start drawing the hair, bow and costume as well as the direction of the hair tips.

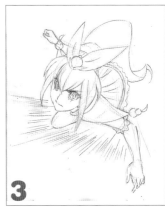

3

Go back over the main outline, filling in to finish.

This drawing extends from the background to the foreground. I've emphasized the pose and have stretched and widened the face a little as it's thrusting forward. Having decided the vanishing point of the ground beneath her, I draw lines with a ruler and between them, I fill in freehand. I use a ruler for lines that can't or shouldn't be distorted.

For characters that have long legs, when they're shown sitting, it's necessary to slightly adjust the length. At the rough stage, I tweak the length and angle of the legs.

Sasha at a Glance

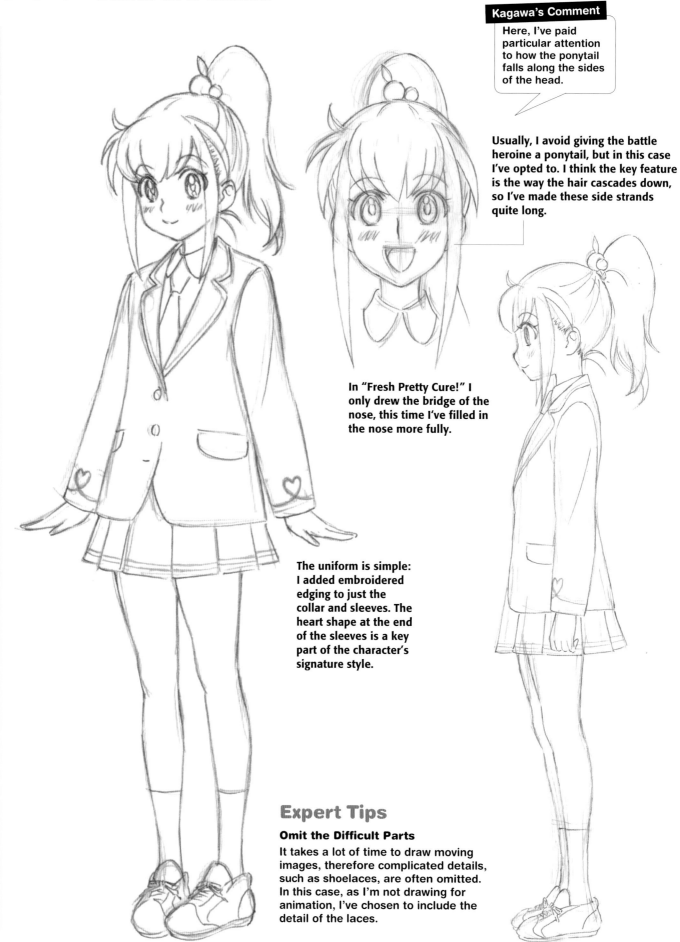

Kagawa's Comment

Here, I've paid particular attention to how the ponytail falls along the sides of the head.

Usually, I avoid giving the battle heroine a ponytail, but in this case I've opted to. I think the key feature is the way the hair cascades down, so I've made these side strands quite long.

In "Fresh Pretty Cure!" I only drew the bridge of the nose, this time I've filled in the nose more fully.

The uniform is simple: I added embroidered edging to just the collar and sleeves. The heart shape at the end of the sleeves is a key part of the character's signature style.

Expert Tips

Omit the Difficult Parts

It takes a lot of time to draw moving images, therefore complicated details, such as shoelaces, are often omitted. In this case, as I'm not drawing for animation, I've chosen to include the detail of the laces.

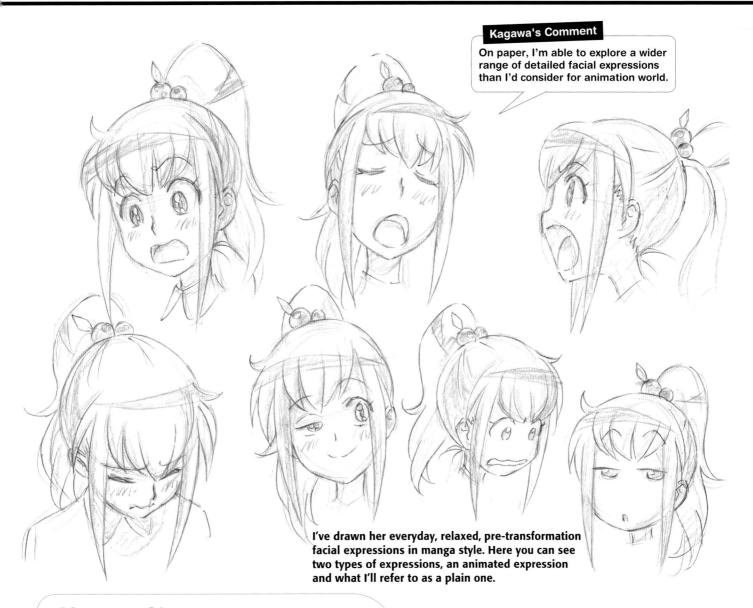

Kagawa's Comment
On paper, I'm able to explore a wider range of detailed facial expressions than I'd consider for animation world.

I've drawn her everyday, relaxed, pre-transformation facial expressions in manga style. Here you can see two types of expressions, an animated expression and what I'll refer to as a plain one.

Master Class

Basic Design & Drawing Pointers

Draw the round contours of the head, and draw a cross to decide the position of the eyes and nose. By deciding the direction of the face, the position of the neck then becomes clear, so next we draw the eyes and mouth.

Next, draw the hair. If the head's inclined, depending on the movement, draw the hair as if it were shaking or in motion. You can see here how it looks from different angles when not shaking.

Expert Advice

Bringing Your Character to Completion

Here, you can see how the character's face and proportions evolve
and the process involved in the transformation.

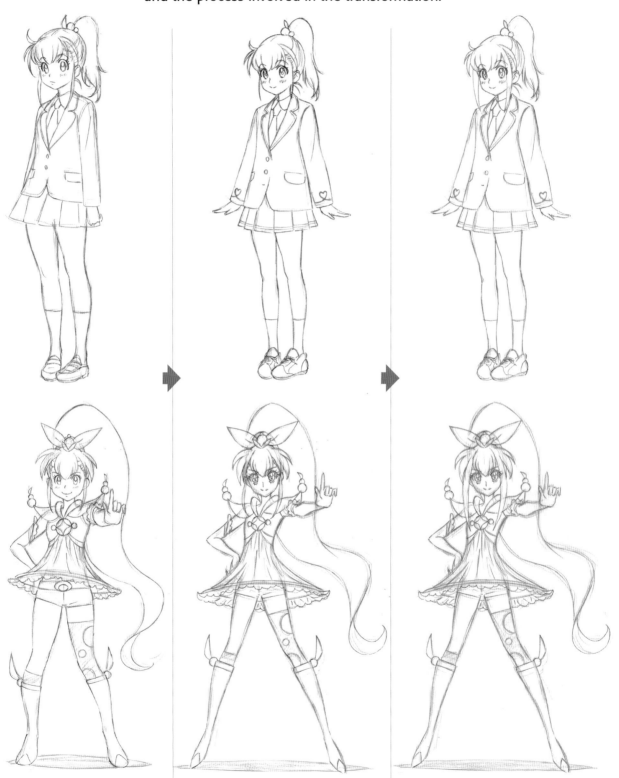

A realistic view, with a slightly fuller physique and frame.

To match the story's theme, I've tweaked the design a little.

I've further elongated the side bangs here.

Part 1
Character
002 Grappling Grape

Grappling Grape. At the same junior high school as Sasha, she is the top member of the fencing club. While she competes on a national level, she also maintains excellent grades. Perceived to be aloof, she's actually warm and kindhearted once she opens up.

Starting Point

Who Is she? A highly intelligent, cool beauty.

Kagawa's Inspiration

I used the image of Mairtle from "Galactic Railway 999" as inspiration, so this character is taller than Sasha and has an older-sister appearance about her.

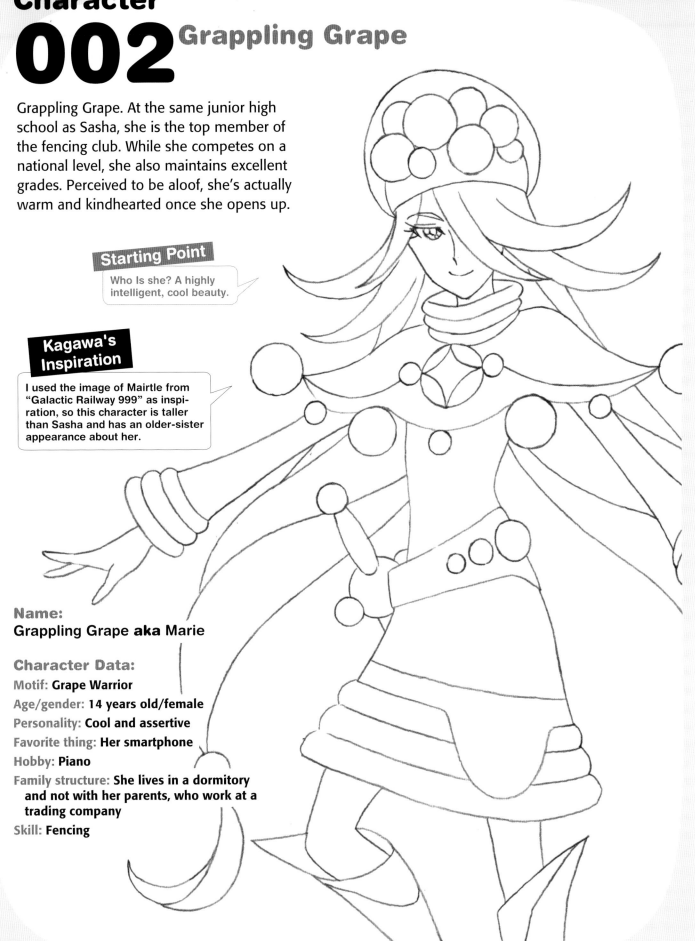

Name:
Grappling Grape aka Marie

Character Data:

Motif: **Grape Warrior**

Age/gender: **14 years old/female**

Personality: **Cool and assertive**

Favorite thing: **Her smartphone**

Hobby: **Piano**

Family structure: **She lives in a dormitory and not with her parents, who work at a trading company**

Skill: **Fencing**

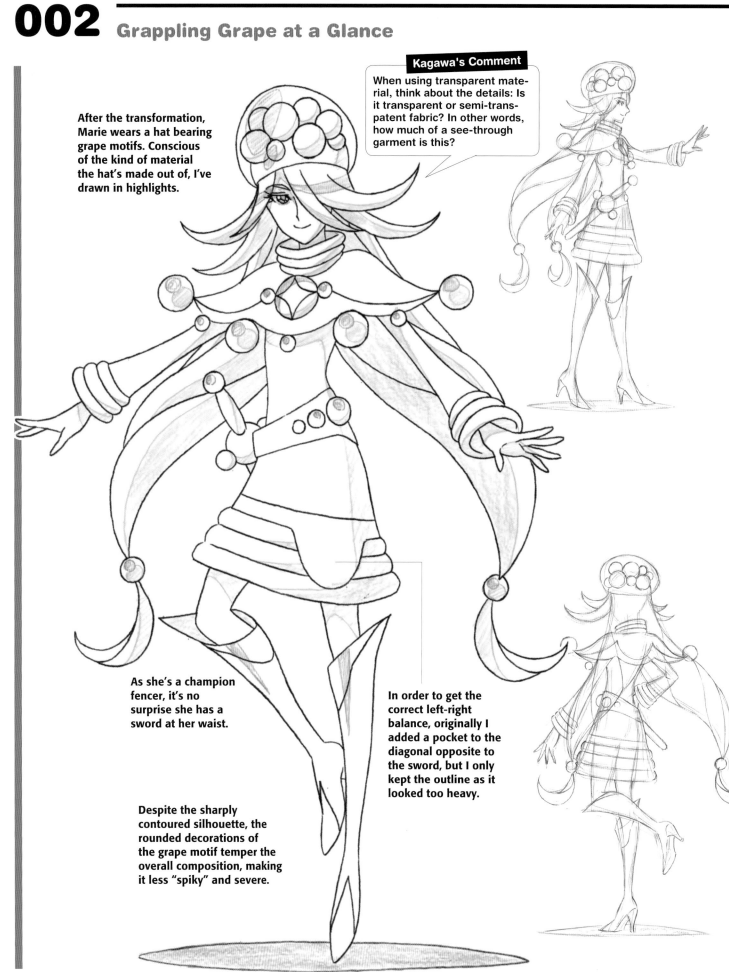

Kagawa's Comment

When using transparent material, think about the details: Is it transparent or semi-transpatent fabric? In other words, how much of a see-through garment is this?

After the transformation, Marie wears a hat bearing grape motifs. Conscious of the kind of material the hat's made out of, I've drawn in highlights.

As she's a champion fencer, it's no surprise she has a sword at her waist.

Despite the sharply contoured silhouette, the rounded decorations of the grape motif temper the overall composition, making it less "spiky" and severe.

In order to get the correct left-right balance, originally I added a pocket to the diagonal opposite to the sword, but I only kept the outline as it looked too heavy.

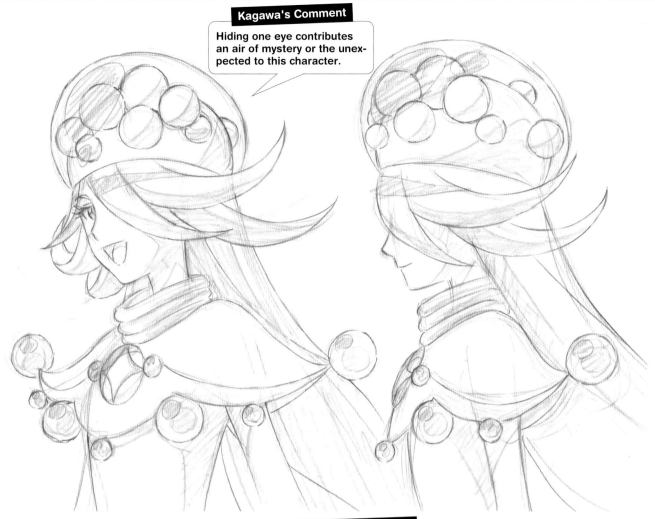

Kagawa's Comment

Hiding one eye contributes an air of mystery or the unexpected to this character.

Revealing the other eye is also an effective way of signaling that this character in the full command of her power after her transformation.

Kagawa's Comment

Surprise and delight are the character's two most common, go-to expressions.

To show the surface and texture of the grapes, I've drawn all the circles freehand. It's difficult to draw so many shapes identically, so in this case, I used a template.

Grappling Grape is reserved, a bit standoffish, and I create the contrasting effects when she smiles by changing the expressions of the eyebrows and eyes. Remember: As she's a junior-high student, there's a limit to how much of a grown-up expression she can have.

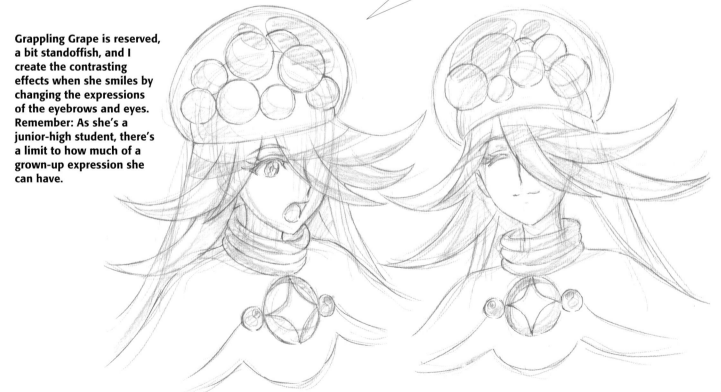

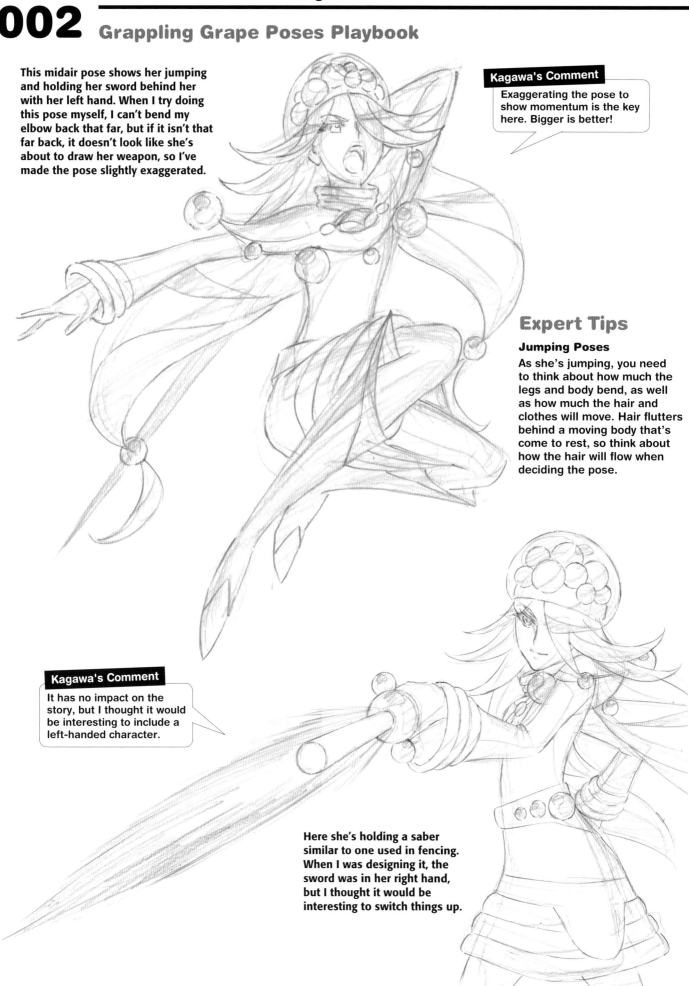

This midair pose shows her jumping and holding her sword behind her with her left hand. When I try doing this pose myself, I can't bend my elbow back that far, but if it isn't that far back, it doesn't look like she's about to draw her weapon, so I've made the pose slightly exaggerated.

Kagawa's Comment

Exaggerating the pose to show momentum is the key here. Bigger is better!

Expert Tips

Jumping Poses

As she's jumping, you need to think about how much the legs and body bend, as well as how much the hair and clothes will move. Hair flutters behind a moving body that's come to rest, so think about how the hair will flow when deciding the pose.

Kagawa's Comment

It has no impact on the story, but I thought it would be interesting to include a left-handed character.

Here she's holding a saber similar to one used in fencing. When I was designing it, the sword was in her right hand, but I thought it would be interesting to switch things up.

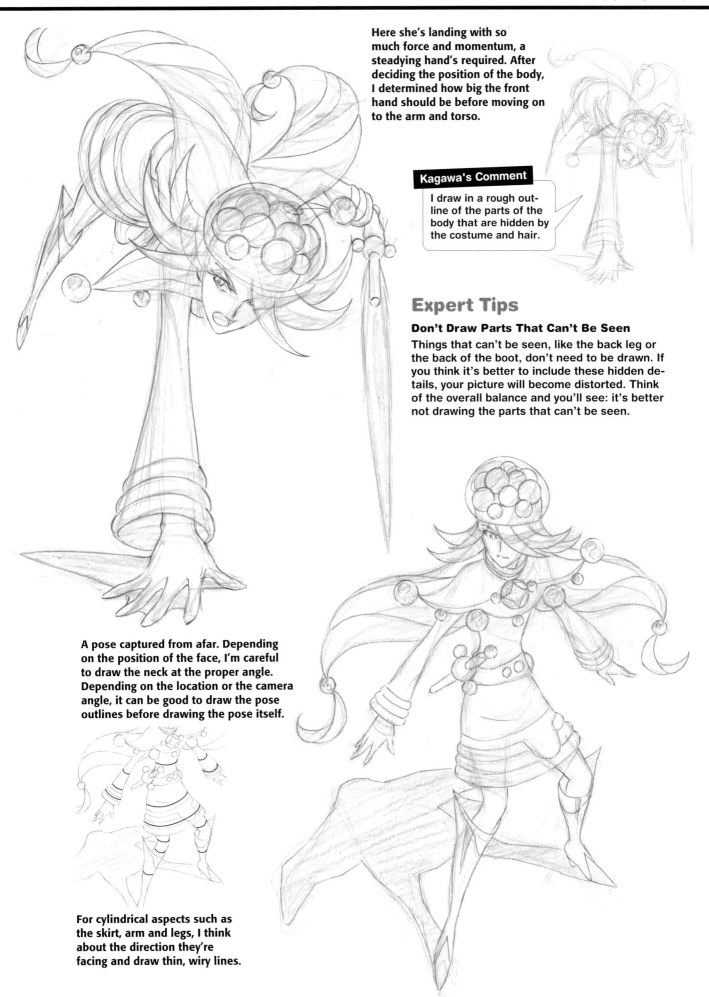

Here she's landing with so much force and momentum, a steadying hand's required. After deciding the position of the body, I determined how big the front hand should be before moving on to the arm and torso.

Kagawa's Comment

I draw in a rough outline of the parts of the body that are hidden by the costume and hair.

Expert Tips

Don't Draw Parts That Can't Be Seen

Things that can't be seen, like the back leg or the back of the boot, don't need to be drawn. If you think it's better to include these hidden details, your picture will become distorted. Think of the overall balance and you'll see: it's better not drawing the parts that can't be seen.

A pose captured from afar. Depending on the position of the face, I'm careful to draw the neck at the proper angle. Depending on the location or the camera angle, it can be good to draw the pose outlines before drawing the pose itself.

For cylindrical aspects such as the skirt, arm and legs, I think about the direction they're facing and draw thin, wiry lines.

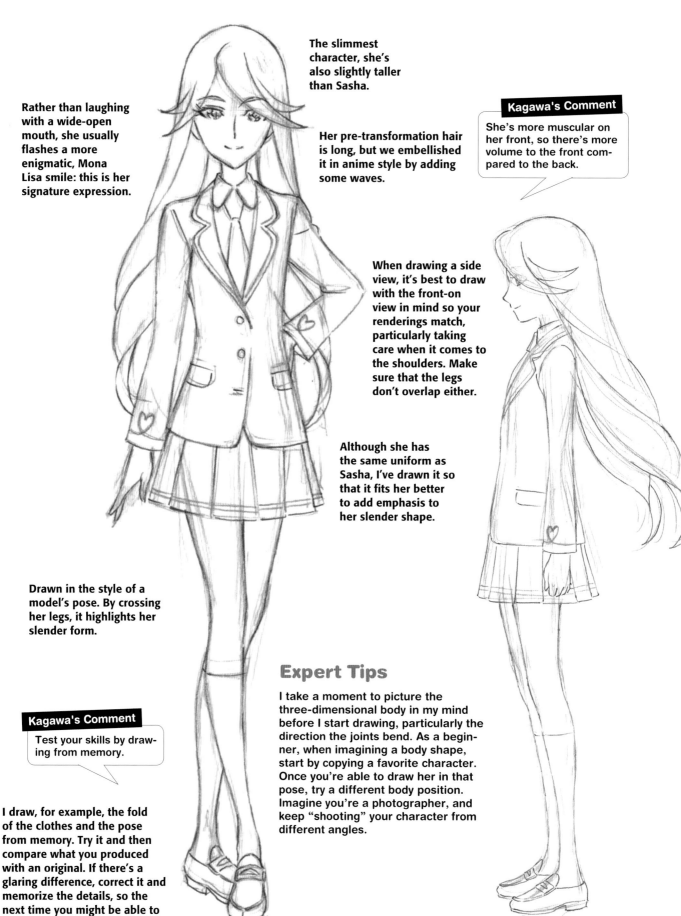

The slimmest character, she's also slightly taller than Sasha.

Rather than laughing with a wide-open mouth, she usually flashes a more enigmatic, Mona Lisa smile: this is her signature expression.

Her pre-transformation hair is long, but we embellished it in anime style by adding some waves.

Kagawa's Comment

She's more muscular on her front, so there's more volume to the front compared to the back.

When drawing a side view, it's best to draw with the front-on view in mind so your renderings match, particularly taking care when it comes to the shoulders. Make sure that the legs don't overlap either.

Although she has the same uniform as Sasha, I've drawn it so that it fits her better to add emphasis to her slender shape.

Drawn in the style of a model's pose. By crossing her legs, it highlights her slender form.

Expert Tips

I take a moment to picture the three-dimensional body in my mind before I start drawing, particularly the direction the joints bend. As a beginner, when imagining a body shape, start by copying a favorite character. Once you're able to draw her in that pose, try a different body position. Imagine you're a photographer, and keep "shooting" your character from different angles.

Kagawa's Comment

Test your skills by drawing from memory.

I draw, for example, the fold of the clothes and the pose from memory. Try it and then compare what you produced with an original. If there's a glaring difference, correct it and memorize the details, so the next time you might be able to do it in your sleep!

She's standoffish, a bit remote, so to make her more human, I've drawn many different expressions, such as surprise or delight.

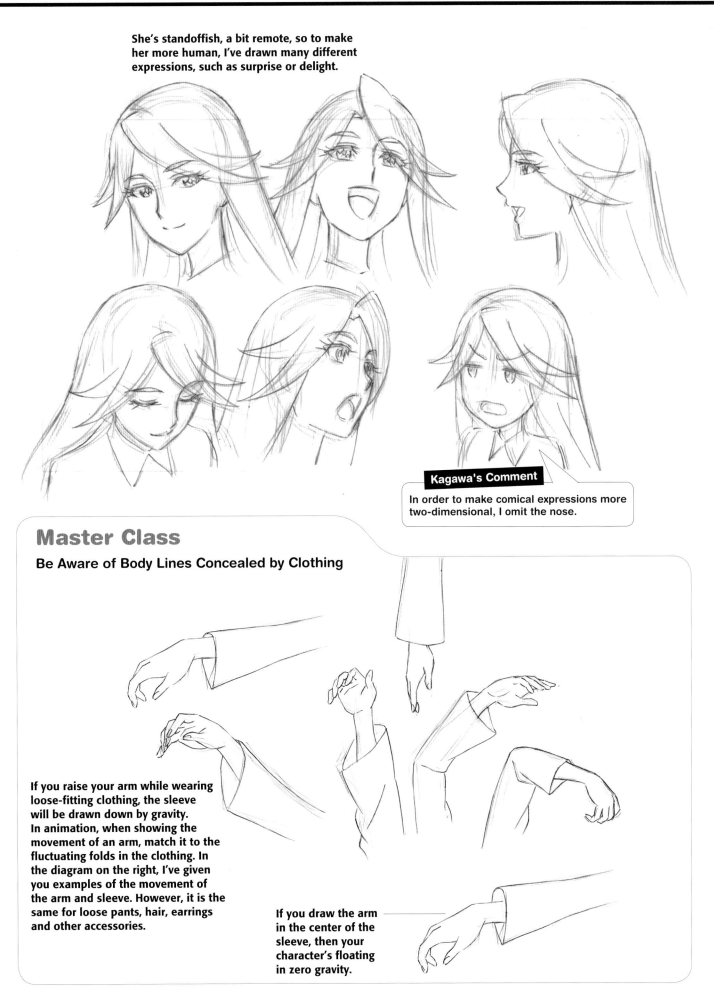

Kagawa's Comment

In order to make comical expressions more two-dimensional, I omit the nose.

Master Class

Be Aware of Body Lines Concealed by Clothing

If you raise your arm while wearing loose-fitting clothing, the sleeve will be drawn down by gravity. In animation, when showing the movement of an arm, match it to the fluctuating folds in the clothing. In the diagram on the right, I've given you examples of the movement of the arm and sleeve. However, it is the same for loose pants, hair, earrings and other accessories.

If you draw the arm in the center of the sleeve, then your character's floating in zero gravity.

Master Class

Basic Design & Drawing Pointers

1

Draw a cross on the face to decide the direction in which it's looking. Draw the arm and leg joints and decide which ones will be in front.

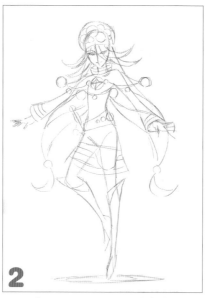

2

Draw the costume. Be careful about the size of the hat and aware of the angle of the boots and when drawing.

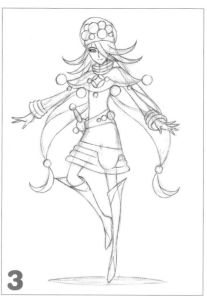

3

Pencil in the main outline adding details such as eyes, eyelashes and fingertips.

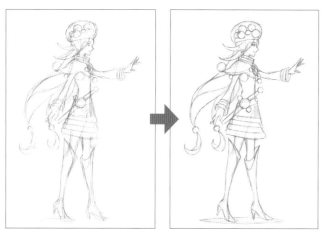

When drawing a character from the side, I draw the upper half horizontally, but when drawing the arms or legs, I shift them forward or backward. In addition to showing them in a natural pose, it also helps define the position of the hands and feet that are in the background.

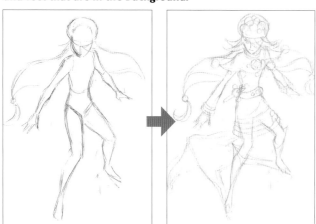

Something to note when drawing shoulders: they hunch forward slightly, so it's important to accurately capture that subtle bend and curvature.

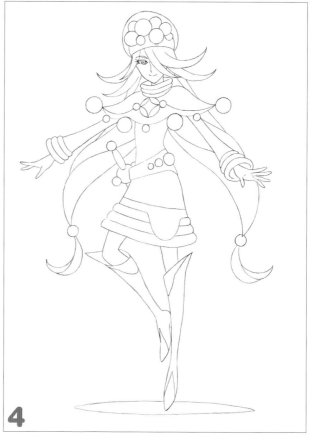

4

In order not to compomise the rough feel of the drawing, trace the main outline.

Part 1
Character
003 Powerful Peach

Meet Powerful Peach. Sasha's friend, she transforms in order to help Sasha and Marie. She's generally easy-going but watch out—if you cross her, she does not forgive and forget. As part of the judo club, she's able to use that as a source of her heroine power.

Starting Point

Weave her personality into your design: she's liked and admired by everyone she meets.

Kagawa's Inspiration

I drew a heroine with a peach as a motif, while keeping in mind her pre-transformation persona, a girl with both a sweet and a tough side.

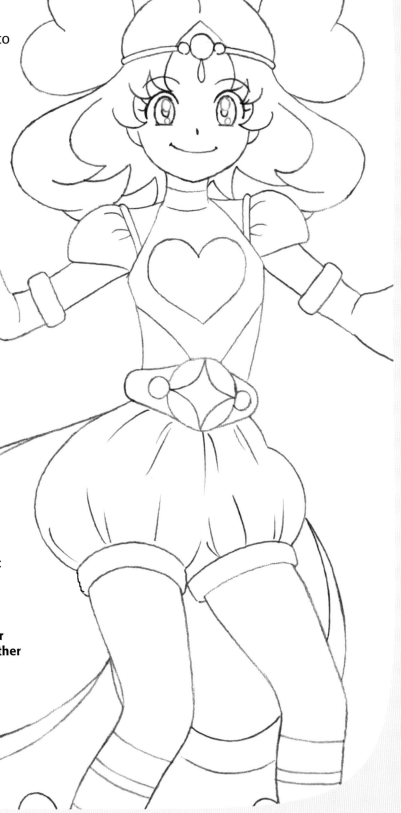

Name:
Powerful Peach aka Tammi Matsuno

Character Data:

Motif: **Peach Warrior**

Age/gender: **14 years old/female**

Personality: **Widely liked, a well-rounded Most Popular type**

Favorite thing: **Baking cookies**

Hobby: **Eating cookies**

Family structure: **Family of 5, she lives with her parents who own a restaurant, her grandmother and younger brother**

Skill: **Judo/martial arts**

With hightop shoes and puffy, pumpkin-shaped shorts, she's a little bit tacky but nevertheless a loveable character.

Although peach is the prevailing motif, I decided to mix things up, designing a Kintaro-style bib for her.

The chest includes a heart-shaped accessory, which also adds volume. Although it appears three-dimensional, I've managed to design it so that it doesn't look heavy.

I wanted to make it a bit raccoon-like but instead of a tail, I added thin feather-like parts instead.

Compared to the other two heroines, in order to make her look stronger, I added knuckle guards.

The shorts also suggest jodhpurs; either way, they add a touch of whimsy to the character and the design.

Horizontal stripes on the socks add volume and height, as well as emphasizing her character's strength.

Her high boots capture her spirit of nerdy coolness.

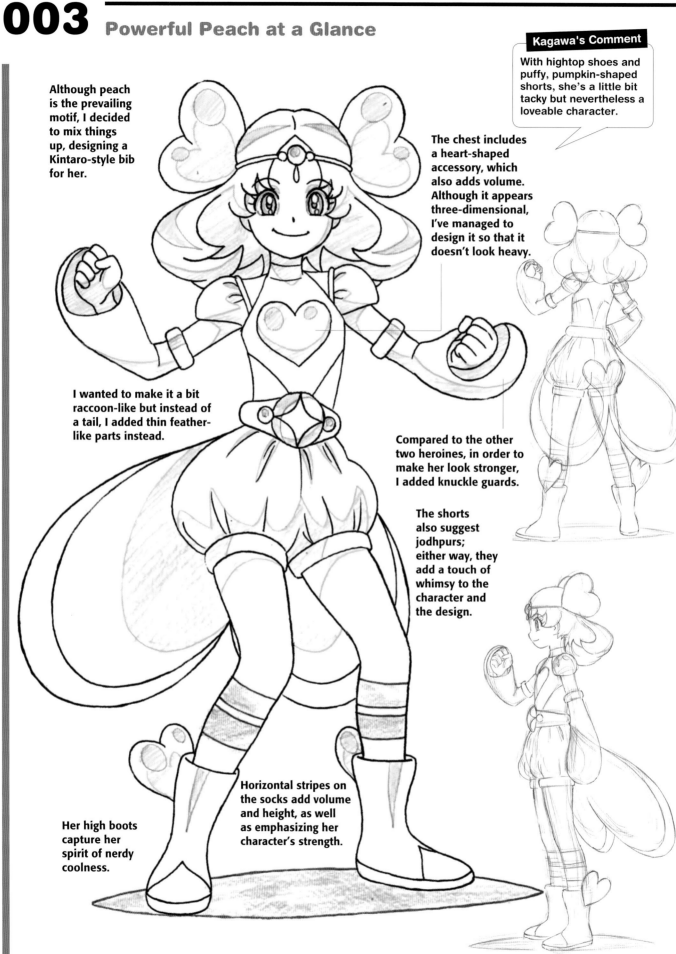

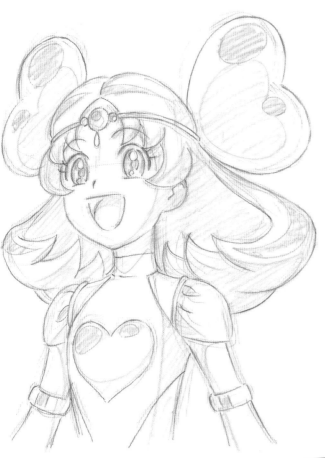

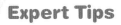

Expert Tips

Expressive Eyebrows

For animators to be able to give characters a wide range of expressions, they need to know the basic expressions first. For characters who have strong personalities such as Powerful Peach, even the use of the eyebrows becomes important. Depending on the scene, it's possible to show anger or a troubled expression by the angle of the eyebrows and the crease of the brow.

In contrast to Grappling Grape's laugh, Powerful Peach laughs with her mouth open, wearing a beaming expression.

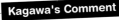

Kagawa's Comment

I've emphasized her round, soft features in her expressions.

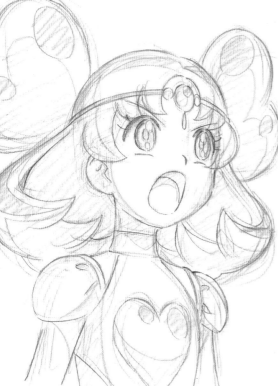

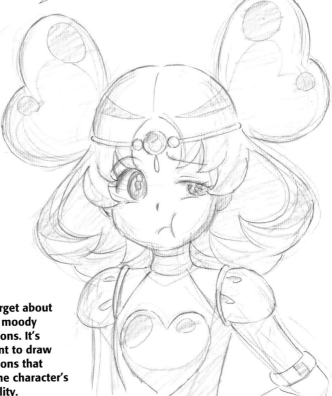

Don't forget about sulky or moody expressions. It's important to draw expressions that match the character's personality.

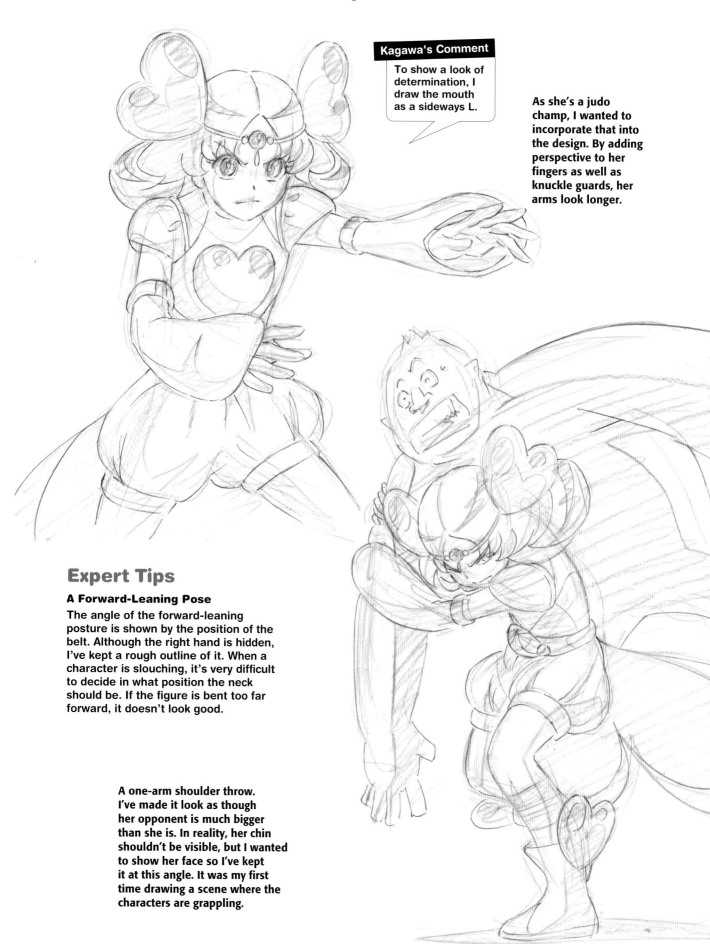

Kagawa's Comment

To show a look of determination, I draw the mouth as a sideways L.

As she's a judo champ, I wanted to incorporate that into the design. By adding perspective to her fingers as well as knuckle guards, her arms look longer.

Expert Tips

A Forward-Leaning Pose

The angle of the forward-leaning posture is shown by the position of the belt. Although the right hand is hidden, I've kept a rough outline of it. When a character is slouching, it's very difficult to decide in what position the neck should be. If the figure is bent too far forward, it doesn't look good.

A one-arm shoulder throw. I've made it look as though her opponent is much bigger than she is. In reality, her chin shouldn't be visible, but I wanted to show her face so I've kept it at this angle. It was my first time drawing a scene where the characters are grappling.

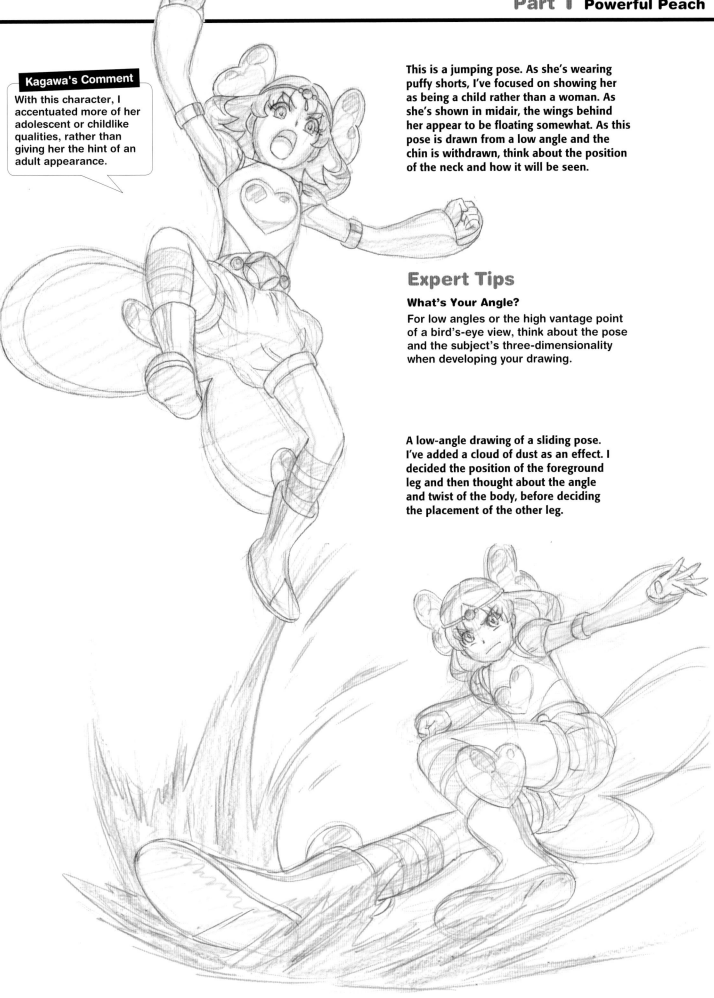

Kagawa's Comment

With this character, I accentuated more of her adolescent or childlike qualities, rather than giving her the hint of an adult appearance.

This is a jumping pose. As she's wearing puffy shorts, I've focused on showing her as being a child rather than a woman. As she's shown in midair, the wings behind her appear to be floating somewhat. As this pose is drawn from a low angle and the chin is withdrawn, think about the position of the neck and how it will be seen.

Expert Tips

What's Your Angle?
For low angles or the high vantage point of a bird's-eye view, think about the pose and the subject's three-dimensionality when developing your drawing.

A low-angle drawing of a sliding pose. I've added a cloud of dust as an effect. I decided the position of the foreground leg and then thought about the angle and twist of the body, before deciding the placement of the other leg.

A Tutorial with Hisashi Kagawa

Tammi Matsuno at a Glance

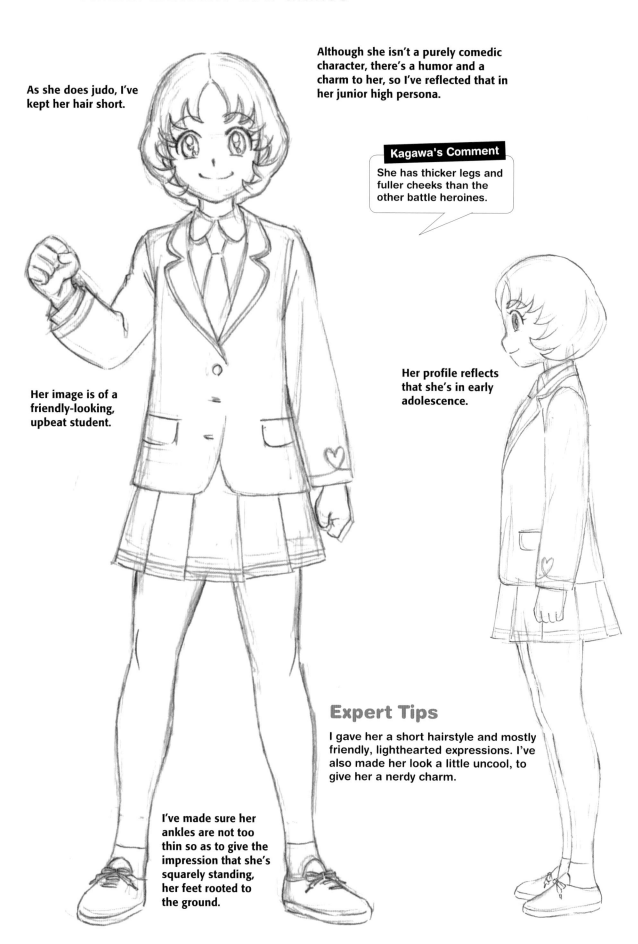

As she does judo, I've kept her hair short.

Although she isn't a purely comedic character, there's a humor and a charm to her, so I've reflected that in her junior high persona.

Kagawa's Comment

She has thicker legs and fuller cheeks than the other battle heroines.

Her image is of a friendly-looking, upbeat student.

Her profile reflects that she's in early adolescence.

Expert Tips

I gave her a short hairstyle and mostly friendly, lighthearted expressions. I've also made her look a little uncool, to give her a nerdy charm.

I've made sure her ankles are not too thin so as to give the impression that she's squarely standing, her feet rooted to the ground.

Kagawa's Comment

Although her laugh isn't too over-the-top, her pre-transformation laugh is more easygoing.

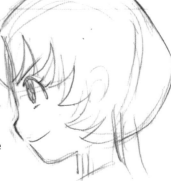

In animation, there are cases where even though the face is drawn from the side, the mouth is drawn as if from the front. However, this looks strange so I tend to draw the mouth at a side angle too.

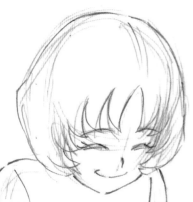

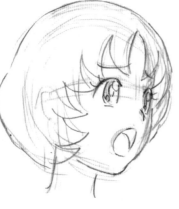

Kagawa's Comment

To make the expression more comical, I draw two-dimensionally and therefore deliberately don't draw the nose.

Master Class
Expressing Personality Through Costume

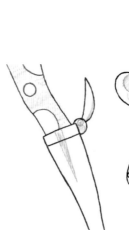

Add features to the character's costume that match her backstory and personality, such as work boots for the protagonist, knee-high boots for the cool character and high-cut shoes for the upbeat, strong character.

Master Class
Basic Design & Drawing Pointers

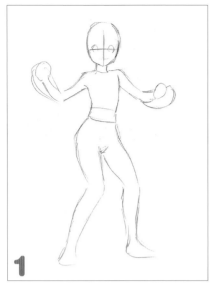

1

Create a general outline first. As she has a slightly fuller figure than the other battle heroines, I've drawn her so that her profile has a touch more volume.

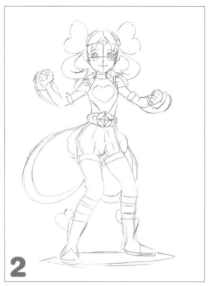

2

Next, add more detail. It's easy to get the position of the face and neck wrong, so be careful here. Draw the chin slightly withdrawn, but not too much or it will look unnatural.

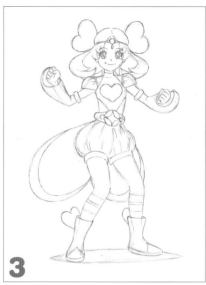

3

Draw a rough main outline with a pencil. Here, I've also drawn details such as the crease in her costume.

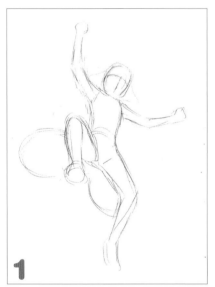

1

While thinking about the angle of the neck, mark the position of the eyes with a cross. Decide the direction and shape of the legs, and while thinking about the position of the waist, start drawing the body line.

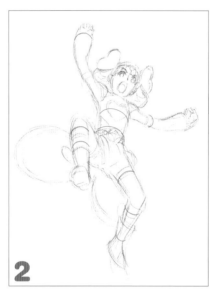

2

To create a three-dimensional effect, I draw parallel rings across the body like a wire frame.

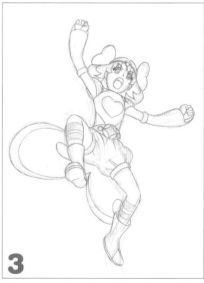

3

Draw a rough main outline in pencil, including the eyes and other detailed features.

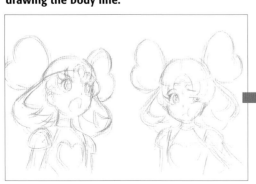

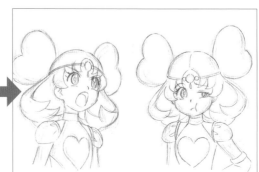

In order to show the roundness of this character and her easygoing expressions, emphasize the curves.

Part 1
Character
004 Pontoon

A fairy who comes to the human world to find someone who can save his home, Loveacre, which was attacked by Chemload. After meeting Sasha, a fierce battle breaks out with Chemload.

Kagawa's Inspiration

As he's a crybaby, in the character design memorandum, I wrote that he "cries orange juice."

Starting Point

He is a fairy whose main motif is also the orange.

Name:
Pontoon

Character Data:
Type: Orange Fairy
Motif: Citrus
Personality: He thinks he's brave but he's really an emotional wreck
Skill: Transforms Sasha into a battle heroine

In order to suggest more flexible movement, I joined a series of oranges into a caterpillar shape. If he has feet, then he has to be able to walk; but if he's in the shape of a caterpillar, he can, for example, fly. There is a lot of room for variation.

Kagawa's Comment

When I have something to convey, I add notes to share with staff.

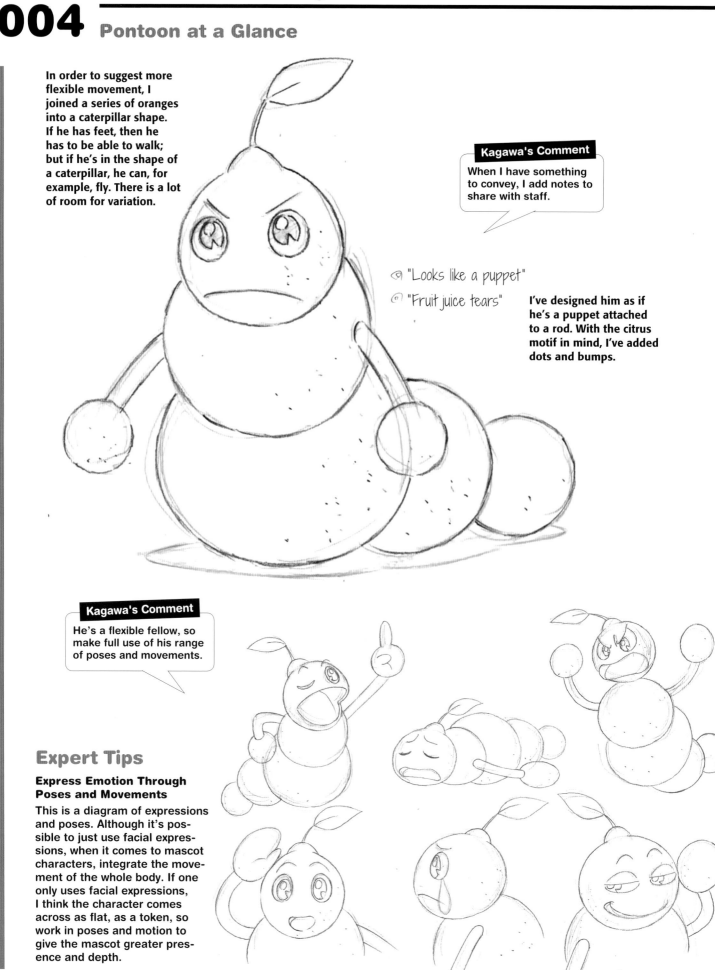

"Looks like a puppet"

"Fruit juice tears"

I've designed him as if he's a puppet attached to a rod. With the citrus motif in mind, I've added dots and bumps.

Kagawa's Comment

He's a flexible fellow, so make full use of his range of poses and movements.

Expert Tips

Express Emotion Through Poses and Movements

This is a diagram of expressions and poses. Although it's possible to just use facial expressions, when it comes to mascot characters, integrate the movement of the whole body. If one only uses facial expressions, I think the character comes across as flat, as a token, so work in poses and motion to give the mascot greater presence and depth.

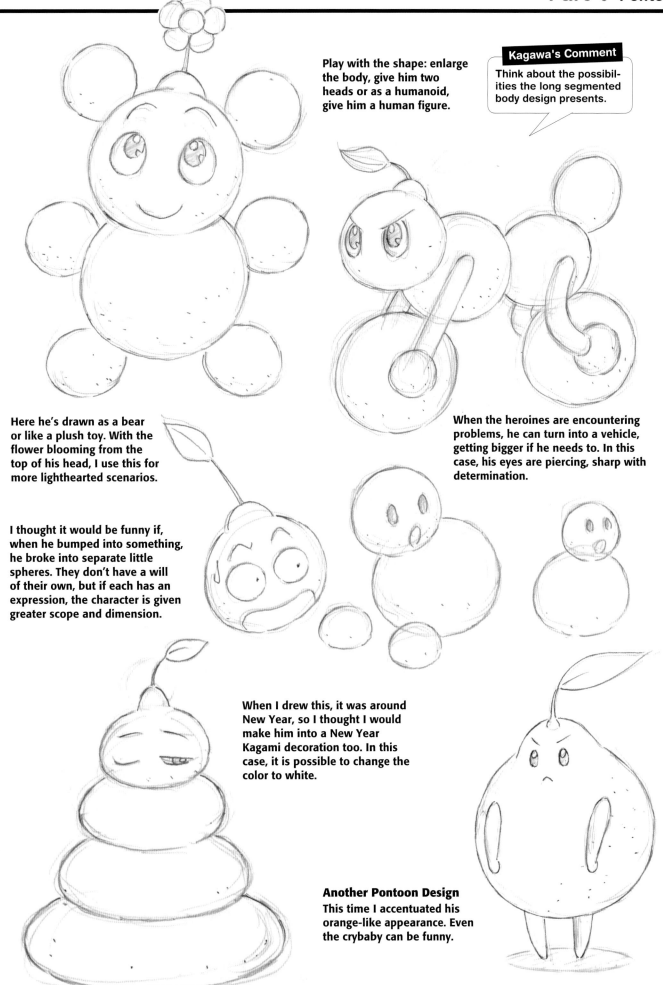

Play with the shape: enlarge the body, give him two heads or as a humanoid, give him a human figure.

Kagawa's Comment
Think about the possibilities the long segmented body design presents.

Here he's drawn as a bear or like a plush toy. With the flower blooming from the top of his head, I use this for more lighthearted scenarios.

I thought it would be funny if, when he bumped into something, he broke into separate little spheres. They don't have a will of their own, but if each has an expression, the character is given greater scope and dimension.

When the heroines are encountering problems, he can turn into a vehicle, getting bigger if he needs to. In this case, his eyes are piercing, sharp with determination.

When I drew this, it was around New Year, so I thought I would make him into a New Year Kagami decoration too. In this case, it is possible to change the color to white.

Another Pontoon Design
This time I accentuated his orange-like appearance. Even the crybaby can be funny.

Expert Advice

Let's Talk About Tracing

I trace during the rough-draft stage, when the lines are more or less fixed. The most important thing is the curve of the eyes and mouth. It's at the rough stage when the lines have the most momentum. When cleaning up the drawing, the momentum of the lines disappears a little, so I make sure that the atmosphere isn't totally lost.

When tracing, it's important to think about where to put the shadows and highlights. For example, do the boots have a bit of a sheen? Do the decorations shine like gemstones?

Dividing Line

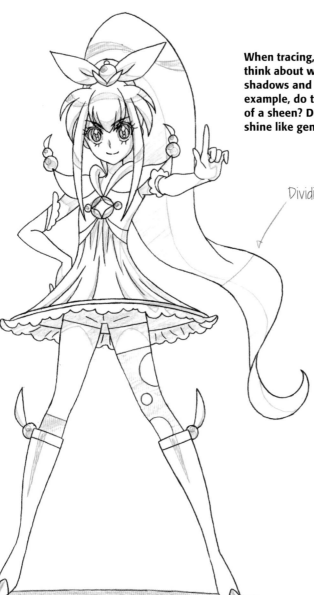

It's possible to change the color of the hair using gradation. This can make it look more luxurious. To the right is something that Hisashi Kagawa colored using a yellow-to-pink gradation.

Here I thought about whether to add highlights, whether to make the top of the hair spiky or jagged, or whether to use circles. For Sasha, I made the highlights wavy. Figuring out these distinguishing details in advance makes it easier when identifying and differentiating between your characters.

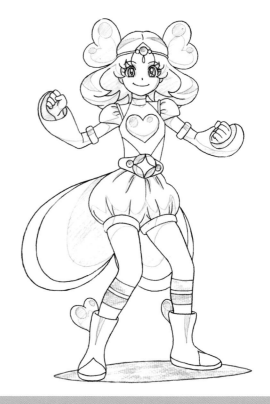

005 Twin Female Villains: Aspar and Tame

This pernicious pair of generals is encroaching on Loveacre. Possessing devilish intelligence and deadly combination attacks (they are twins after all), they torment the battle heroines. Sometimes synchronizing their speech and movements, they combine their powers to pummel the battle princesses.

Starting Point

While they're smart, quick-thinking twins, they both have short fuses and are prone to rash or snap judgments.

Kagawa's Inspiration

Since they're twins, I used the idol group Vanilla Beans as reference for the hairstyles, so one has her hair curled out, and the other curled in.

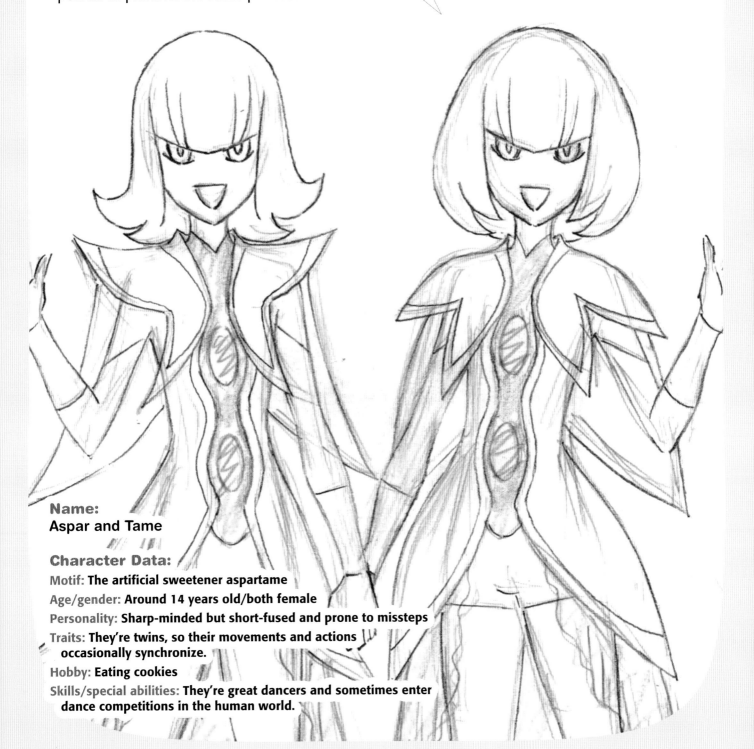

Name:
Aspar and Tame

Character Data:

Motif: **The artificial sweetener aspartame**

Age/gender: **Around 14 years old/both female**

Personality: **Sharp-minded but short-fused and prone to missteps**

Traits: **They're twins, so their movements and actions occasionally synchronize.**

Hobby: **Eating cookies**

Skills/special abilities: **They're great dancers and sometimes enter dance competitions in the human world.**

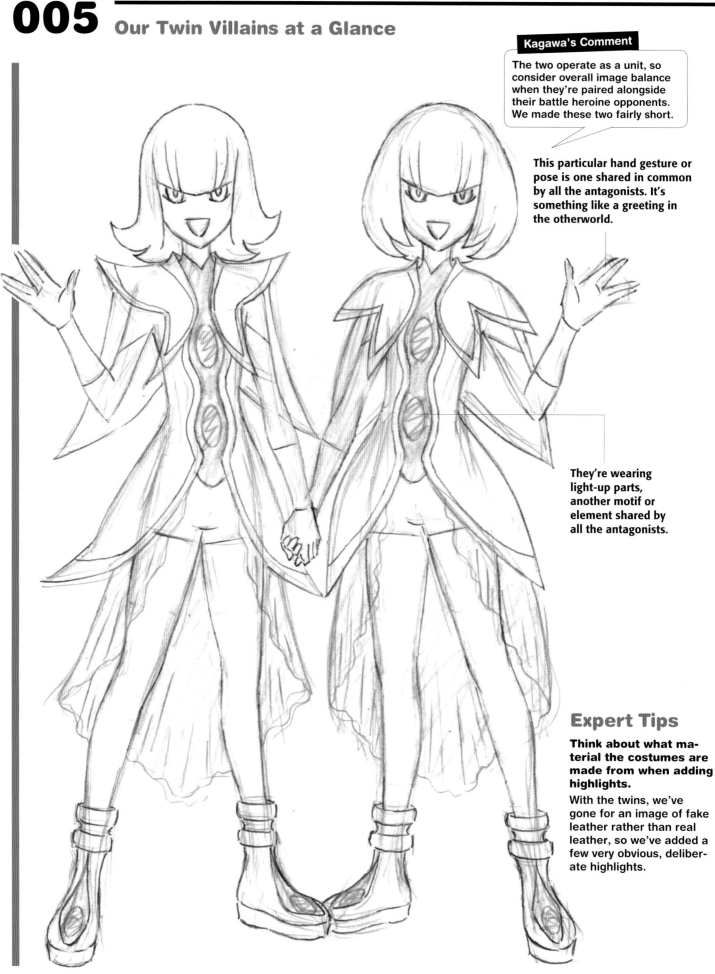

Kagawa's Comment

The two operate as a unit, so consider overall image balance when they're paired alongside their battle heroine opponents. We made these two fairly short.

This particular hand gesture or pose is one shared in common by all the antagonists. It's something like a greeting in the otherworld.

They're wearing light-up parts, another motif or element shared by all the antagonists.

Expert Tips

Think about what material the costumes are made from when adding highlights.

With the twins, we've gone for an image of fake leather rather than real leather, so we've added a few very obvious, deliberate highlights.

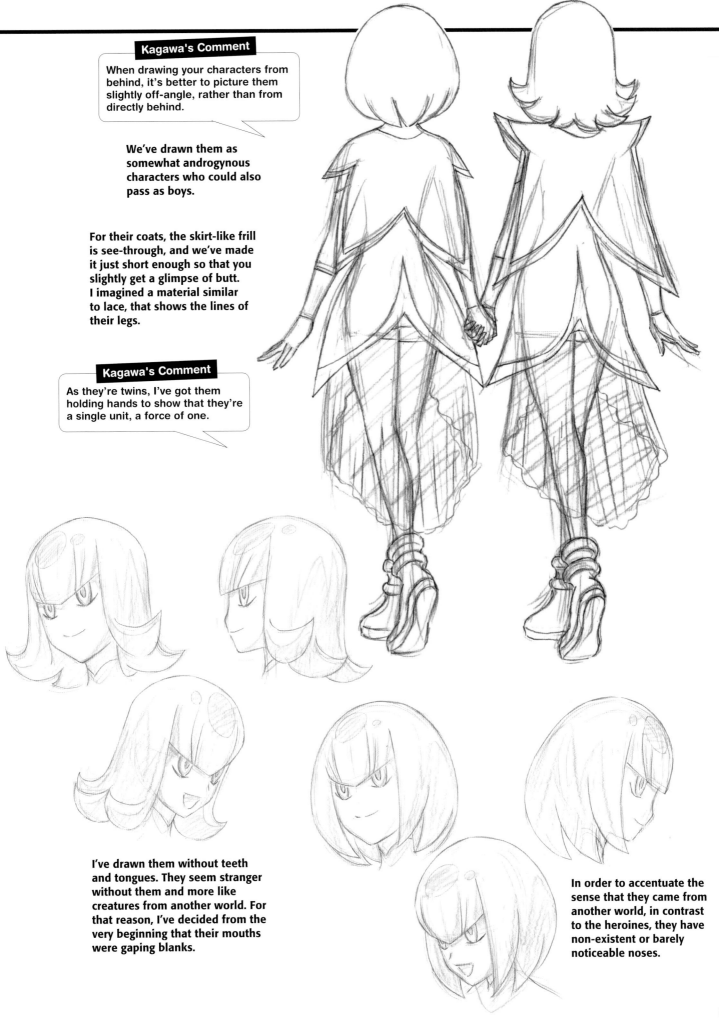

When drawing your characters from behind, it's better to picture them slightly off-angle, rather than from directly behind.

We've drawn them as somewhat androgynous characters who could also pass as boys.

For their coats, the skirt-like frill is see-through, and we've made it just short enough so that you slightly get a glimpse of butt. I imagined a material similar to lace, that shows the lines of their legs.

As they're twins, I've got them holding hands to show that they're a single unit, a force of one.

I've drawn them without teeth and tongues. They seem stranger without them and more like creatures from another world. For that reason, I've decided from the very beginning that their mouths were gaping blanks.

In order to accentuate the sense that they came from another world, in contrast to the heroines, they have non-existent or barely noticeable noses.

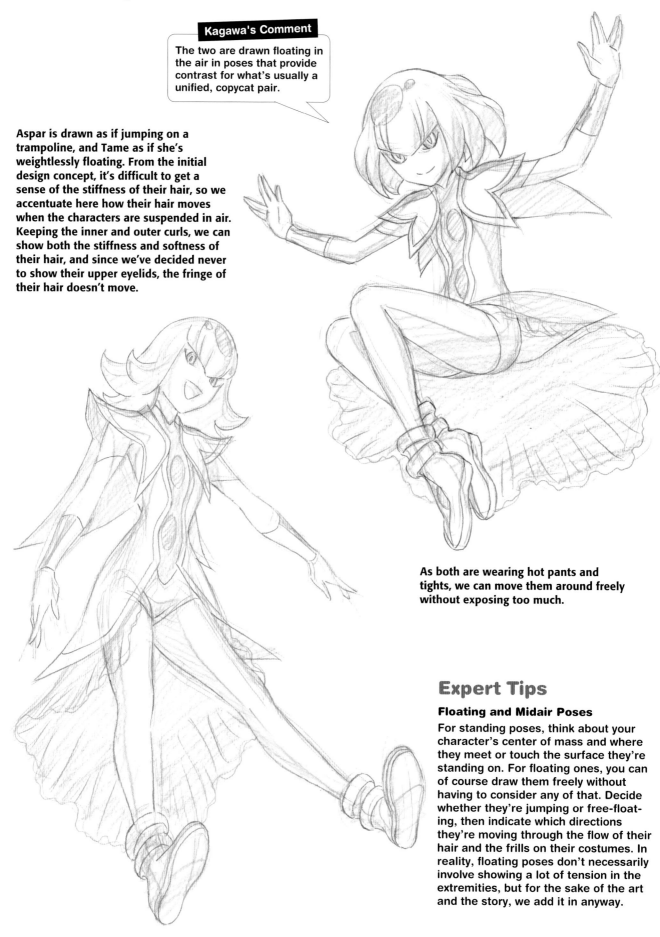

Kagawa's Comment

The two are drawn floating in the air in poses that provide contrast for what's usually a unified, copycat pair.

Aspar is drawn as if jumping on a trampoline, and Tame as if she's weightlessly floating. From the initial design concept, it's difficult to get a sense of the stiffness of their hair, so we accentuate here how their hair moves when the characters are suspended in air. Keeping the inner and outer curls, we can show both the stiffness and softness of their hair, and since we've decided never to show their upper eyelids, the fringe of their hair doesn't move.

As both are wearing hot pants and tights, we can move them around freely without exposing too much.

Expert Tips

Floating and Midair Poses

For standing poses, think about your character's center of mass and where they meet or touch the surface they're standing on. For floating ones, you can of course draw them freely without having to consider any of that. Decide whether they're jumping or free-floating, then indicate which directions they're moving through the flow of their hair and the frills on their costumes. In reality, floating poses don't necessarily involve showing a lot of tension in the extremities, but for the sake of the art and the story, we add it in anyway.

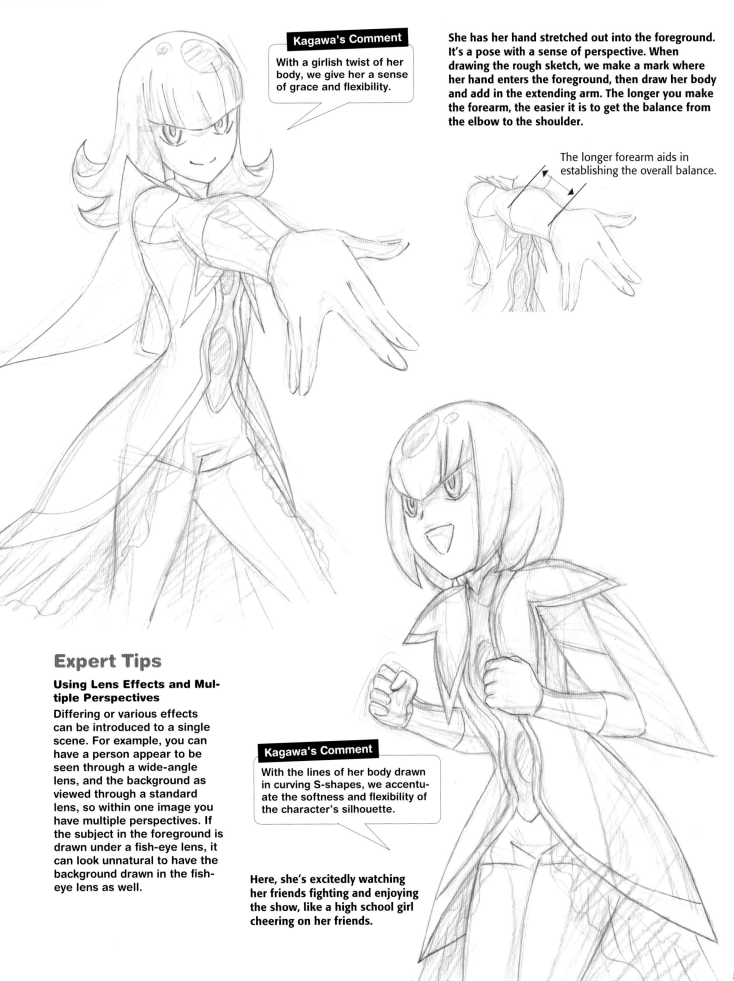

Kagawa's Comment

With a girlish twist of her body, we give her a sense of grace and flexibility.

She has her hand stretched out into the foreground. It's a pose with a sense of perspective. When drawing the rough sketch, we make a mark where her hand enters the foreground, then draw her body and add in the extending arm. The longer you make the forearm, the easier it is to get the balance from the elbow to the shoulder.

The longer forearm aids in establishing the overall balance.

Expert Tips

Using Lens Effects and Multiple Perspectives

Differing or various effects can be introduced to a single scene. For example, you can have a person appear to be seen through a wide-angle lens, and the background as viewed through a standard lens, so within one image you have multiple perspectives. If the subject in the foreground is drawn under a fish-eye lens, it can look unnatural to have the background drawn in the fish-eye lens as well.

Kagawa's Comment

With the lines of her body drawn in curving S-shapes, we accentuate the softness and flexibility of the character's silhouette.

Here, she's excitedly watching her friends fighting and enjoying the show, like a high school girl cheering on her friends.

Expert Advice

Expressing Characters' Individuality Even in the Extremities

When drawing characters, don't forget about the body's expressive extremities (including with these characters the ends of their hair). Here, using fingertips as an example, we'll explain how the extremities can be used to enhance expression in your character.

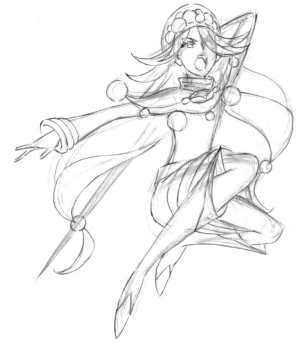

Rules of Thumb

You can dramatically change the expressiveness of a hand gesture based on whether you place the thumb to the side of the index finger or point it away. Compared to the other fingers, the thumb in its neutral position is already quite bent. How fingers bend and the directions they point in is important when drawing expressive hands.

The Hand's Information Load

When drawing the palm of the hand, I pay particular attention to the second finger joint. In the case of animation, I often don't draw the first joint with any detail just to keep the overall design simple.

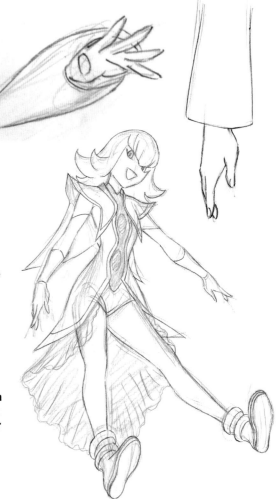

The Hand's Many Moods

Too much tension in the hand can make the gesture seem unnatural. When making hands expressive, it's often easier to make them look more natural by not drawing the bending of the first finger joints, which reduces the tension in the hands. At the opposite extreme, there are some who like to draw characters bracing themselves, with the first finger joint direction reversed, but this is quite distinctive, and I don't use it myself.

Practical Pointers

After drawing the character's head and arms, I often get stuck on the directions I want to draw the hands and fingers. I also find it difficult deciding whether I want the legs stretched out or not, or whether to point or relax the toes. Thinking about the kinds of impressions these generate on viewers as I draw really makes a big difference in the final poses I settle on.

Part 1
Character
006

A Male Villain: Sucrose

The enemy general with a constant smile and cool and haughty attitude, he's the one responsible for destroying Pontoon's homeland. In order to take over not only Loveacre but the human world as well, he uses ruthless tactics such as brainwashing fairies and humans and launching vicious chemical terror attacks.

Starting Point

A cool, collected but most of all condescending character. He's above it all.

Kagawa's Inspiration

Our sole male character. Beyond being portrayed as coldhearted, we also wanted to convey the sense that he's a little bit of an idiot.

Name:
Sucrose

Character Data:

Motif: **The artificial sweetener sucrose**

Age/gender: **Around 16 years old/male**

Personality: **Cool and composed, he looks down on everything and everyone**

Traits: **He torments the humans with ruthless chemical terror attacks**

Skills/special abilities: **His brainwashing abilities enable him to control any human who ingests food additives**

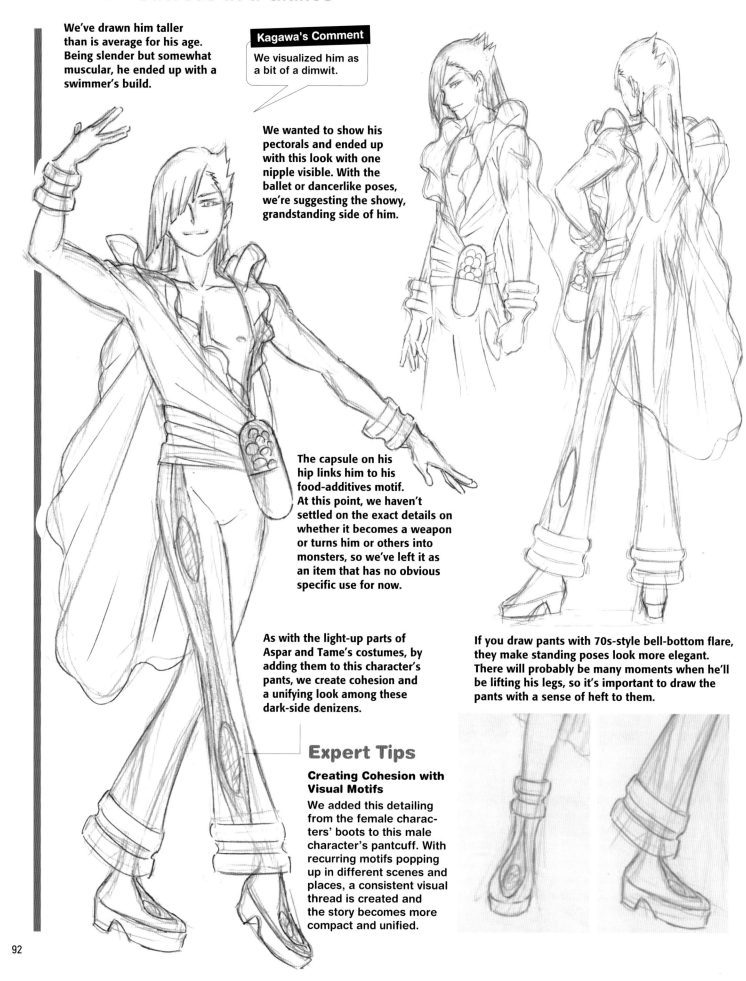

We've drawn him taller than is average for his age. Being slender but somewhat muscular, he ended up with a swimmer's build.

Kagawa's Comment

We visualized him as a bit of a dimwit.

We wanted to show his pectorals and ended up with this look with one nipple visible. With the ballet or dancerlike poses, we're suggesting the showy, grandstanding side of him.

The capsule on his hip links him to his food-additives motif. At this point, we haven't settled on the exact details on whether it becomes a weapon or turns him or others into monsters, so we've left it as an item that has no obvious specific use for now.

As with the light-up parts of Aspar and Tame's costumes, by adding them to this character's pants, we create cohesion and a unifying look among these dark-side denizens.

If you draw pants with 70s-style bell-bottom flare, they make standing poses look more elegant. There will probably be many moments when he'll be lifting his legs, so it's important to draw the pants with a sense of heft to them.

Expert Tips

Creating Cohesion with Visual Motifs

We added this detailing from the female characters' boots to this male character's pantcuff. With recurring motifs popping up in different scenes and places, a consistent visual thread is created and the story becomes more compact and unified.

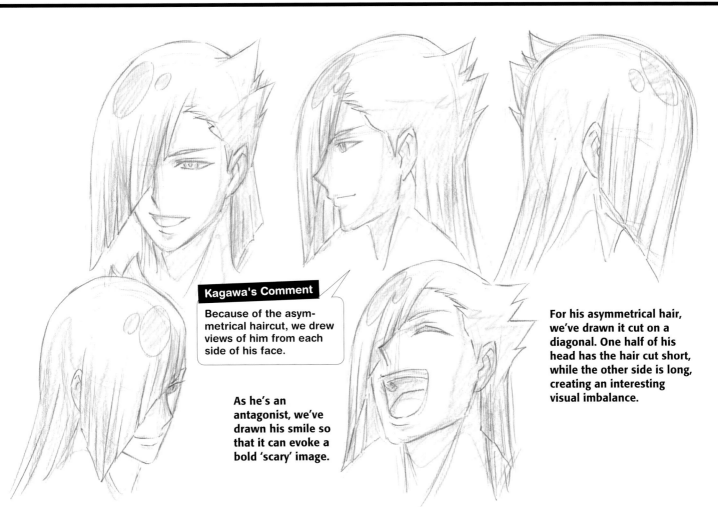

Kagawa's Comment

Because of the asymmetrical haircut, we drew views of him from each side of his face.

As he's an antagonist, we've drawn his smile so that it can evoke a bold 'scary' image.

For his asymmetrical hair, we've drawn it cut on a diagonal. One half of his head has the hair cut short, while the other side is long, creating an interesting visual imbalance.

Master Class
Considering Costume Design

It isn't a cape, but his collar extends outward like a shawl.

The costume includes lots of diagonal lines to match his hair. It's a strange design, but as he's supposed to be a good-looking character, we've kept its proportions slim and well-fitted. His chest is showing and his back his bare.

The Back View

From behind, you see more of Aspar and Tame's see-through skirts. When considering the back view of a costume, think about the overall silhouette and remember to keep it simple.

This is a chart that compares the sizes of the characters. First we pick one character among the 3 protagonists (in this case, Outrageous Orange) to be our base and then we decide the heights of the other two and the antagonists in relation to her. The mascot Pontoon's head is about the size of an actual tangerine.

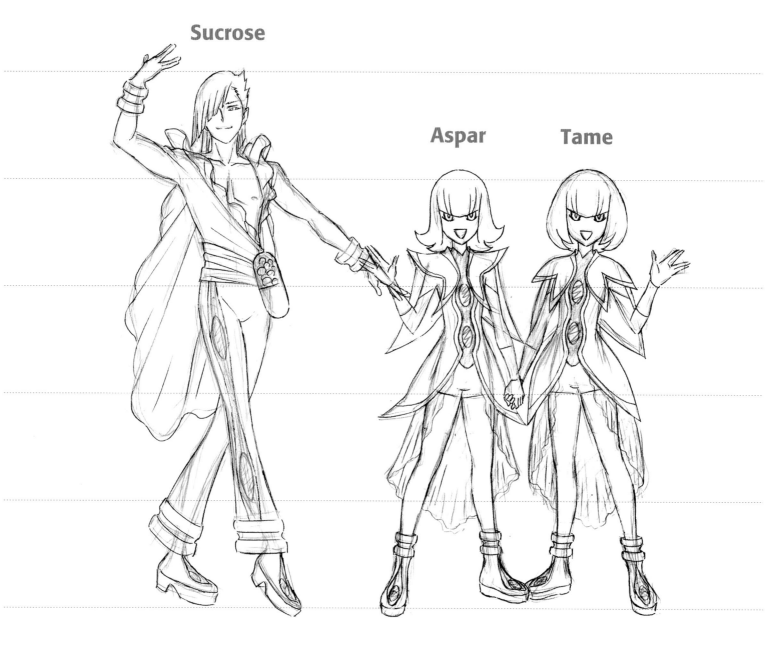

Outrageous Orange
(Sasha)

Grappling Grape
(Marie)

Powerful Peach
(Tammi)

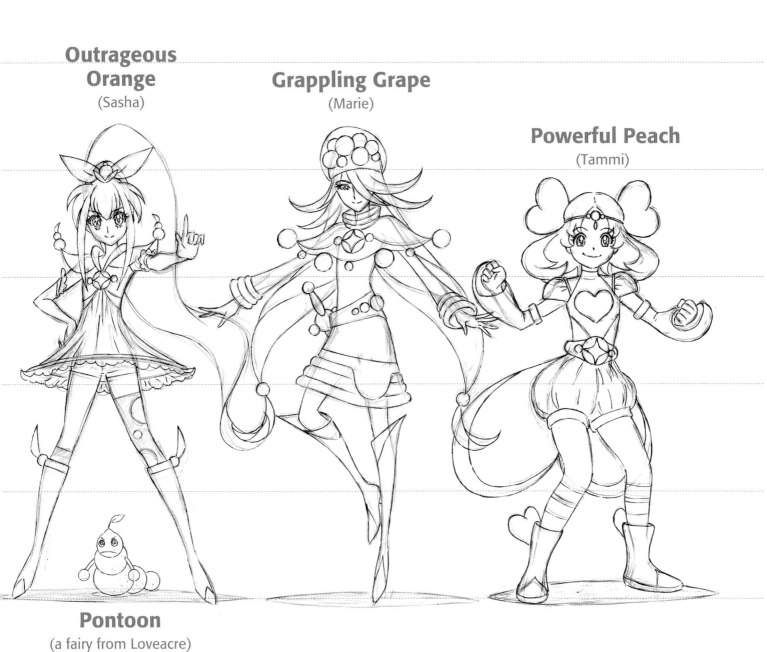

Pontoon
(a fairy from Loveacre)

Expert Advice

Drawing Exaggerated Movements, Anime-Style

In animation, exaggerated unrealistic movements are often better for expressive storytelling than using poses that stick rigidly to reality. Here are a few poses and movement techniques that can exist within animation but not in the realm of reality.

Building from both reality and fantasy

The final positions of poses are decided first in animation, so even if the steps leading up to the final position have unlikely joint movements or unusual contortions to the body, they can all come together into fairly realistic or believable poses. We often use midair poses from professional wrestling as references.

Fighting stances

When characters assume their fighting stances, we twist their hips and show their hair flowing behind them. Using hair and parts of costumes that can flutter and flow to create movement is key. Also, making the left hand into too tightly a clenched fist will yield a stance that's too karate-like, so since she's a battle heroine, we show the fist as more loosely clenched.

Unseen effects

Depicting elements that cannot be seen—such as shock waves or the paths of attack movements—is a technique you can only use in animation or illustration. These kinds of inclusions add a dynamism and visual flair that you wouldn't be able to capture in live action.

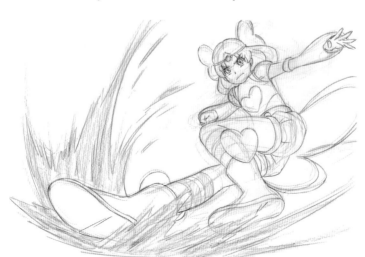

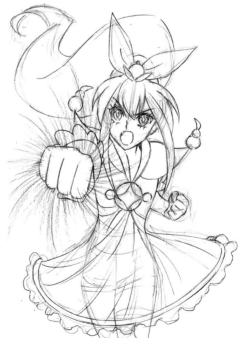

Theme

Date　　　·　　　·　　　（　　　）

Design Variations

We've drawn chibi and non-chibi design versions of the original characters created for this book.
Let's compare and contrast the lines used for the heads and bodies and look at the differences.

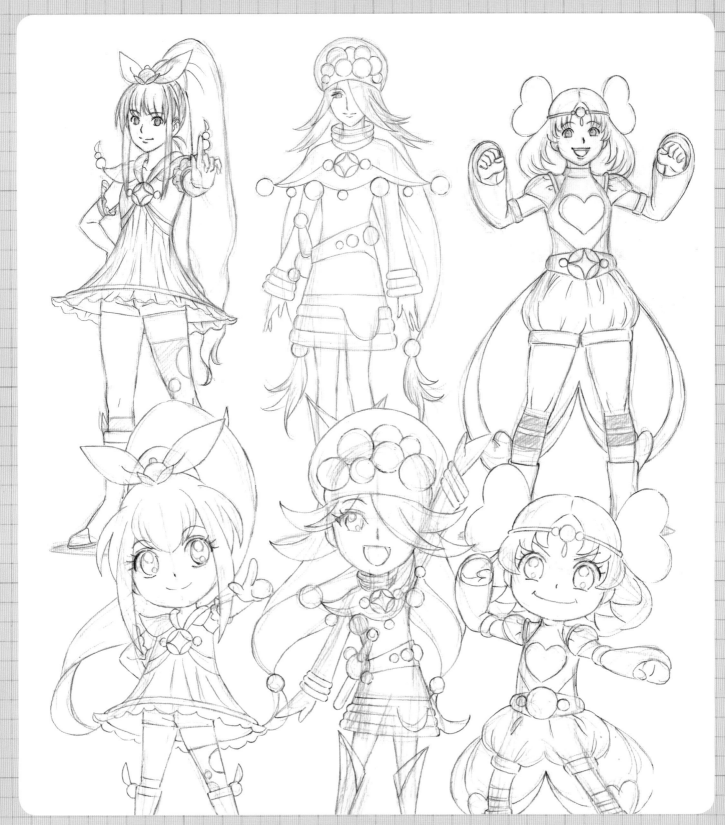

Semi-Realistic Character Designs

Designed with semi-realism in mind, as opposed to making them more naturalistic or more closely resembling actual humans. The slim, pointy boots have been adjusted to favor proportions more like those in reality, right down to the thinner ankles. Their waists aren't as diminutive, and the overall style is more subdued, less over the top or in your face.

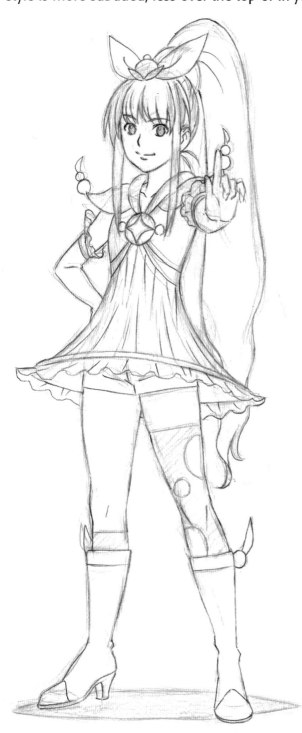

Outrageous Orange

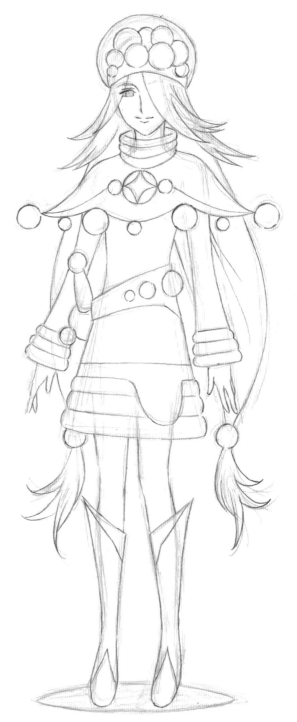

Grappling Grape

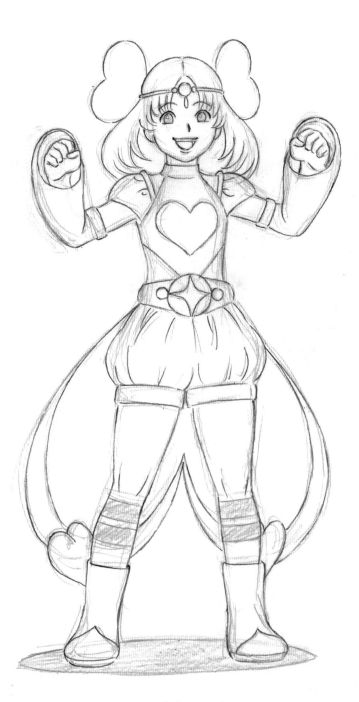

Powerful Peach

Master Class
Drawing & Design Pointers

Outrageous Orange

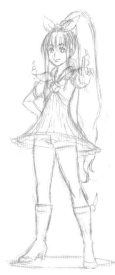

We roughly decide her head and body proportions and positions, then draw in the costume. At this stage, we can still adjust her head and body proportions as we go. To counterbalance the larger head, we make her neck a little thicker. We've adjusted her heels to a height she can reasonably move in too. In order to differentiate the characters, we introduced a greater degree of variation into their body shapes.

Grappling Grape

This character didn't change much from the original over all, but we shortened the length of her legs past her knee, which were quite stretched in the original design. Her hair's the most fantastical, but we've added more variation to the tips and let it fall more naturally. We've opened up the sharp toes of her boots to a width that wouldn't give her bunions, and drawn more lines to her lower lip, making her lips more three-dimensional. After that, it's just a slight difference in posing.

Powerful Peach

We've highlighted the rounded features of her overall look, and changed the appearance of her legs and hips to be more muscular. With these adjustments, she now looks less as though she'd fall over from a slight shove. She looks sturdier, but although she's lost a little bit of the girlishness, her face retains it. We've kept her hairstyle to something you might be able to purchase as an actual wig. Like Grappling Grape, we've shortened the length of her lower legs.

Chibi-Style Character Designs

We've redrawn the main three in chibi-style designs. When the three are lined up, the differences in their body shapes are revealed. The parts themselves haven't changed so much in design, but the variation in the hairstyles has been diminished and more detailed parts, such as hands and fingers, have been simplified from the original. Some legs have become thinner, others wider. The proportions of the hands and feet have been drawn with the image of the individual characters in mind and to distinguish them from one another.

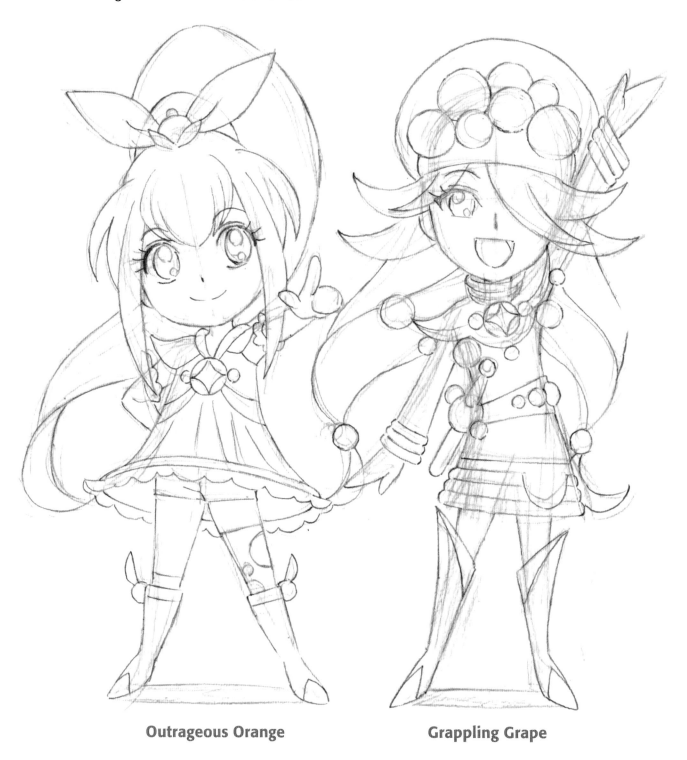

Outrageous Orange　　　　**Grappling Grape**

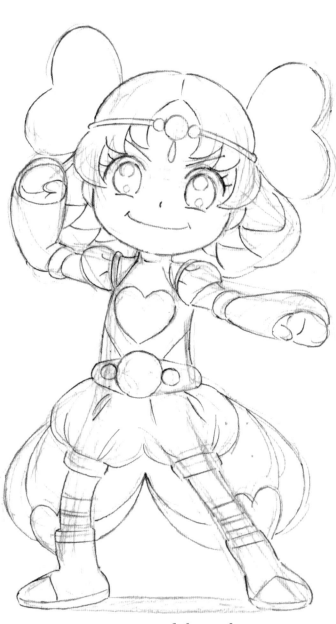

Powerful Peach

Master Class
Basic Drawing & Design Pointers

1

First you draw the circles for their heads, then draw their bodies the same size. These characters have voluminous hairstyles, so we've made their legs slightly longer than usual for overall style.

2

For chibi characters, we make the outlines more rounded. We don't change the size of the eyes and roughly keep their original shapes. When it comes to intricate details, keeping them the same as their original design looks crowded on their shrunken bodies, so the details are simplified.

3

Cleaning up the outlines of the rough sketch gives us the eventual chibi outlines.

Expert Advice

Creating Character Designs for an Original Story

Try thinking about your own original stories, coming up with the backstories and settings for the characters and developing their concept designs. These images come from a science-fiction suspense tale I've been thinking about. I've used real-life pop stars and actors as reference points for these working designs.

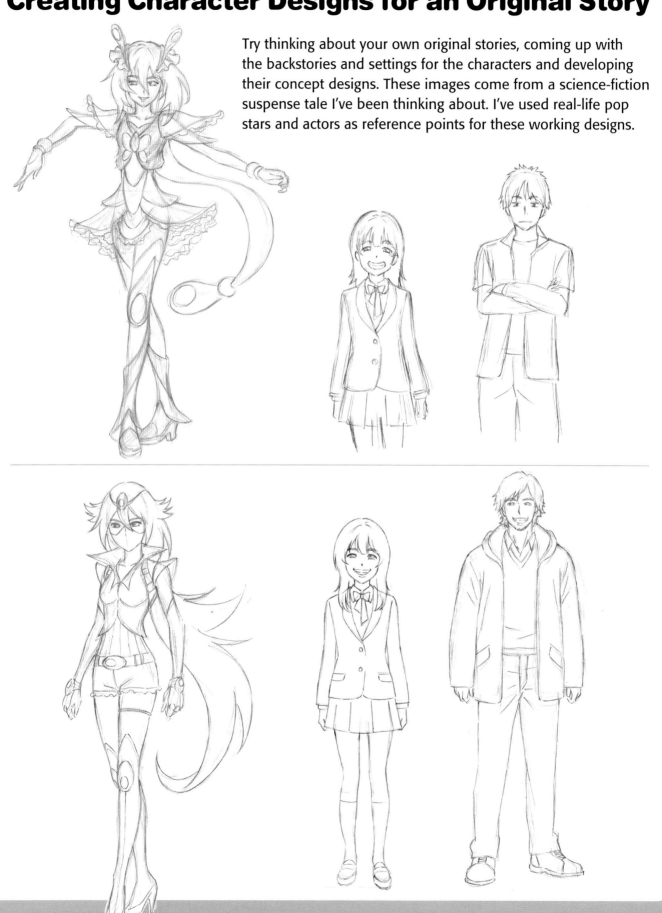

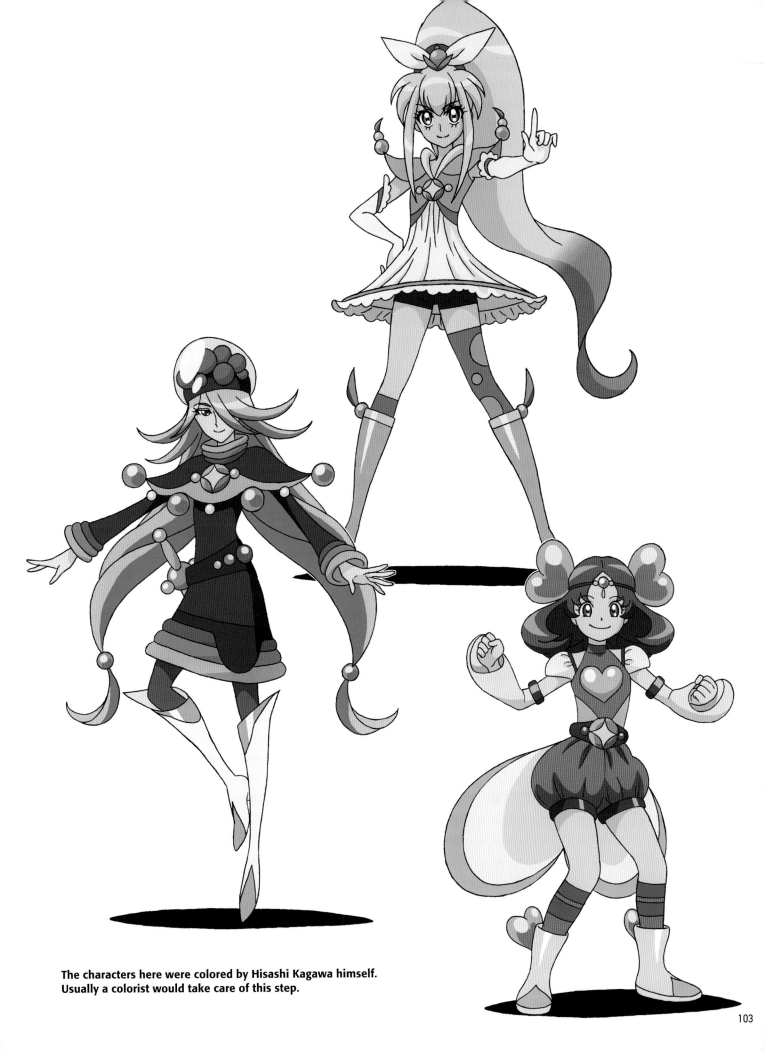

The characters here were colored by Hisashi Kagawa himself.
Usually a colorist would take care of this step.

INTERVIEW WITH HISASHI KAGAWA

We asked Hisashi Kagawa, who's worked as an animator on Pretty Cure and many other popular series, about the many meetings and happenings at the start of his professional career, and his journey to the present.

Everyday was like boot camp, the daily life of a new man in the industry

—Tell us the about the first piece you worked on:

Kagawa: It wasn't broadcast in Japan, but it was a joint production between Toei Animation and a foreign studio. Aside from that, I worked on frames for the "Transformers" movie. It was quite different from how animation is done these days. There were a lot of detailed instructions in the storyboards and about 7 patterns for the speaking mouth shapes. I drew those sorts of things in frames and sometimes tried drawing a few principal frames. At the time I was based at one of Toei's sub-studios, so the first pieces I worked on were Toei Animation productions. A particularly memorable piece was "Fist of the North Star", for which Suda Masami did the character designs and Hayama Junichi was the director of animation. Unlike these days, the frames had to be drawn by copying images onto cels with a trace machine, so I remember struggling to draw the lines as thick as possible. In that sort of work environment, there the prevailing idea was that "For animators, lines are life", so we had to draw lines that were lively. Thinking about that, there's a part of me that's definitely been influenced quite strongly by Hayama Junichi and Kimizuka Katsunori. Now that I think about it, I wasn't there all that long a time, but every day was like a training camp. You felt such a strong sense of achievement at the end of each episode, when you'd all struggled together to complete it. I think because the art for "Fist of the North Star" was so detailed and difficult, the series that I worked on after it felt easier. Of course, there was a lot of trial and error. It's just that, as a person who prefers to draw with thinner lines, in that sense what came after was easier for me. For "Fist of the North Star" I had to make sure that the lines were thick in the principal frames and then be careful to draw the movement frames so that the thickness of the lines wasn't destroyed. In the past, strong and weakly drawn lines would appear just as you drew them on the screen, so the lines truly seemed alive. After that, there was the primary shadow, secondary shadow, black . . . there are so many shadows! But it was very enjoyable drawing a world with such outlandish aesthetics.

The Road to Character Design

—Which do you find easier to design: male and female characters?

Kagawa: That's getting harder and harder to say. But characters are easier to draw the more detached from reality they are. For example, for men, if they're these extraordinary mountain-of-muscle characters, or for women, if they're cute little girls or seductive women, the more exaggerated their features, the easier they are to draw. There's actually a lot more to think about when drawing a totally normal, utterly ordinary man. In Pretty Cure, the main characters were girls, but there were points when their angry expressions and poses could look quite mannish, so those had to be adjusted. We'd look at a pose and think, "A girl wouldn't strike a pose like that." I'm getting the impression that I'm better at entertaining people with the women I draw.

—Tell us about the animators or other creators who've influenced you.

Kagawa: The first person I became aware of as an animator was Yasuhiko Yoshikazu, and the first I worked closely with was Hayama. I also had the chance to look at a lot of pictures by Suda Masami, who was Hayama's mentor. In hindsight, there were lots of others, like Komatsubara Katsuo and Araki Shingo too. Among those, I think Araki had a very strong influence on me, because he was involved with a lot of the series I'd watched. Araki's pictures had a lot of strength to them, and I think he was an early pioneer in the shoujo genre. I think it was because Araki drew with such flair and flamboyance that series such as Saint Seiya were so scintillatingly brilliant. Aside from those, I worked on "Sailor Moon" quite a long time ago, so there was influence from the directors of each episode, and Itou Ikuko, who was something of a specialist in bishoujo animation series. Also, Suga Shigeyuki made a strong impression on me as someone who could draw very clean, sharp images and make them look cool. There's a feeling in how I take inspiration from others that I'm looking out for amazing layout and movement, spotting where things work well in their overall effect and then patching up where I'm lacking by drawing from those people.

—Tell about your entry into character design.

Kagawa: I was introduced to my first animation character design job by Itou Ikuko for Saint Luminous Mission High School. Thinking about the character and backstories and the core elements that make up the workings of this particular fictional world—the workings being the cherry on top of the cake that is the script—in your character gestures and movements makes them more vivid. Itou is the sort of person who puts a lot of thought into that kind of thing, and I started to think more about creating backstories when designing characters too. Itou is both an animator and a character designer.

An Animator's Struggles

—*Tell us about what you found difficult as an animator at the beginning of your career.*

Kagawa: First, there were times when I realized I hadn't studied enough or simply didn't know enough about moving pictures. Things like how to make characters perform emotively, such as "I need to put in this picture to make it move properly" or how many frames I need for a particular movement. I learned those on the job, but timing was very hard to learn. There are timesheets where no matter how many times I redo them, they still don't seem right to me. Having said that, in terms of where I spent the most time, I had a habit of focusing too much on single frames and spending too long on them. How your frames fit into the timesheet makes a huge difference to the character's expressiveness in their presence onscreen, and you can feel that difference, and you have to put a lot of thought into your character's performance, but I know I have a tendency to focus too much on and be fussy with the small details. Because of that, I still don't have much confidence moving the characters, even though as an animator, I'm here to make pictures move! But it's partially because I'm not fond of that side of things that I'm being allowed to direct and character design more. Just as there are many kinds of animation directors, there are animators who are especially good at expressions, or poses, or placing shadows to make the image look cool, and so they come in many different kinds too. Me, personally, I'm aiming to become an animator who thinks like an animation director, even though, as the title "director" suggests, this means I need to pay more attention to production and the like. Through my career in animation, I've gone from being fussy over single images, to fussy over single cuts, to fussy over a whole episode as a director, to fussy over an entire series in terms of its overall balance as character designer and head animation director. From here on, I'd still like to be active in drawing the principle frames of a show.

—*Can you tell us about what you use for references?*

Kagawa: When brainstorming signature poses, we often used the musical group Perfume as our reference, because their poses and choreography were quite unique. Recently, Buruson Chiemi's poses have also been catching my eye.

—*What did you do for practice?*

Kagawa: There wasn't any time for practice, so it was all purely what I picked up on the job. I was working so hard that I didn't want to draw when I went home! I even stopped doodling.

—*When you draw, what sort of environment is most conducive to you?*

Kagawa: My desk is tidy—it'd be difficult to work without some space. I turn the page as I draw, so if I didn't have space, I wouldn't be able to rotate the sheet. Also, there are times where I can focus better when I listen to music as I draw. However, when I'm drawing at the workbenches in the animation studio, I need to be able to hear instructions and it's important to respect the atmosphere of the place, so I'm careful not to wear headphones.

Advice for Future Animators

—*What do we need to do in order to come up with more and a greater variety of scenes?*

Kagawa: I think it would be wise to be curious and go out to explore, absorb and have a broad if superficial knowledge of lots of different things. While you of course need to study how to draw certain things for your work, it might be better to develop a more general mentality of learning to enjoy studying and learning. You certainly need to go out and expand your range of experiences. For example, in the case of the movements used in driving a car, there are movements you can't leave out, and likewise, in the case of driving a motorbike or knowing how to use a gun, you can't compare with those who have in-depth specialist knowledge of the movements pertaining to both. Having said that, stories these days are becoming detailed to the point of mania, and the knowledge of the viewing audience of clothes and places in particular time periods is increasing too. That's why I think it might be better to have a broad-sweeping range of knowledge and to try lots of different experiences. If there's anything you particularly enjoy, your knowledge of it will become deeper. After that, just spending time with people you really like, and listening to the voices of real people, might do you a lot of good.

—*What sort of practice do you think people aiming to become animators should do?*

Kagawa: Times are changing, and 3D animators are producing whole new possibilities for artistic expression, so I don't think there's any need to focus on hand-drawing techniques. First, you've got to think about what your springboard is . . . do you want to draw pictures? Do you want to make them move? Do you want to make footage? Do you find it fun seeing where a single image takes you as you build on it, image by image? Or do you just like pictures, and don't care what job you do so long as you're drawing? Whatever it is, it's important to understand your own motivation. If the pictures you enjoy drawing match the pictures others find most entertaining, then that's fantastic. Also, when making pictures move, whether you can gain satisfaction in looking at a picture and thinking, "What smooth and fluid movements!" is an important consideration.

—*Finally, tell us about something that made you glad you work in an artistic industry and the world of drawing?*

Kagawa: Being able to draw pictures that, via animation, have the chance to reach the eyes of many people; especially since I'm working on TV series, which perhaps is more likely to deliver the drawings to a greater number of people than simply art or illustrations. The actual story itself is not my own, so there might only be a little sense of the series belonging to me, but I'm happy if there's even a small something in there that shines. It makes me very happy to be told, "I've seen it!" about series that I've worked so desperately hard on. Like, "I watched Pretty Cure when I was little!" When I hear from total strangers that they've seen it, or that they remember details that I myself had forgotten, it makes me very proud and happy to have been involved with the project.

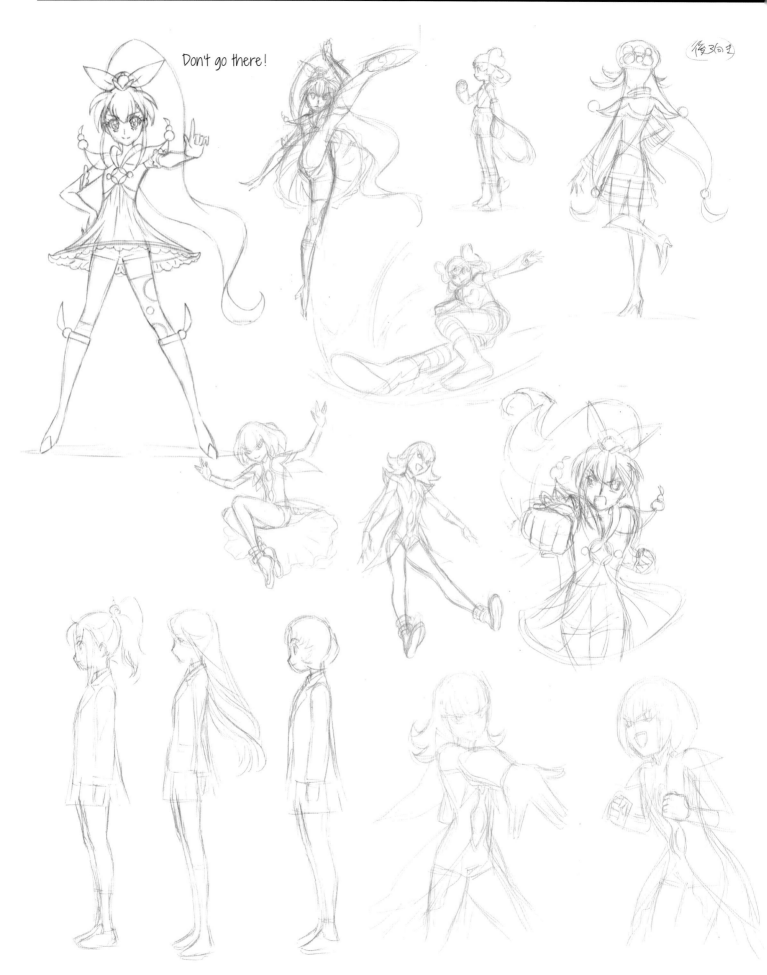

Don't go there!

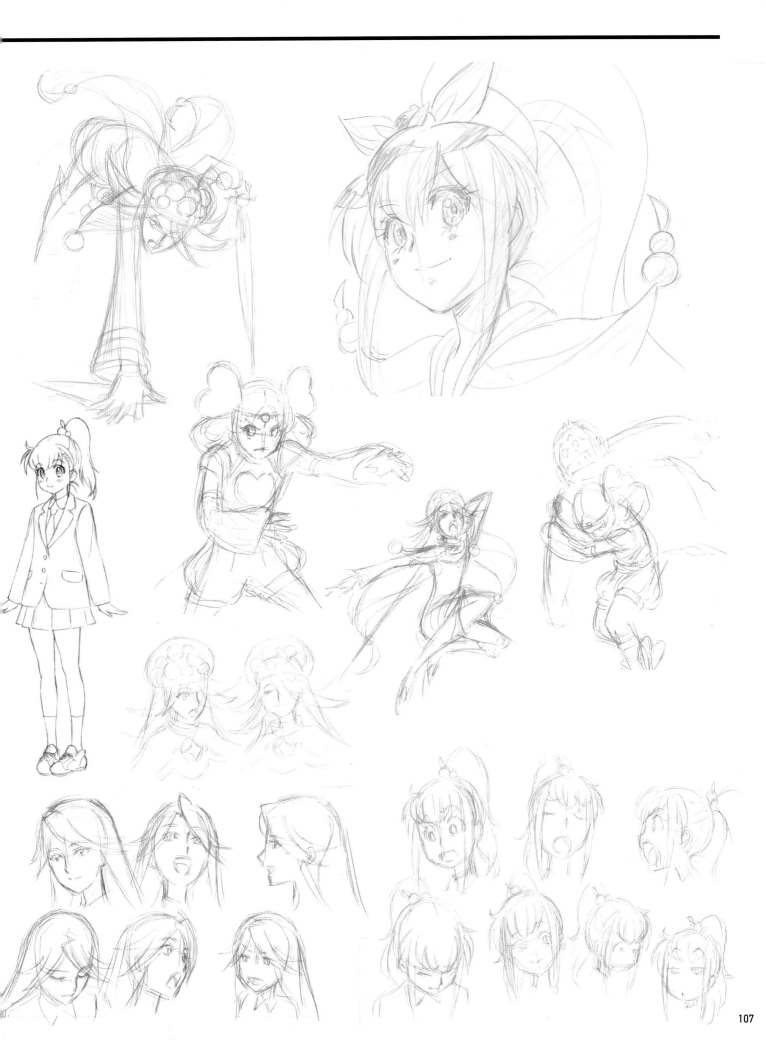

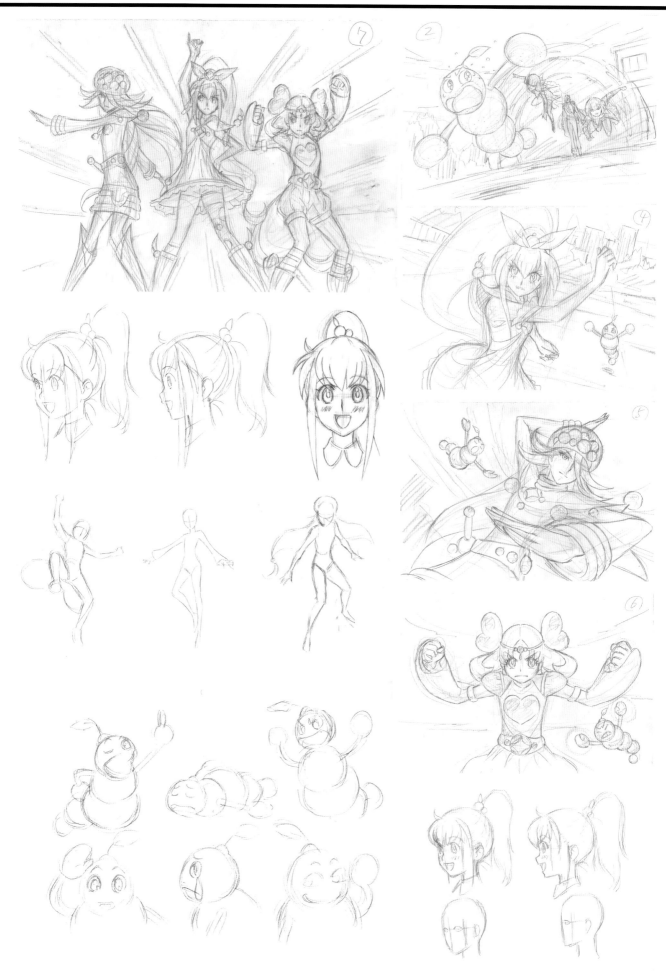

Part 2

A Tutorial with Yoshihiko Umakoshi

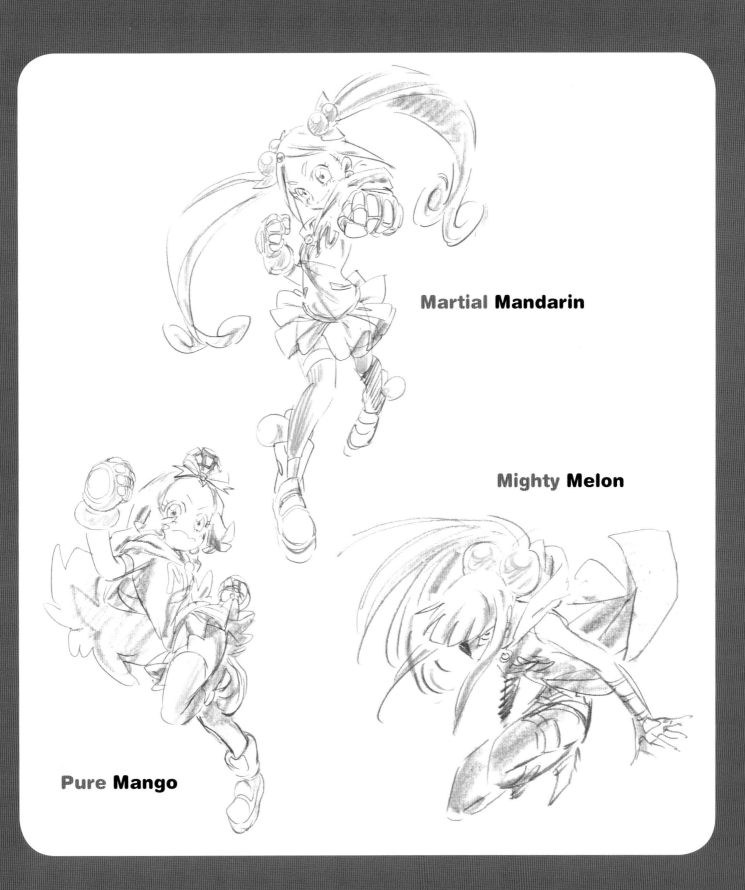

Martial Mandarin

Mighty Melon

Pure Mango

Part 2

Yoshihiko Umakoshi's Original Character Designs

Scenario:

A magical middle school girl going into battle.

Stage Setting:

Three years after the previous film, Chemload, who was lurking in the human world, produces a monster. A message of warning was sent to the heroines, a new fierce fighter is born, and the battle begins.

Storyline:

Chemload was hiding in the human world, turning people into chemical monsters. The elder battle heroine, who has detected the crisis in the human world, sends the fairy messengers with a warning. At the same time, the middle schooler Miriam, knowing that schoolteachers had been changed into chemical monsters, was chased by executive Acerus. Just as she's about to be changed into a chemical monster, she's transformed into the legendary warrior, Martial Mandarin. Outrageous Orange, war weary, depleted from battle, has lost most of her power. Can a new orange warrior save the world from the hands of Chemload?

Highlights:

♦ Unlike the previous battle heroines, these new power princesses have the ability to summon more natural power to fight in the real world.

♦ Benefiting from the power of nature, not only are their abilities but their costumes and hairstyles are supercharged.

What follows are the character designs based on this synopsis.

Part 2
Character
001 Martial Mandarin

A second-year middle schooler, she's the immediately likable cool girl with an enduringly positive attitude. Due to some unfortunate events, though, she got involved in some trouble. She's the kind of character you can see mature as her storyline develops.

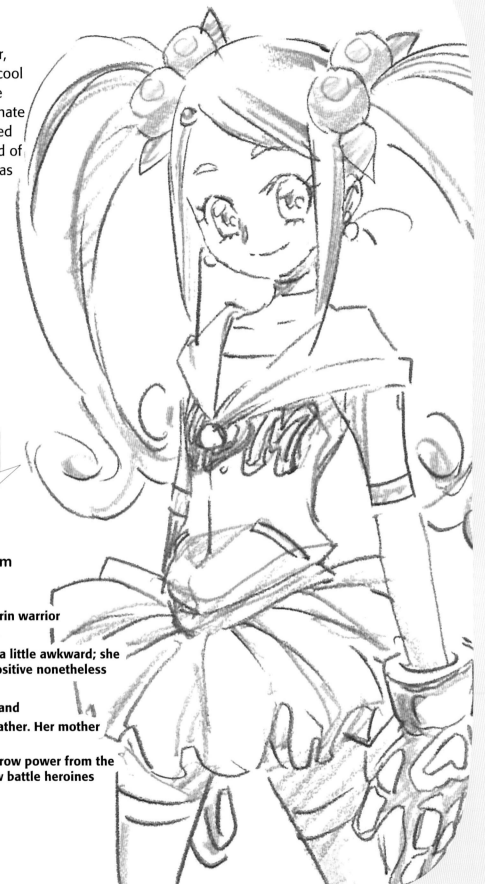

Starting Point

Energetic and positive, she's the shining star of the next-generation battle heroines.

Umakoshi's Inspiration

Try adding fruit or food to her accessories, or some letter logos to her clothes to add a sporty look to the character.

Name:
Martial Mandarin aka Miriam

Character Data:

Motif: **Second-generation Mandarin warrior**

Age/gender: **14 years old/female**

Personality: **Happy-go-lucky and a little awkward; she had a difficult past but stays positive nonetheless**

Favorite: **Music, chick flicks**

Hobbies: **Plays drums in a rock band**

Family structure: **Lives with her father. Her mother died when she was little.**

Ability: **During battle she can borrow power from the earth as well as from her fellow battle heroines**

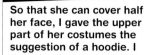

Umakoshi's Comment

So that she can cover half her face, I gave the upper part of her costumes the suggestion of a hoodie. I thought about a part of the hair accessory sticking out while the hood's up.

When she transforms into Martial Mandarin, I want her signature hairstyle to stand out, so I went with the perky pigtails.

Umakoshi's Comment

The letter design on the chest is easily avoided in anima-tion—that kind of detail can be overkill in that format—but I added the detail here on paper.

The decoration of the shoes extends and continues the orange motif, but because they're white they look like items from another world.

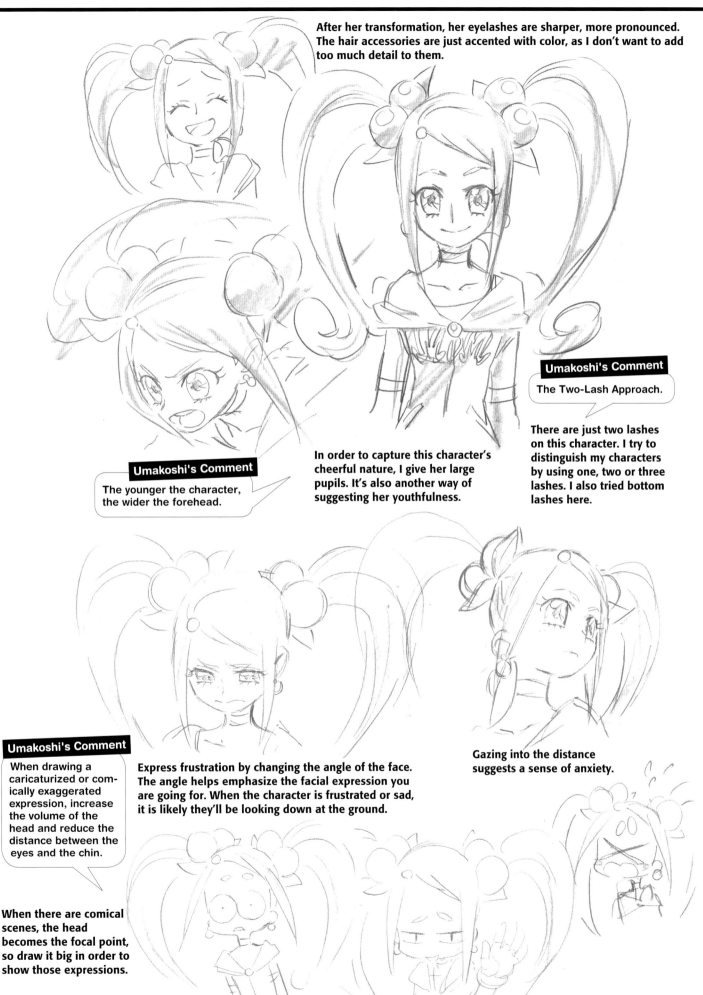

After her transformation, her eyelashes are sharper, more pronounced. The hair accessories are just accented with color, as I don't want to add too much detail to them.

Umakoshi's Comment

The Two-Lash Approach.

There are just two lashes on this character. I try to distinguish my characters by using one, two or three lashes. I also tried bottom lashes here.

Umakoshi's Comment

The younger the character, the wider the forehead.

In order to capture this character's cheerful nature, I give her large pupils. It's also another way of suggesting her youthfulness.

Umakoshi's Comment

When drawing a caricaturized or comically exaggerated expression, increase the volume of the head and reduce the distance between the eyes and the chin.

Express frustration by changing the angle of the face. The angle helps emphasize the facial expression you are going for. When the character is frustrated or sad, it is likely they'll be looking down at the ground.

Gazing into the distance suggests a sense of anxiety.

When there are comical scenes, the head becomes the focal point, so draw it big in order to show those expressions.

I think it's more interesting to mix and match girly and boyish accessories together such as adding these tactical gloves.

Umakoshi's Comment

The tactical gloves add a touch of the unexpected.

Umakoshi's Comment

Here are some of her signature poses and moves.

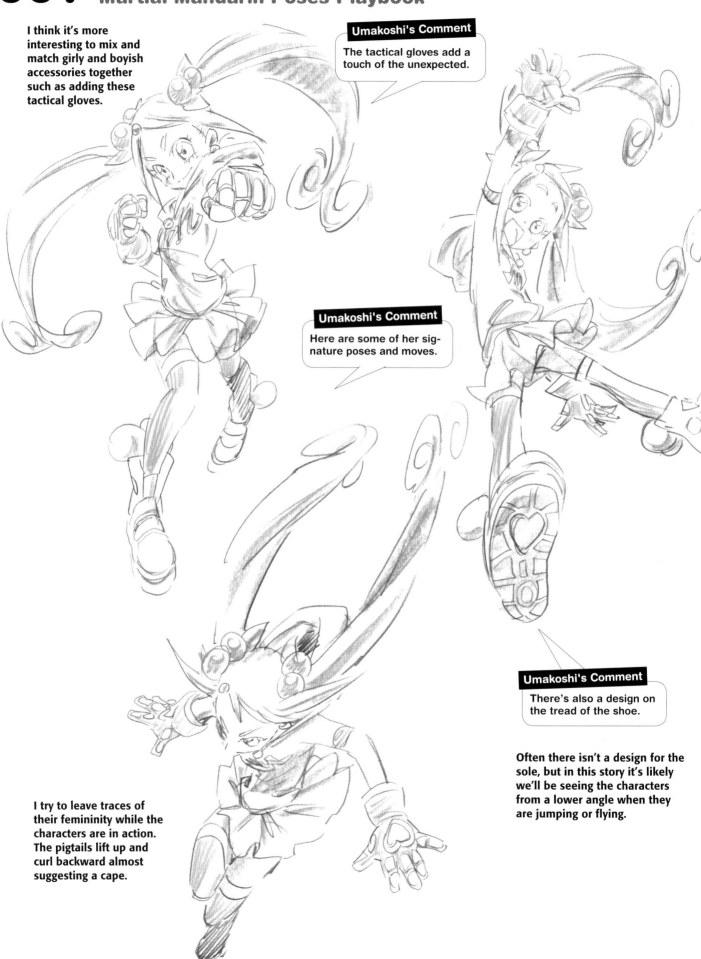

Umakoshi's Comment

There's also a design on the tread of the shoe.

Often there isn't a design for the sole, but in this story it's likely we'll be seeing the characters from a lower angle when they are jumping or flying.

I try to leave traces of their femininity while the characters are in action. The pigtails lift up and curl backward almost suggesting a cape.

Master Class
Basic Design & Drawing Pointers

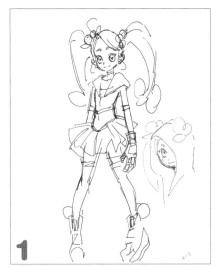

1

Do a rough draft of the whole picture. At this stage, sketch in the important parts of the figures. It's all right if the characters look a bit more mature than they should.

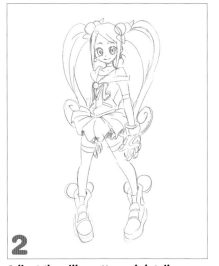

2

Adjust the silhouette and details once you have a better idea of where to place things. For instance, you might notice you want the skirt to be puffier. At this point, you can add details such as the M logo.

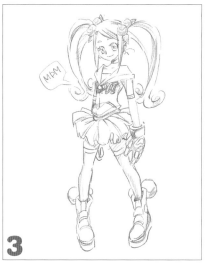

3

Clean up the lines and the character is complete. Add color to finish off the design.

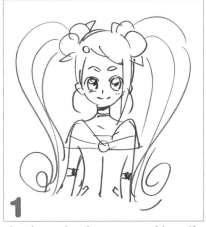

1

Sketch out the character roughly as if you are taking notes. This includes the expression in the character's eyes.

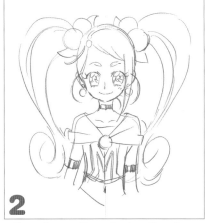

2

Adjust the pupils and other fine details. At this point in the sketch, I decide to add the M logo on the top. I also considered making it a crop top just to see.

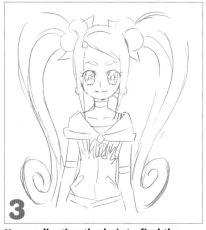

3

Keep adjusting the hair to find the best length.

Striking a Pose

Here the focus is on the body in motion. The most important thing is to compare the differences between how the three bodies are posed and to be sure the design makes use of the battle heroine's defining characteristics. It is important that the scene allow you to see characters in action, such as how the hair whips around as they fight.

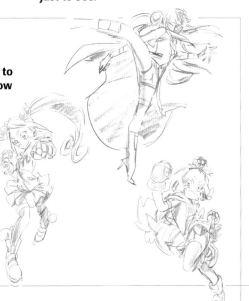

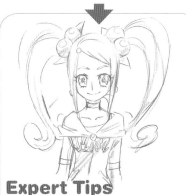

Expert Tips
Symmetrical Characters

This could be just my personal preference, but main characters are generally designed to be symmetrical. There may be some heroines you want to try out asymmetric styles with, but I prefer to have my heroines in balance.

Umakoshi's Comment

For the heroine's schoolgirl persona, I went for a plain, dressed-down look.

Umakoshi's Comment

To add variety to the character designs, I let the forehead protrude more through the hair.

For her pre-transformation persona, I decided to go with a plain look, but her personality doesn't change. I swept the bangs aside to expose more of the forehead. After her transformation, we can bring out the flashy pigtails for contrast.

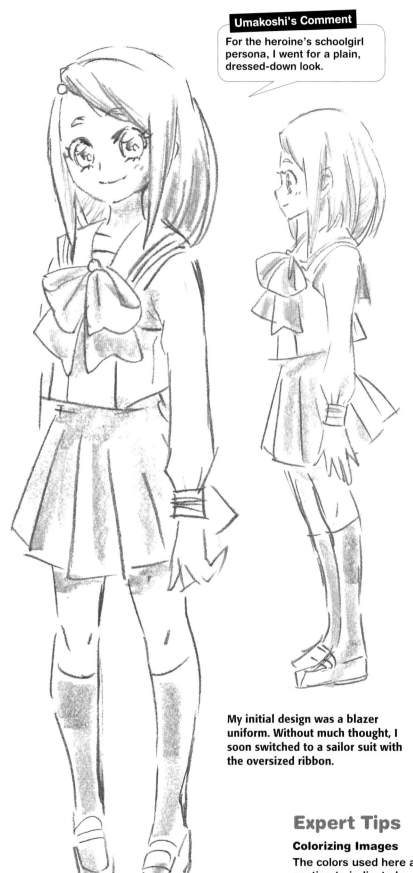

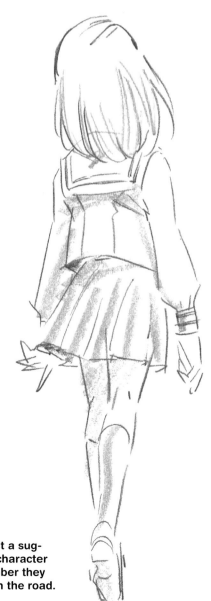

My initial design was a blazer uniform. Without much thought, I soon switched to a sailor suit with the oversized ribbon.

Expert Tips

Colorizing Images

The colors used here are just a suggestion to indicate how the character can be colorized, but remember they can always be changed down the road.

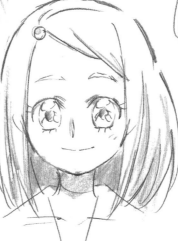

Thick eyelashes makes her look strong.

For her basic expressions, the thick lashes add a forcefulness and clarity.

Her daily style looks plain and simple, but that basic approach gives you a lot to work with and build from.

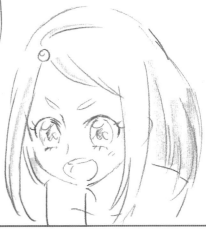

Lash Awareness
Since I'm using a minimal eyelash effect this time, two lower ones are included. For younger characters in elementary or middle school, you can leave out the lower lashes altogether.

Master Class
Basic Design & Drawing Pointers

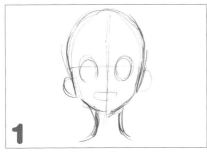

1 Draw a cross line at the center and decide the eye position while considering the overall outline. The eye position is slightly lower than the middle of the face.

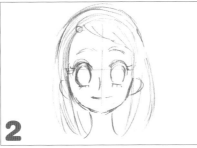

2 Hair accentuates and follows the shape of the skull. I also consider at this point how large the eyes are.

3 Finally, arrange the rough lines and highlight the eyes.

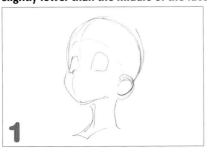

1 Determine the face angle and add in some contour. Be aware that one of the ears isn't visible.

2 The eyelashes and eyes have a slight three-dimensional effect. The eyebrows also reflect this.

3 Add highlights to guide the direction of the eyes. Eyelashes curve when viewed from the side.

Expert Advice

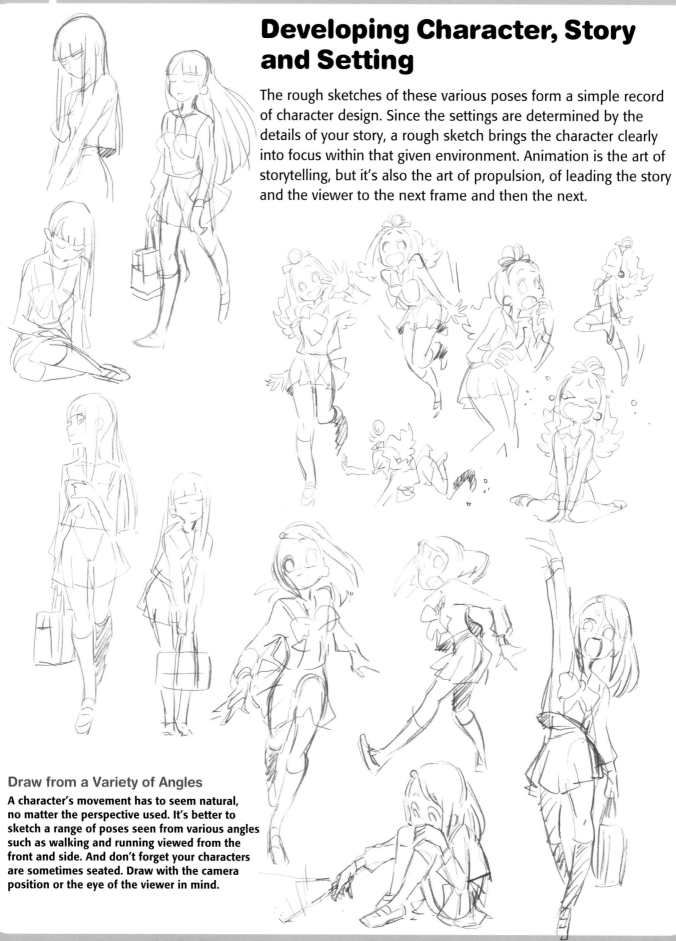

Developing Character, Story and Setting

The rough sketches of these various poses form a simple record of character design. Since the settings are determined by the details of your story, a rough sketch brings the character clearly into focus within that given environment. Animation is the art of storytelling, but it's also the art of propulsion, of leading the story and the viewer to the next frame and then the next.

Draw from a Variety of Angles

A character's movement has to seem natural, no matter the perspective used. It's better to sketch a range of poses seen from various angles such as walking and running viewed from the front and side. And don't forget your characters are sometimes seated. Draw with the camera position or the eye of the viewer in mind.

Part 2
Character
002 Mighty Melon

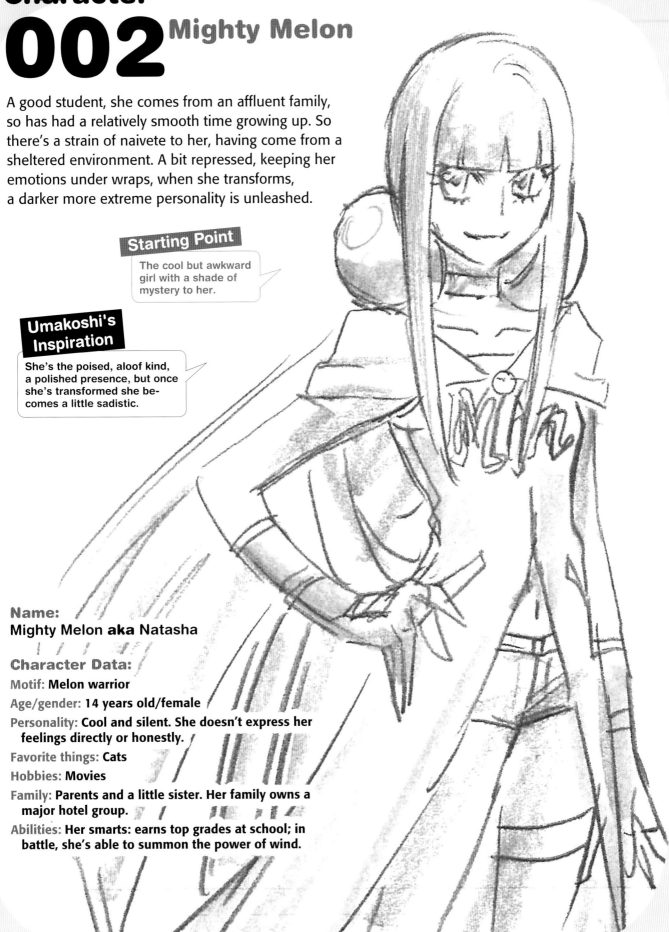

A good student, she comes from an affluent family, so has had a relatively smooth time growing up. So there's a strain of naivete to her, having come from a sheltered environment. A bit repressed, keeping her emotions under wraps, when she transforms, a darker more extreme personality is unleashed.

Starting Point

The cool but awkward girl with a shade of mystery to her.

Umakoshi's Inspiration

She's the poised, aloof kind, a polished presence, but once she's transformed she becomes a little sadistic.

Name:
Mighty Melon aka Natasha

Character Data:

Motif: Melon warrior

Age/gender: 14 years old/female

Personality: Cool and silent. She doesn't express her feelings directly or honestly.

Favorite things: Cats

Hobbies: Movies

Family: Parents and a little sister. Her family owns a major hotel group.

Abilities: Her smarts: earns top grades at school; in battle, she's able to summon the power of wind.

A Tutorial with Yoshihiko Umakoshi

Mighty Melon at a Glance

Umakoshi's Comment

A character whose personality changes as much as her physical appearance.

Don't forget about internal transformations, the changes that can't necessarily be seen, but are then made manifest in some way: a pose, a glimpse, a gesture. It's especially interesting when the wallflower turns into a vicious avenger.

Umakoshi's Comment

Her transformation turns her into an assertive leader.

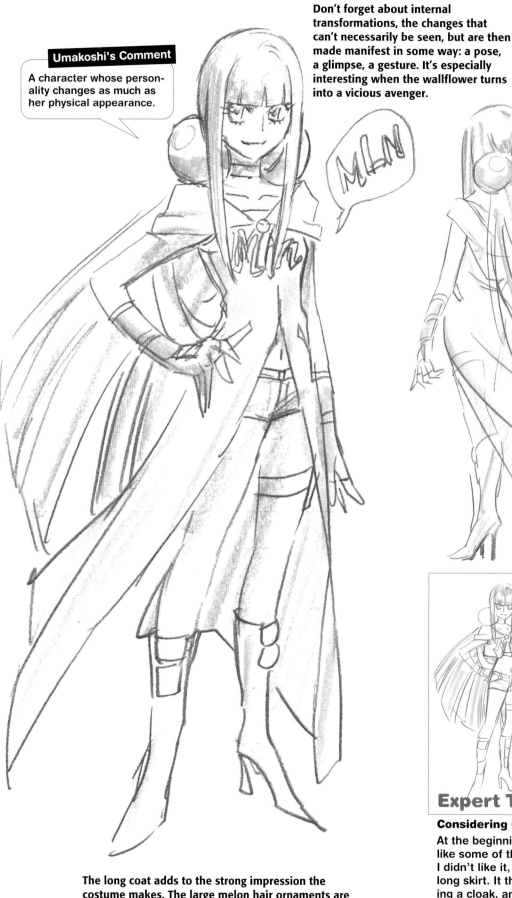

Expert Tips

Considering Costume

At the beginning, I had her midriff exposed, like some of the other battle heroines, but I didn't like it, so I opted for the jacket and long skirt. It then looked like she was wearing a cloak, and suddenly the design became much more interesting.

The long coat adds to the strong impression the costume makes. The large melon hair ornaments are simple with no adornment.

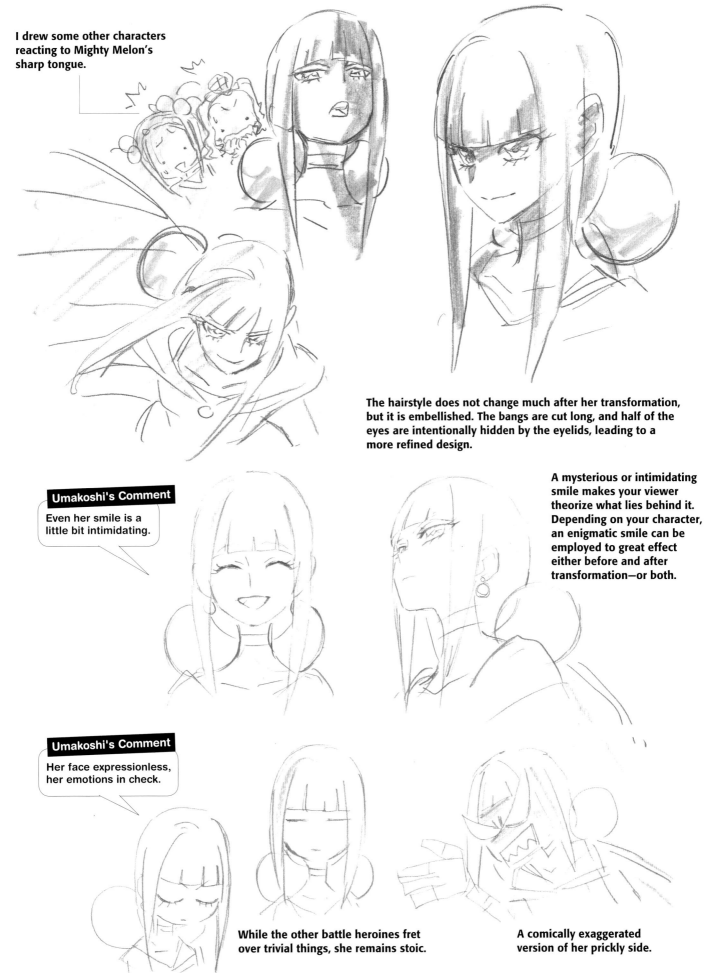

I drew some other characters reacting to Mighty Melon's sharp tongue.

The hairstyle does not change much after her transformation, but it is embellished. The bangs are cut long, and half of the eyes are intentionally hidden by the eyelids, leading to a more refined design.

A mysterious or intimidating smile makes your viewer theorize what lies behind it. Depending on your character, an enigmatic smile can be employed to great effect either before and after transformation—or both.

Umakoshi's Comment

Even her smile is a little bit intimidating.

Umakoshi's Comment

Her face expressionless, her emotions in check.

While the other battle heroines fret over trivial things, she remains stoic.

A comically exaggerated version of her prickly side.

Running: as the coat's flaps flare, the pivot of the body exaggerates the action.

Umakoshi's Comment

After her transformation, it's as if she's been released from a private prison.

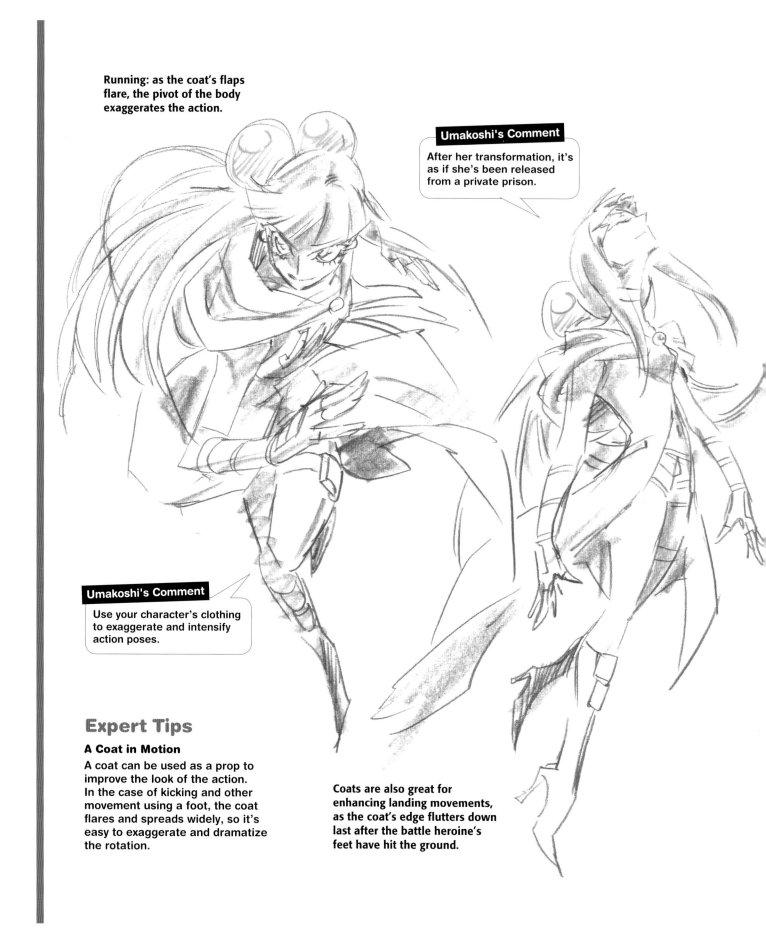

Umakoshi's Comment

Use your character's clothing to exaggerate and intensify action poses.

Expert Tips

A Coat in Motion

A coat can be used as a prop to improve the look of the action. In the case of kicking and other movement using a foot, the coat flares and spreads widely, so it's easy to exaggerate and dramatize the rotation.

Coats are also great for enhancing landing movements, as the coat's edge flutters down last after the battle heroine's feet have hit the ground.

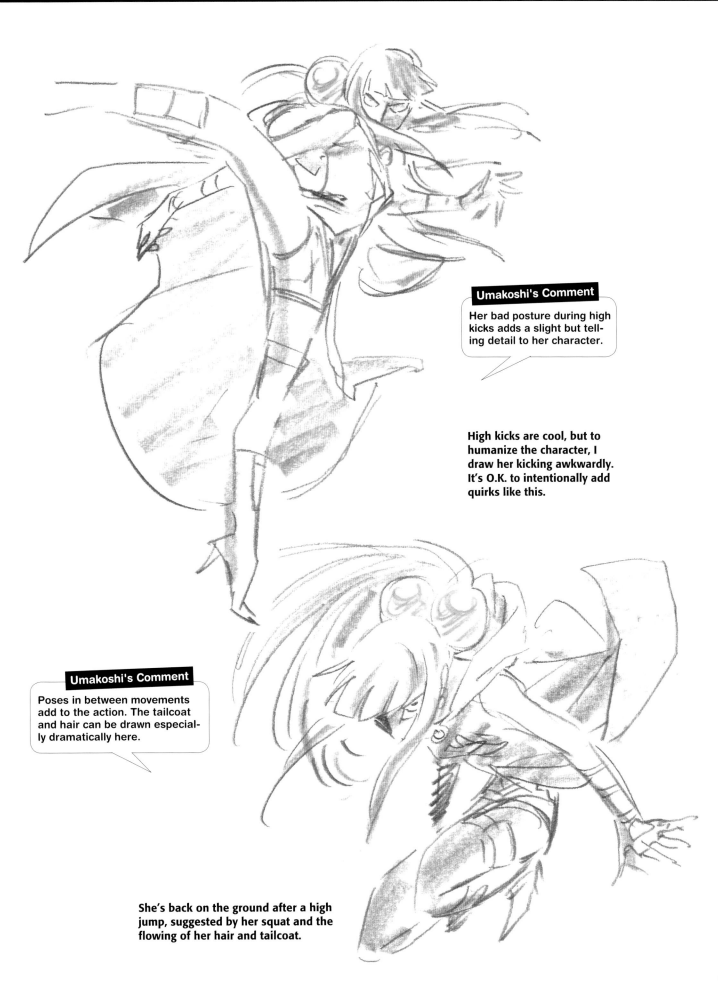

Umakoshi's Comment

Her bad posture during high kicks adds a slight but telling detail to her character.

High kicks are cool, but to humanize the character, I draw her kicking awkwardly. It's O.K. to intentionally add quirks like this.

Umakoshi's Comment

Poses in between movements add to the action. The tailcoat and hair can be drawn especially dramatically here.

She's back on the ground after a high jump, suggested by her squat and the flowing of her hair and tailcoat.

Umakoshi's Comment

Her bangs cover her forehead and eyebrows. This is one obvious way to conceal her expressions.

Her hairstyle is reminiscent of Chiaki Kuriyama's from "Kill Bill." She gives the vibe of a cool big sister.

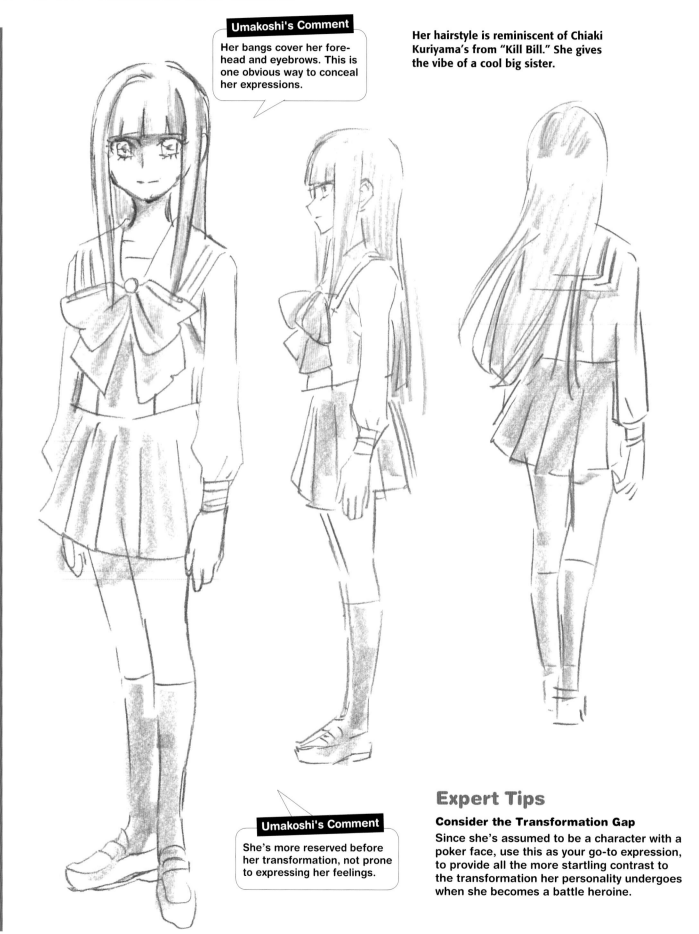

Umakoshi's Comment

She's more reserved before her transformation, not prone to expressing her feelings.

Expert Tips

Consider the Transformation Gap

Since she's assumed to be a character with a poker face, use this as your go-to expression, to provide all the more startling contrast to the transformation her personality undergoes when she becomes a battle heroine.

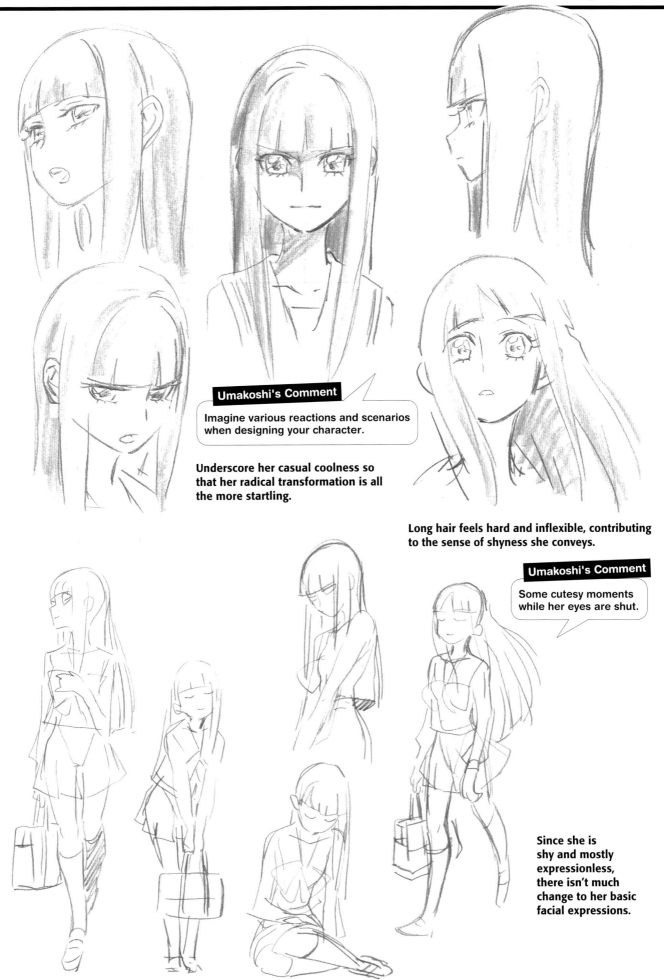

Umakoshi's Comment

Imagine various reactions and scenarios when designing your character.

Underscore her casual coolness so that her radical transformation is all the more startling.

Long hair feels hard and inflexible, contributing to the sense of shyness she conveys.

Umakoshi's Comment

Some cutesy moments while her eyes are shut.

Since she is shy and mostly expressionless, there isn't much change to her basic facial expressions.

Master Class

Basic Design & Drawing Pointers

1

At the first rough sketch stage, the melon costume was a bit provocative, with a split-seam dress and the garter and stocking elements.

2

While filling in the silhouette, add the details. At this point, the logo on the chest is designed with a single letter M to make her seem a bit more girly and innocent.

3

Adjust the overall design, and complete with a rough color pencil.

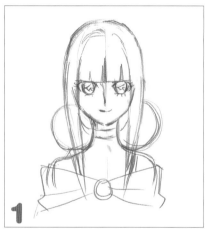

1

First I drew the initial incarnation of a double-personality princess character. As her appearance will thus change, I'll make adjustments in the next steps.

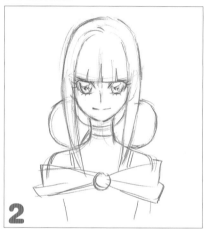

2

I added a little chin; that, along with the lines on the eyelids and lines on the bangs, adds to the image of strength and firmness. I'll make the mouth a little longer.

3

With a character like this, consider showing her off-angle and how even that shift helps capture and suggest her personality.

Rough Poses

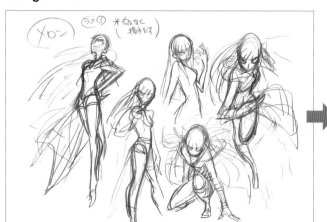

Dramatic hair and the flowing coattails add to her sense of elegance.

Keeping a playbook of rough poses helps you envision your character in a range of scenarios.

Part 2
Character
003 Pure Mango

Miriam's best friend. To roughly explain the character, she's blunt and chatty, often saying too much, and is constantly interrupted by Mighty Melon. Although she can be rough at times, she's generous and much loved by her friends.

Starting Point

She often does things her way, the type who's admired for her individuality and independence.

Umakoshi's Inspiration

She's the happy-go-lucky girl who faces challenges head on. She might be the weakest one at the beginning, but the one who matures the most throughout the story.

Name:
Pure Mango aka Manuela

Character Data:

Motif: Mango warrior

Age/gender: 14 years old/female

Personality: The rough-edged sweet girl

Favorite things: Food

Hobbies: Cooking, though she's not a particularly talented chef

Family: An only child in a middle-class family, her mother stayed home to raise her, while her father is an office manager.

Ability: During battle, she can summon the sun's fire.

A Tutorial with Yoshihiko Umakoshi

Pure Mango at a Glance

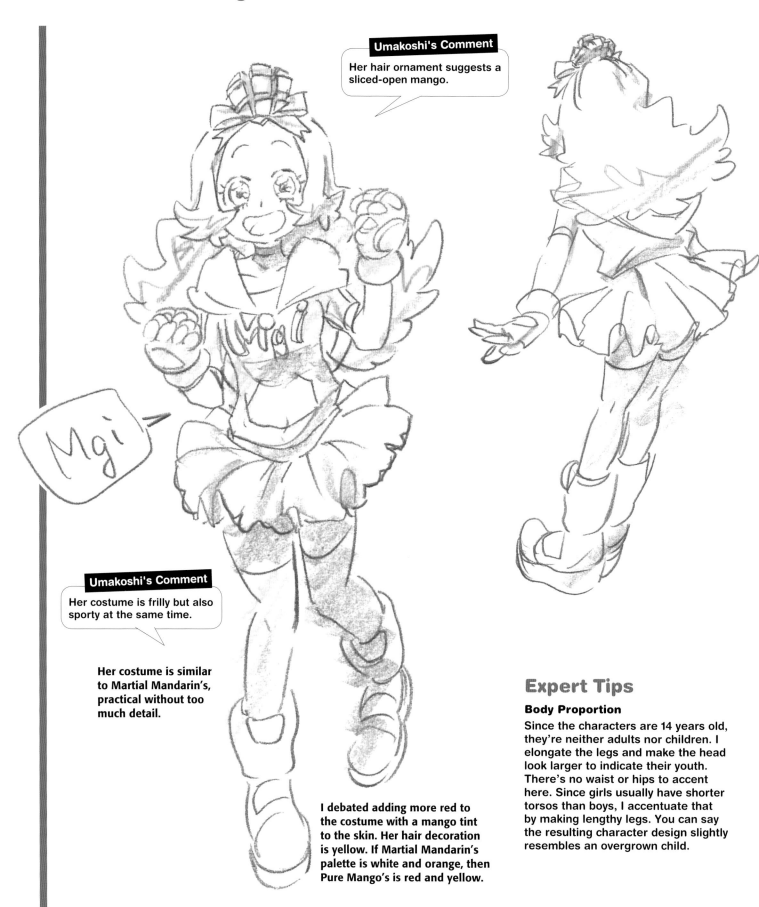

Umakoshi's Comment
Her hair ornament suggests a sliced-open mango.

Mgi

Umakoshi's Comment
Her costume is frilly but also sporty at the same time.

Her costume is similar to Martial Mandarin's, practical without too much detail.

I debated adding more red to the costume with a mango tint to the skin. Her hair decoration is yellow. If Martial Mandarin's palette is white and orange, then Pure Mango's is red and yellow.

Expert Tips

Body Proportion

Since the characters are 14 years old, they're neither adults nor children. I elongate the legs and make the head look larger to indicate their youth. There's no waist or hips to accent here. Since girls usually have shorter torsos than boys, I accentuate that by making lengthy legs. You can say the resulting character design slightly resembles an overgrown child.

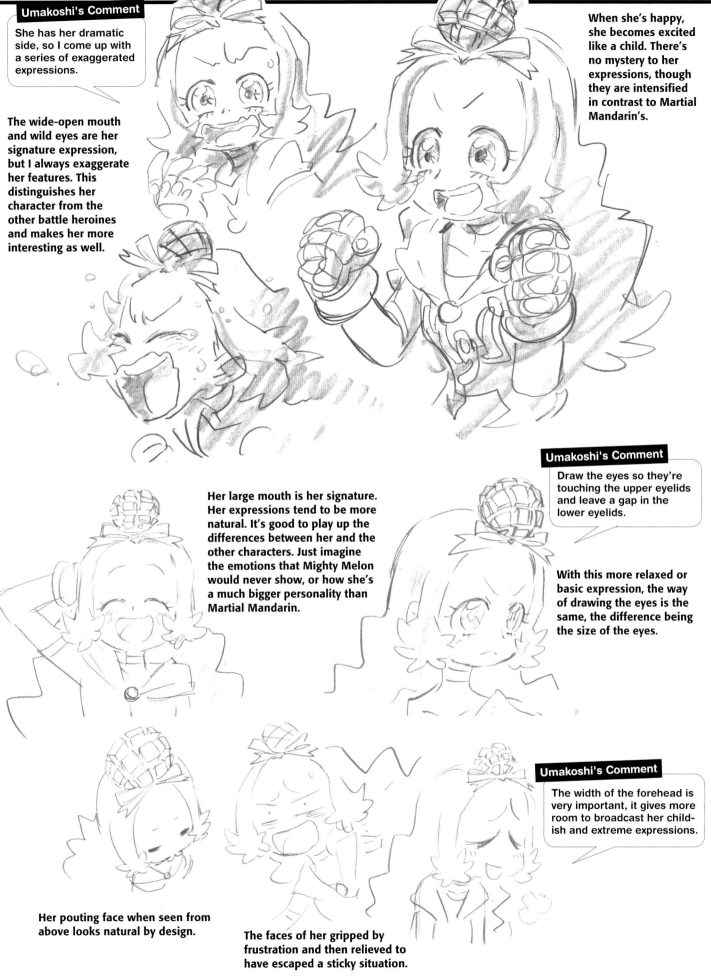

She has her dramatic side, so I come up with a series of exaggerated expressions.

When she's happy, she becomes excited like a child. There's no mystery to her expressions, though they are intensified in contrast to Martial Mandarin's.

The wide-open mouth and wild eyes are her signature expression, but I always exaggerate her features. This distinguishes her character from the other battle heroines and makes her more interesting as well.

Her large mouth is her signature. Her expressions tend to be more natural. It's good to play up the differences between her and the other characters. Just imagine the emotions that Mighty Melon would never show, or how she's a much bigger personality than Martial Mandarin.

Draw the eyes so they're touching the upper eyelids and leave a gap in the lower eyelids.

With this more relaxed or basic expression, the way of drawing the eyes is the same, the difference being the size of the eyes.

The width of the forehead is very important, it gives more room to broadcast her childish and extreme expressions.

Her pouting face when seen from above looks natural by design.

The faces of her gripped by frustration and then relieved to have escaped a sticky situation.

129

Pure Mango Poses Playbook

Umakoshi's Comment

A clumsy character can make a startling transformation, suddenly summoning mysterious powers.

While she's seen mostly simplistically portrayed, as awkward and unformed, that leaves the character with the most room for growth.

Expert Tips

Be Aware of Body Movement
Twist the body while your character is running. In theory, I'm drawing a funny pose here, just making it softer and more dynamic.

Umakoshi's Comment

Half of the poses are of her falling on her butt. A comical expression is a go-to given her personality.

Most of Pure Mango's poses are comical, another signature of the character. When I play around with these poses, I pull in chibi-style elements to exaggerate the comedy.

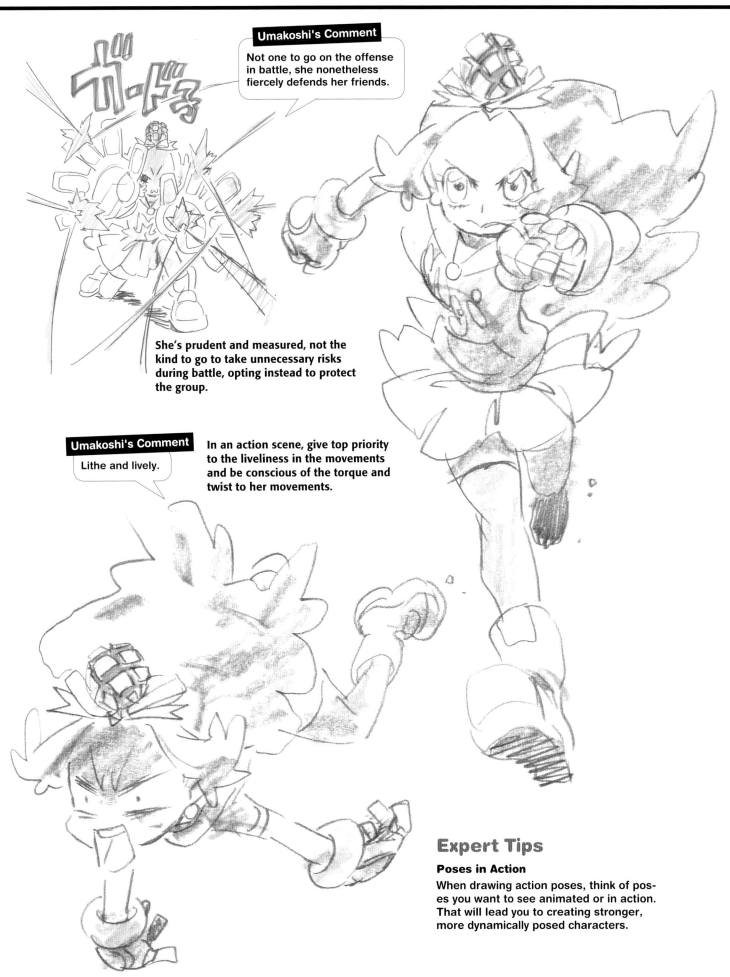

Umakoshi's Comment

Not one to go on the offense in battle, she nonetheless fiercely defends her friends.

She's prudent and measured, not the kind to go to take unnecessary risks during battle, opting instead to protect the group.

Umakoshi's Comment

Lithe and lively.

In an action scene, give top priority to the liveliness in the movements and be conscious of the torque and twist to her movements.

Expert Tips

Poses in Action

When drawing action poses, think of poses you want to see animated or in action. That will lead you to creating stronger, more dynamically posed characters.

131

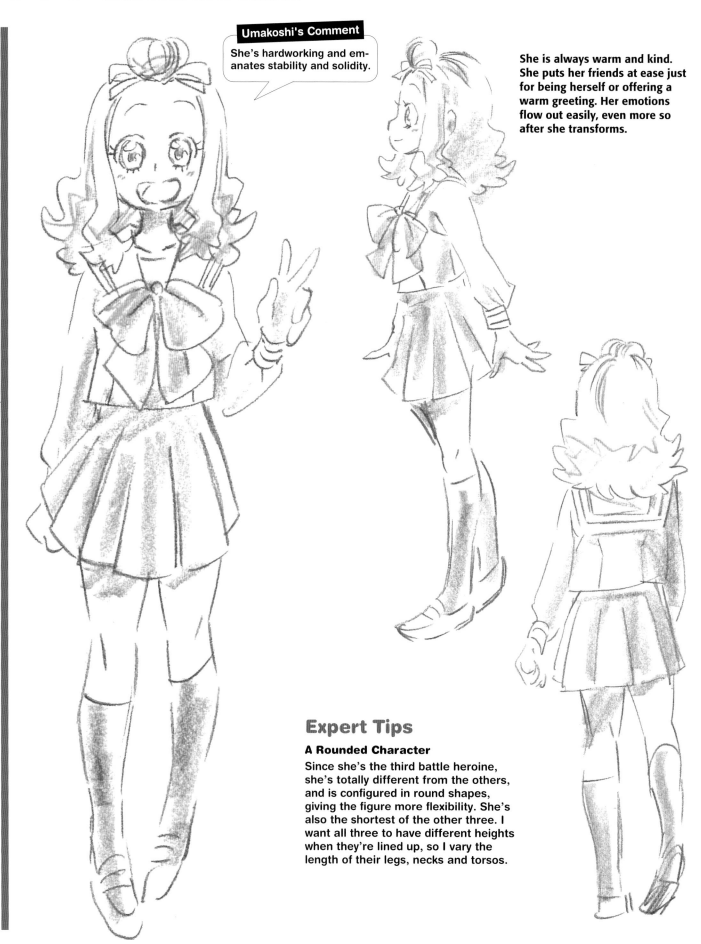

Umakoshi's Comment
She's hardworking and emanates stability and solidity.

She is always warm and kind. She puts her friends at ease just for being herself or offering a warm greeting. Her emotions flow out easily, even more so after she transforms.

Expert Tips

A Rounded Character

Since she's the third battle heroine, she's totally different from the others, and is configured in round shapes, giving the figure more flexibility. She's also the shortest of the other three. I want all three to have different heights when they're lined up, so I vary the length of their legs, necks and torsos.

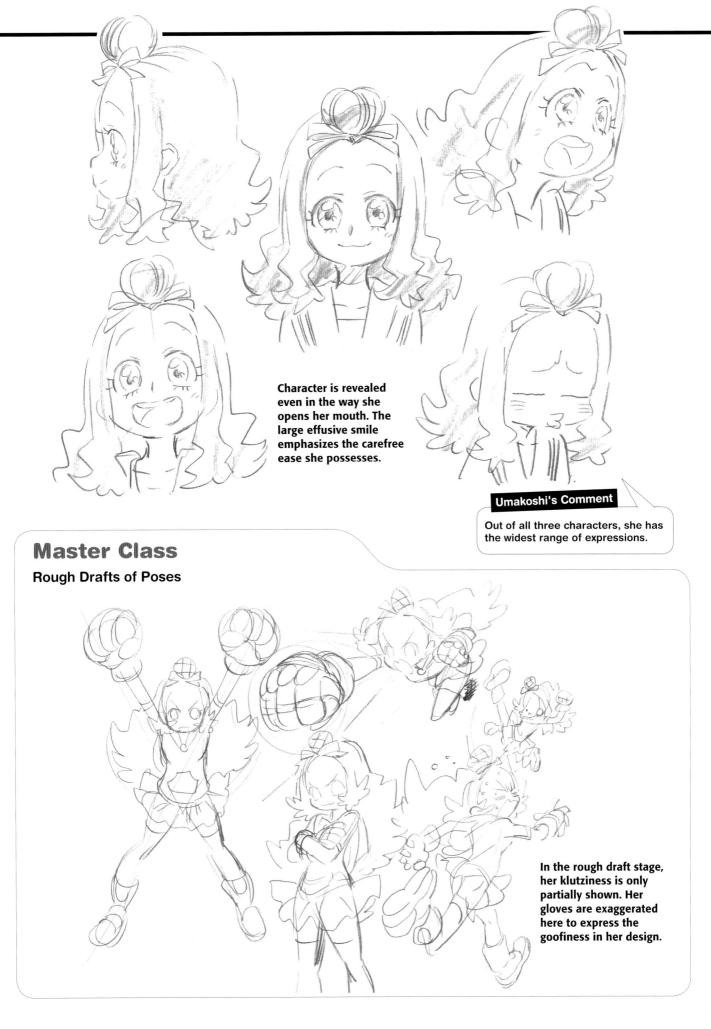

Character is revealed even in the way she opens her mouth. The large effusive smile emphasizes the carefree ease she possesses.

Umakoshi's Comment

Out of all three characters, she has the widest range of expressions.

Master Class

Rough Drafts of Poses

In the rough draft stage, her klutziness is only partially shown. Her gloves are exaggerated here to express the goofiness in her design.

Expert Advice

Drawing Skirts

This time the costume includes a skirt both before and after the transformation, so the point is to draw while imagining the position of the legs that are concealed beneath the skirt. If you're a beginner, your drawings may look like the legs are growing out of the skirt, so try to imagine and draw the structure of the entire body.

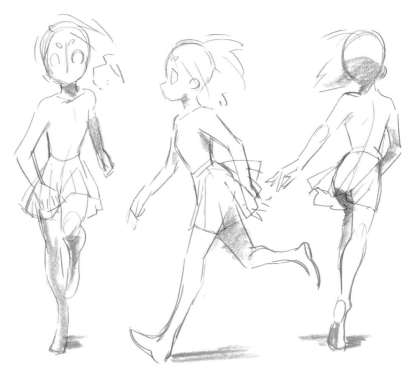

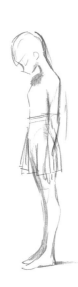

A running pose. I draw her with the top of the thigh hidden in the skirt. If your character is jogging or running slowly, the knee and thigh movements are a bit clearer.

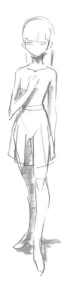
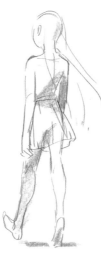

Even if your character is standing still, you still need to be aware of her feet meeting the ground. You can replicate a natural way of standing by positioning the character with one foot in front of the other. Just don't make this junior-high character look too mature. No matter what, it's better to make the waist positioned a little higher than it actually is or to make the upper body shorter.

The more movement that's involved, the greater the variation of the pose. You also need to imagine the parts of the body the garment conceals, but with the movement of the skirt you can also highlight the article of clothing itself. You can use the flow of the skirt to accentuate the range of motion involved.

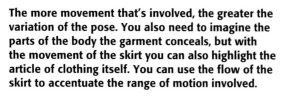

Part 2
Character
004 Sidekicks and Mascots

A fairy whose deep admiration of Pontoon leads to its own transformation. This character always wears an expressionless face, but that can be an advantage as there are times when you don't know what exactly the character's thinking.

Starting Point

A similar orange motif is at work here, but slightly different from the look we used for Pontoon.

Umakoshi's Inspiration

He looks a little bit like a bloated child. Instead of a hood, I gave him a handkerchief.

Name:
Decoupage

Character Data:
Type: **Pontoon-derived**
Motif: **Oranges, handkerchiefs**
Personality: **A bit reckless, hard to read, unpredictable**
Abilities: **Breaking the tension**

Umakoshi's Comment

Think of this character like a decorative mochi with an orange on top.

The head accessory and head are just as round as the body. The whole character looks as if three oranges have been stacked on top of each other.

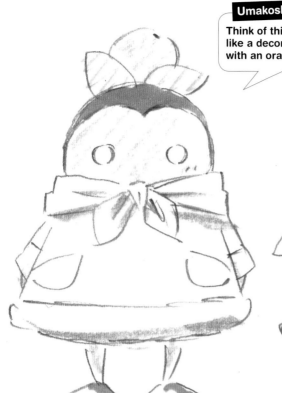

Umakoshi's Comment

Imagine Decoupage as a toddler when designing his costume.

Is Decoupage a boy or a girl? It could really go either way.

Decoupage Poses Playbook

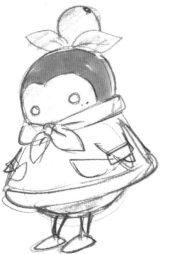

The head is hairless, so the darker color serves as the accent.

Umakoshi's Comment

While this character certainly stands out from the others, the handkerchief is another signature element.

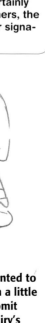

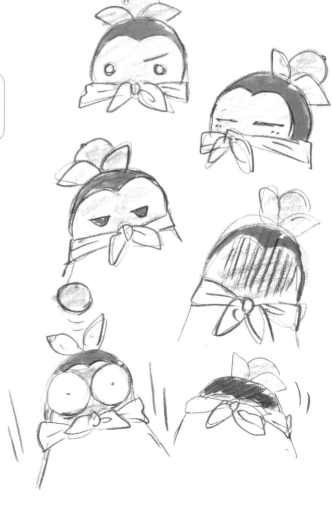

Decoupage isn't human, so I wanted to make the character's expression a little blank like a stuffed animal's. I omit the mouth, which adds to the fairy's blankness. But not to worry. Even if your character doesn't have a mouth, you can still give him or her—or it—dynamic and interesting expressions.

Master Class
Rough Drafts

Basically three stacked oranges of decreasing size.

The stooped posture, always pitched a little forward, adds to this character's cuteness.

Adding the costume.

Here the character looks a little like a badminton shuttlecock.

Adding a front pocket is a simple embellishment that may come in handy later.

Falling flat on its face.

Expert Advice

Pens and pencils give you the freedom to dash off your visual ideas on the spot. Rather than overthinking the direction of a sketch, I draw freely, see how it develops and then adjust on the fly. You never know what's going to assemble before you!

Rough Sketches

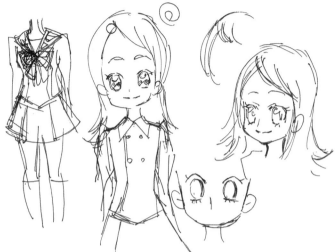

I try to make the size of the eyes very small; I can always change the shape.

This is the stage to factor in how the characters interrelate and helps establish height and physical differences.

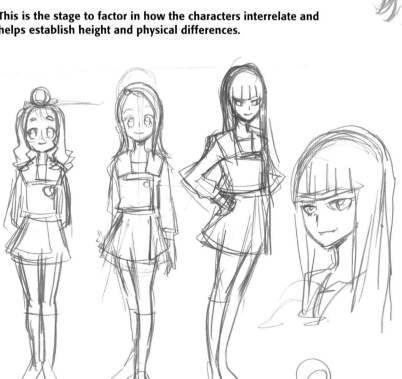

At this stage in the rough sketching, I considered giving Pure Mango glasses but later abandoned the idea. I also wanted to get a look at Mighty Melon from another angle.

Part 2
Character
005 Sasha

A high school student now, she uses her battle-hardened experience to lead and advise the heroines. She has changed radically through the recent years, both mentally and physically, and despite being the "senior adviser" to the group, she's prepared to take up the fight on her own if she has to.

Starting Point

She's a battle heroine from the past and the knowledge she gleaned from that experience still glimmers in her eyes.

Umakoshi's Inspiration

I decided to make her more mature looking. As the senior member, she has the coolest vibe of the group.

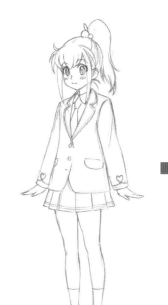

Name:
Outrageous Orange aka Sasha

Character Data:
Type: Battle Heroine
Motif: Orange warrior
Personality: Battle-hardened, wise, an old soul
Abilities: A mentor and senior adviser

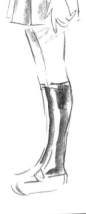

Umakoshi's Comment

This character bears battle scars, both physically and mentally. Somehow that should be expressed in her design.

You can indicate her maturity by adding more hair, and slightly elongating the head. The uniform now has a shoulder strap.

Umakoshi's Comment

I try to stick to the original Outrageous Orange design as much as I can.

The black knee-high socks are the perfect costume detail identifying her as a high school student.

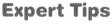

Expert Tips

Turning Her Back

Remember to visualize your character from all angles so the conception is consistent. Also, the fall of her hair as it drapes onto her shoulders is an important detail to master.

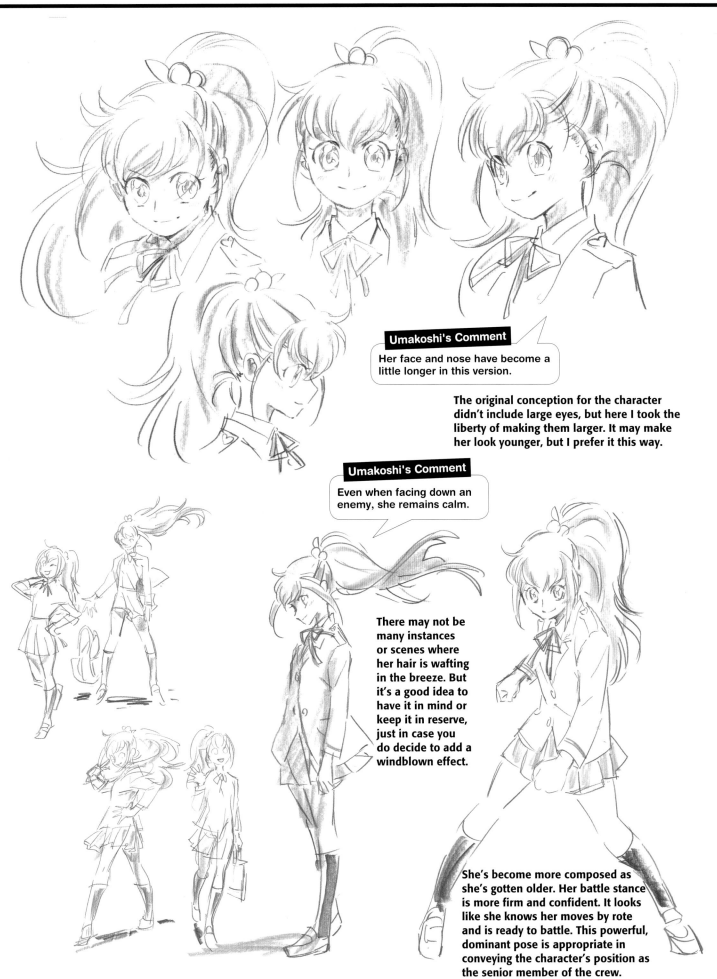

Umakoshi's Comment

Her face and nose have become a little longer in this version.

The original conception for the character didn't include large eyes, but here I took the liberty of making them larger. It may make her look younger, but I prefer it this way.

Umakoshi's Comment

Even when facing down an enemy, she remains calm.

There may not be many instances or scenes where her hair is wafting in the breeze. But it's a good idea to have it in mind or keep it in reserve, just in case you do decide to add a windblown effect.

She's become more composed as she's gotten older. Her battle stance is more firm and confident. It looks like she knows her moves by rote and is ready to battle. This powerful, dominant pose is appropriate in conveying the character's position as the senior member of the crew.

Expert Advice

Chibi-Style Facial Expressions

It's typically difficult to express or capture emotions wholly or fully in just one image. Chibi-style expressions, great for moments of levity, help convey amplified or intensified emotions such as surprise or relief.

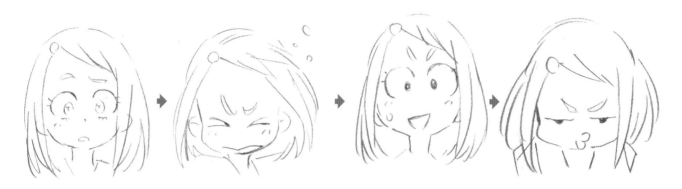

"You scared me!" Then once she realizes they got her again, she reacts with a pout.

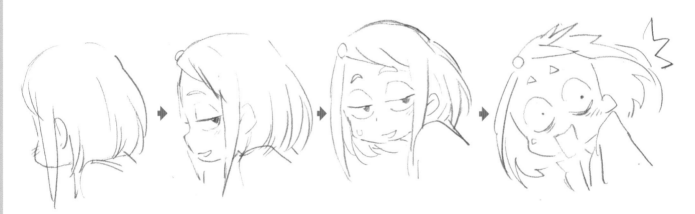

Eavesdropping on gossip, denying the rumor could really be true. She then realizes the subject of the rumor has just appeared within earshot.

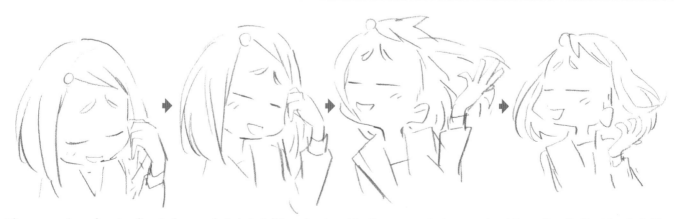

The expression of pretending to know what she's talking about and feeling somewhat smug about it, sealing it all with a hair flip.

Part **2**
Character
006 Stevia

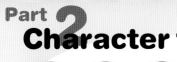

The leader of Chemload. Her face is frozen with an unfalteringly creepy smile. She has the terrifying ability to make beautiful people into reckless monsters.

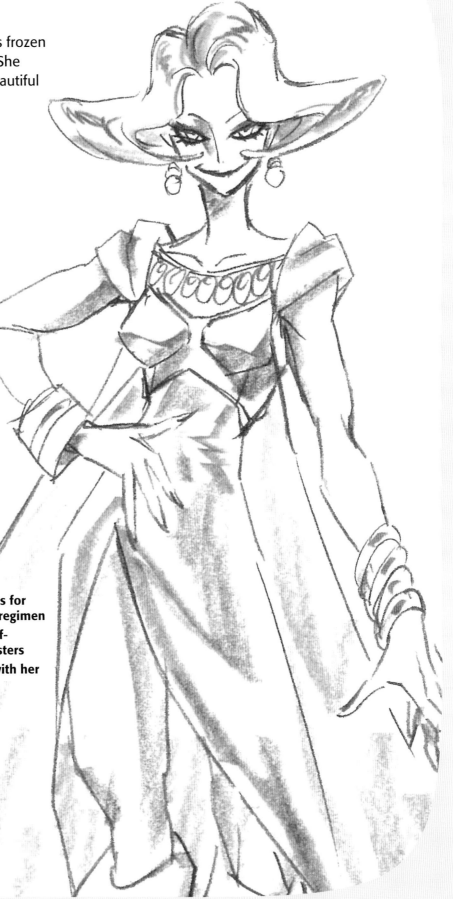

Starting Point

A muscular witch with an artificial-sweetener motif.

Umakoshi's Inspiration

The key point is artificial: she's pushed her pursuit of beauty to its limits.

Name:
Stevia

Character Data:

Motif: Artificial sweetener

Age/gender: 24 years old/female

Personality: A muscular witch who lives for dieting, working out and her beauty regimen

Feature: She transforms shallow or self-conscious people into seething monsters

Skill: Tormenting the battle heroines with her overwhelming power

A Tutorial with Yoshihiko Umakoshi

Stevia at a Glance

Umakoshi's Comment

I've designed her as a figure of vanity and excess, possessing an hauteur and beauty that's artificially created and unnaturally produced.

The smile is as though it is stuck, plastered, a terrifyingly frozen or Botoxed expression. The corners of her mouth are always upturned, because she's always sneering.

The view from behind is relatively simple.

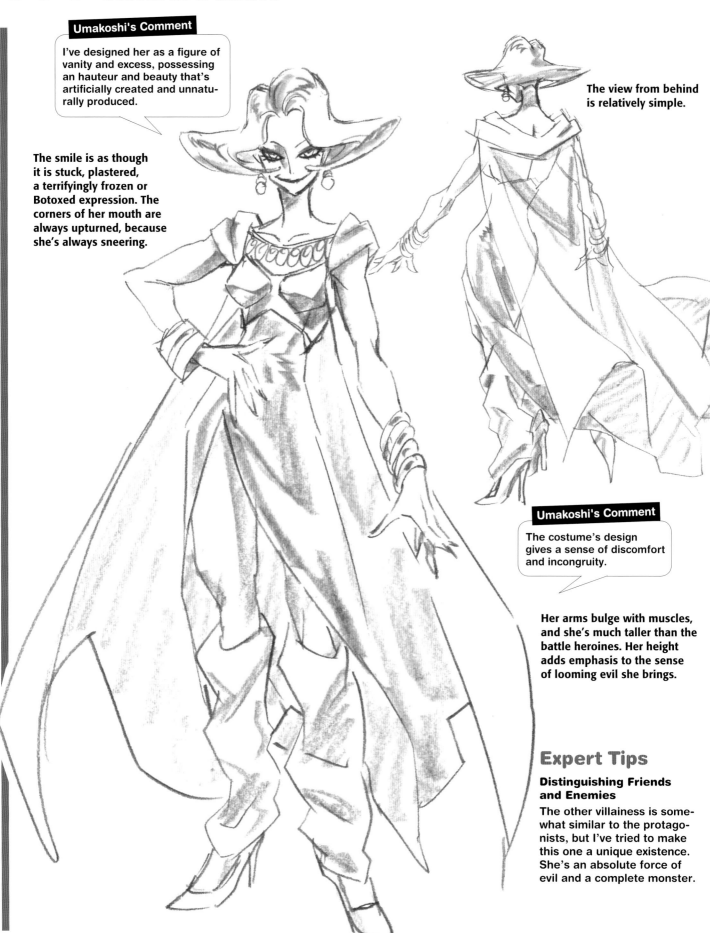

Umakoshi's Comment

The costume's design gives a sense of discomfort and incongruity.

Her arms bulge with muscles, and she's much taller than the battle heroines. Her height adds emphasis to the sense of looming evil she brings.

Expert Tips

Distinguishing Friends and Enemies

The other villainess is somewhat similar to the protagonists, but I've tried to make this one a unique existence. She's an absolute force of evil and a complete monster.

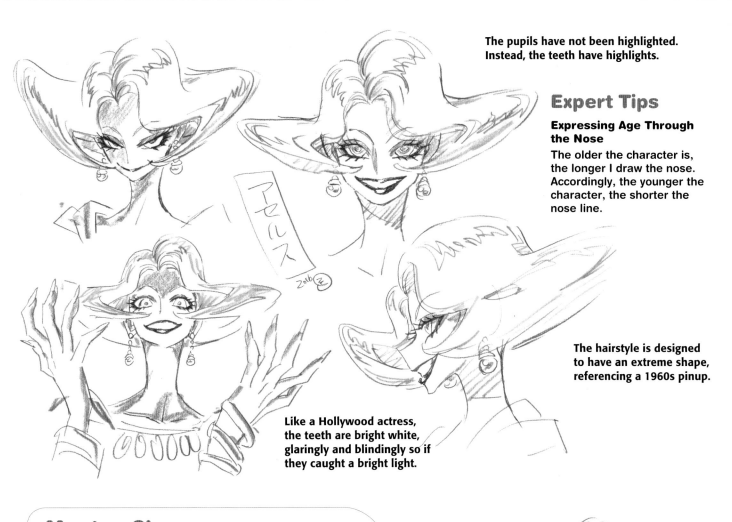

The pupils have not been highlighted. Instead, the teeth have highlights.

Expert Tips

Expressing Age Through the Nose

The older the character is, the longer I draw the nose. Accordingly, the younger the character, the shorter the nose line.

The hairstyle is designed to have an extreme shape, referencing a 1960s pinup.

Like a Hollywood actress, the teeth are bright white, glaringly and blindingly so if they caught a bright light.

Master Class

Roughing Out the Idea

In these sketches, I tried to emphasize the cheekbones by adding wrinkles when the corners of the mouth are raised, but I realized the effect didn't look good, so I decided to abandon the notion.

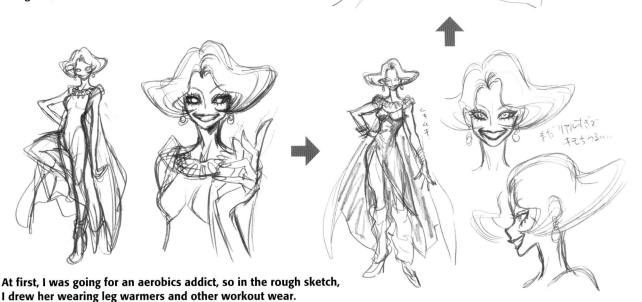

At first, I was going for an aerobics addict, so in the rough sketch, I drew her wearing leg warmers and other workout wear.

Veritable Villains

There are several points to keep in mind when drawing villainous characters. Here are some examples of villains, original to this book, that introduce various design techniques.

Comic Villains

Villains don't necessarily all have frightening faces. Even comical characters such as Sucrose can be effective villains. In fact, it's probably scarier for the audience if the character's comical appearance and tone mask a deep propensity for evil.

Strange Villains

For more traditionally villainous characters, there's something extreme or alien that sticks out about them. For characters such as Stevia or Aspar and Tame, who also possess beautiful or cute qualities, the impact lies in the fact that they are actually unbelievably evil people at heart.

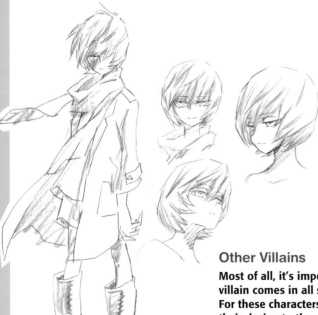

Other Villains

Most of all, it's important to remember that a villain comes in all shapes, sizes and disguises. For these characters, it is necessary to match their design to the story, more so than the typical breed of supervillains.

Part 2
Character
007 Sweet-n-Low

A young Chemload girl and minion of Stevia. In contrast to her, she has relatively little facial expression. At first, she follows her mentor blindly, but after meeting Martial Mandarin, she begins to develop human emotions.

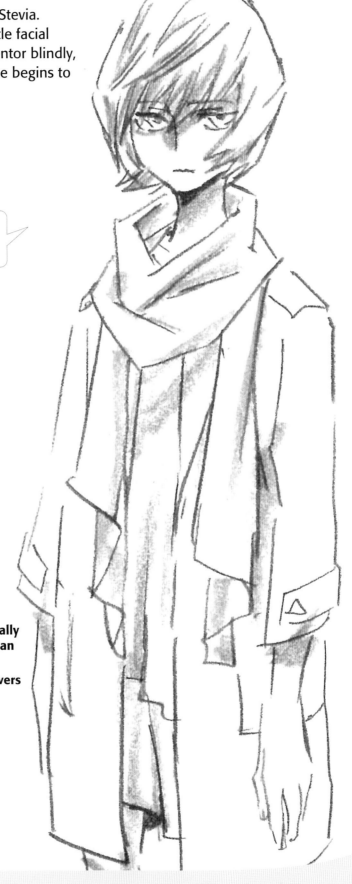

Starting Point

Make her a neutral villain, caught in the middle, conflicted by her divided and transitioning allegiances.

Umakoshi's Inspiration

I've made her neutral and some-what androgynous. I designed her in complete contrast to the beauty-obsessed Stevia.

Name:
Sweet-n-Low

Character Data:

Motif: **Artificial sweetener**

Age/gender: **17 years old/female**

Personality: **Initially ruthless and emotionally mechanical, she comes to embrace human attributes.**

Feature: **As a newly human being, she wavers between her emotions and her mission.**

Skill: **She can manipulate people's minds through the power of scent.**

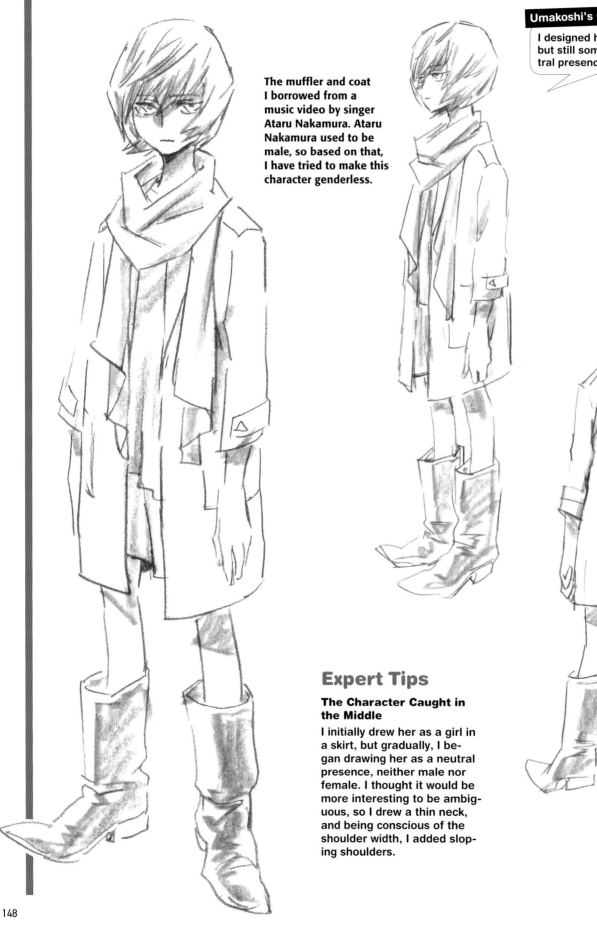

The muffler and coat I borrowed from a music video by singer Ataru Nakamura. Ataru Nakamura used to be male, so based on that, I have tried to make this character genderless.

Umakoshi's Comment

I designed her as a cool but still somewhat neutral presence.

Expert Tips

The Character Caught in the Middle

I initially drew her as a girl in a skirt, but gradually, I began drawing her as a neutral presence, neither male nor female. I thought it would be more interesting to be ambiguous, so I drew a thin neck, and being conscious of the shoulder width, I added sloping shoulders.

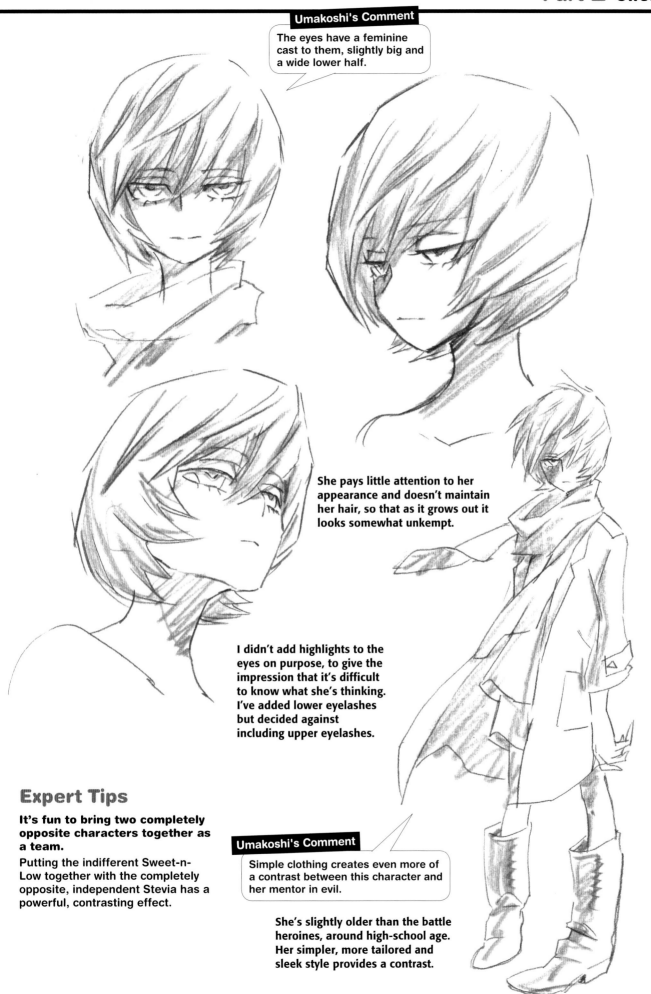

She pays little attention to her appearance and doesn't maintain her hair, so that as it grows out it looks somewhat unkempt.

I didn't add highlights to the eyes on purpose, to give the impression that it's difficult to know what she's thinking. I've added lower eyelashes but decided against including upper eyelashes.

Expert Tips

It's fun to bring two completely opposite characters together as a team.

Putting the indifferent Sweet-n-Low together with the completely opposite, independent Stevia has a powerful, contrasting effect.

She's slightly older than the battle heroines, around high-school age. Her simpler, more tailored and sleek style provides a contrast.

Expert Advice

Designing a Neutral Character

Neutral, caught between the forces of good and evil, does not translate here to a girl simply dressed as a boy. She's a character with girlish features but wearing boyish clothing, a design approach that also makes her look young.

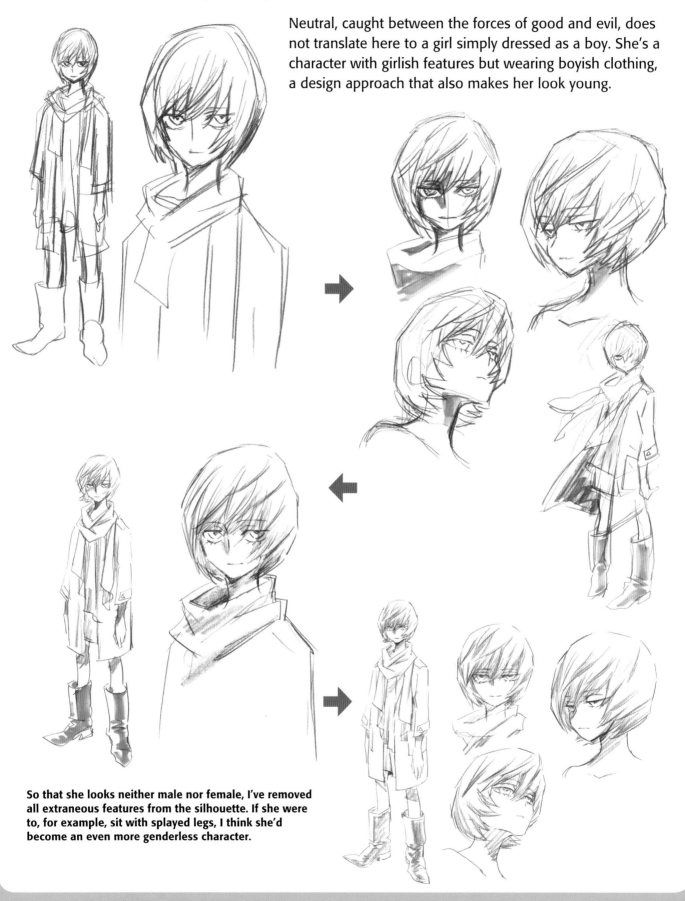

So that she looks neither male nor female, I've removed all extraneous features from the silhouette. If she were to, for example, sit with splayed legs, I think she'd become an even more genderless character.

Theme

Date · · ()

Illustration Meets Animation

Here we move beyond the world of character design and offer a glimpse into copyrighted illustrations and image boards, as well as how to manage action scenes when creating animations.

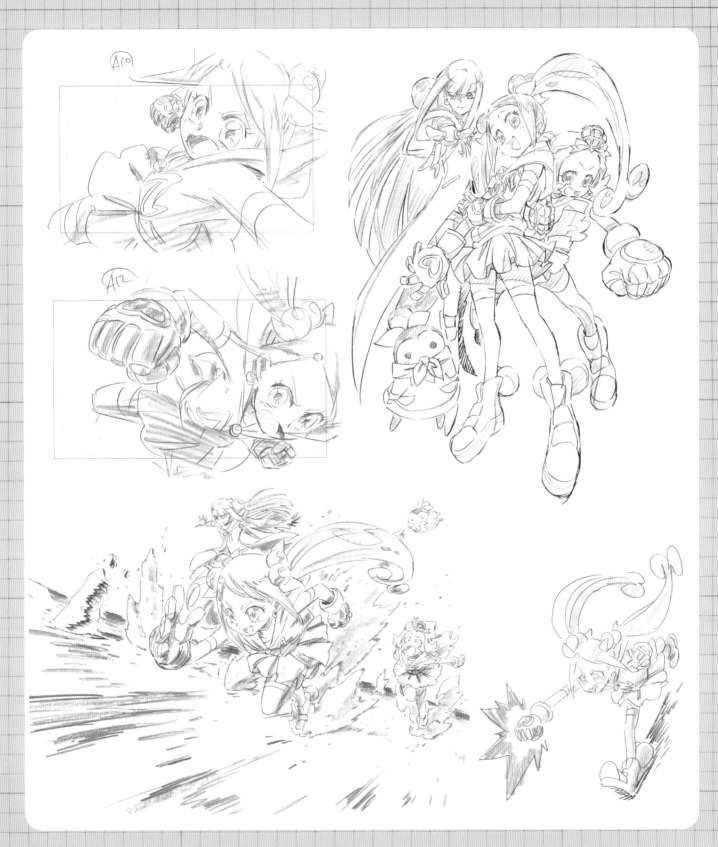

Image Boards

For original works and to give colleagues a sense of the world and sensibility I'm creating, I draw an image board as if it is a still showing a backdrop from the main story. The backdrop is key as it sets the scene and signals the style and setting. Image boards can also be used to promote your project and sell your skills.

An Everyday Scene of the Three Main Characters

This image board captures the three protagonists' everyday lives and relationships. Martial Mandarin and Pure Mango are always loud and chatty, while Mighty Melon is more reserved, always watching from a distance. The street in the rough version was too wide for an alley, so I started over and made a clean copy.

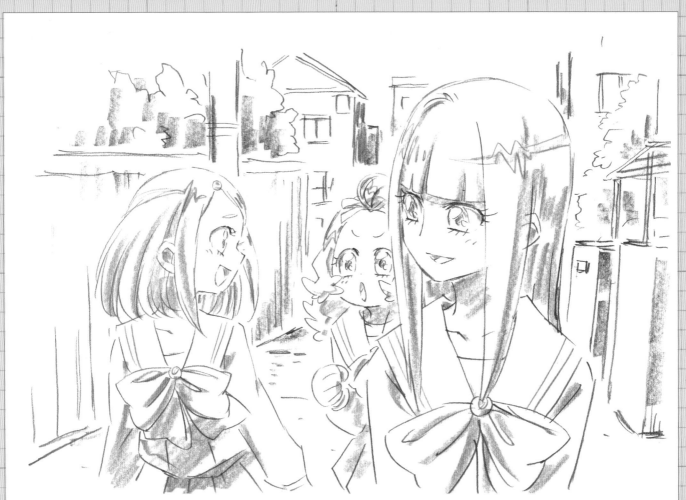

Theme

Date · · ()

An Everyday Scene of the Three Main Characters in the Classroom

As the battle heroines are students, the classroom is an important element and the main setting of the story. Notice I've added classmates and other unidentified characters to the background.

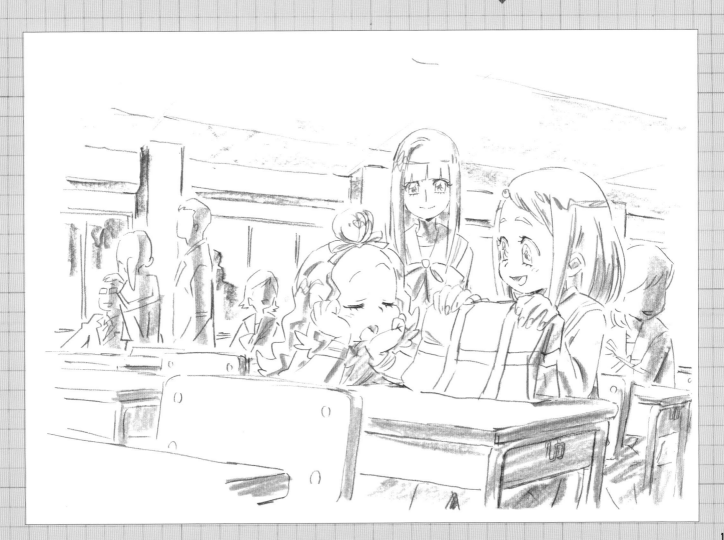

Image Boards

Theme

Date . . ()

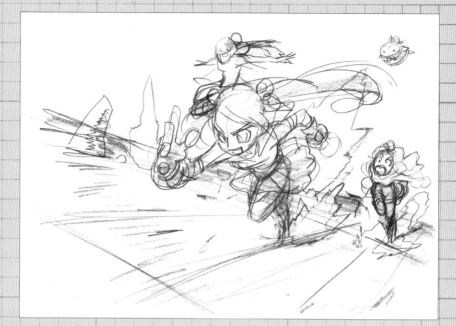

A Dash with Determination

The effect captured here suggests running across a shallow pool of water. If it's a key visual, I usually draw the characters so they can all be prominently seen, but sometimes I think it can be interesting to pursue this kind of composition with multiple perspectives.

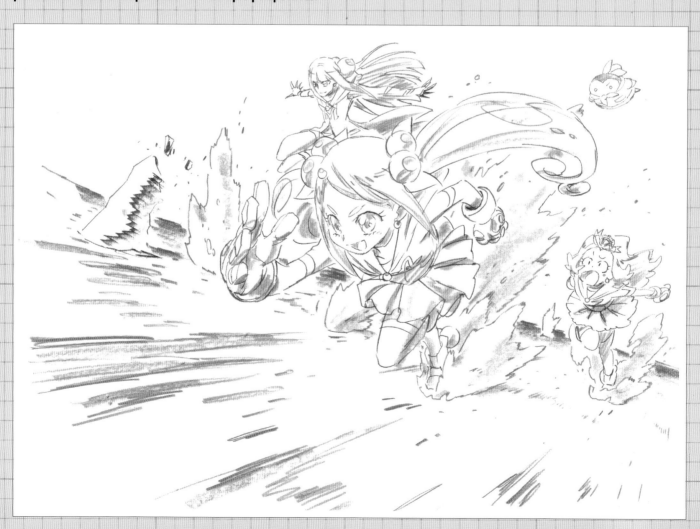

Theme

Date . . ()

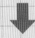

Hiding from the Enemy

This scene comes near the end, where the enemy gains strength to the point that the battle heroines have to escape and hide, chased and ruthlessly pursued as if they are falsely accused criminals. I have given all of them hoods like in an American comic.

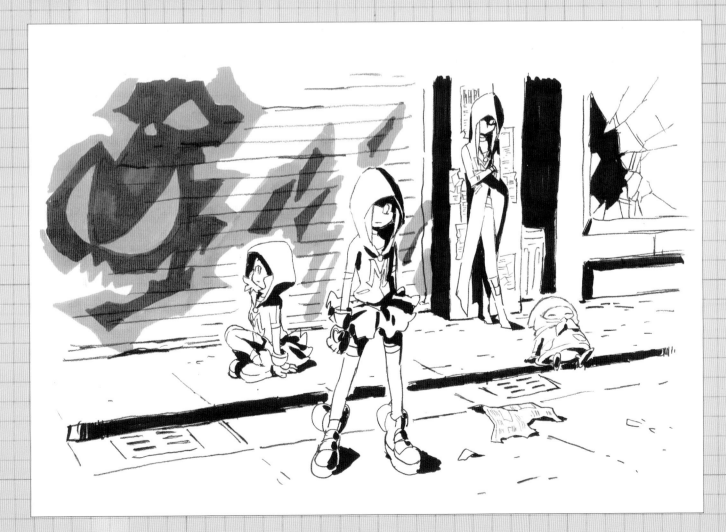

Theme

Date　　　　・　　　・　　　（　　）

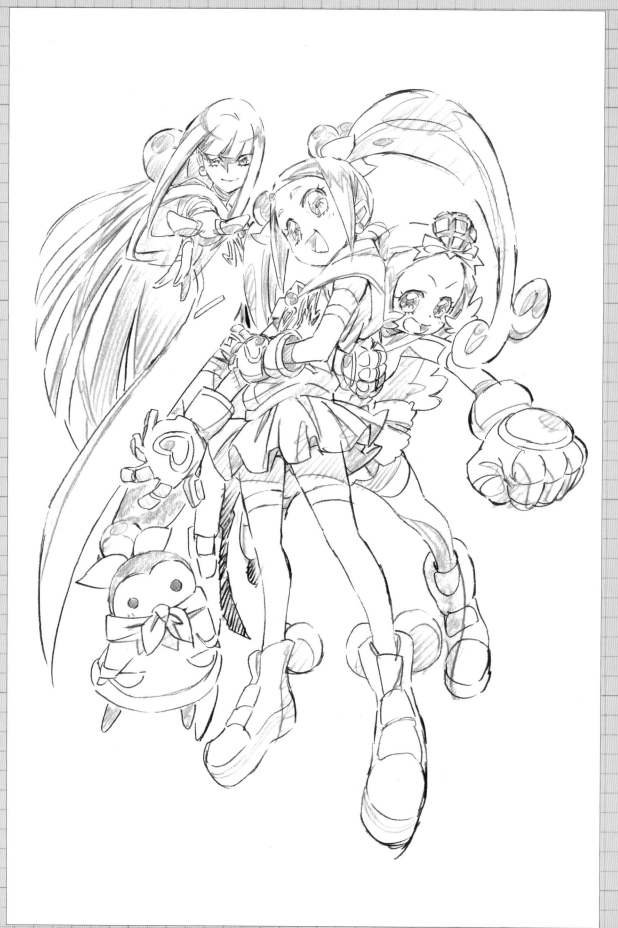

Theme

Date　　·　　·　　（　　）

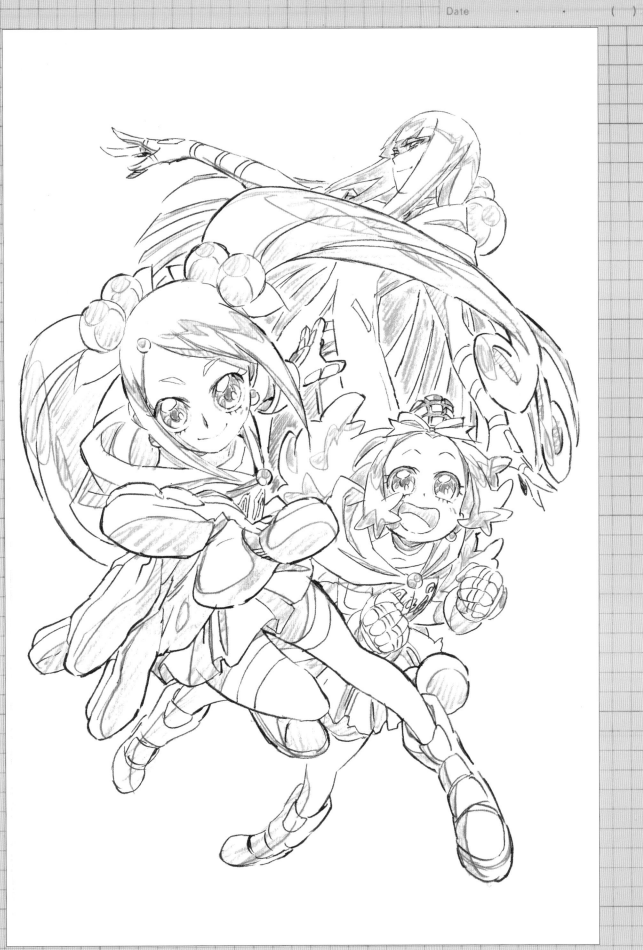

Copyright Illustrations

A single picture that captures the spirit and essence of the work, whether it's a key scene, an advertising poster, an illustration for a print or online publication or any illustration that is for anything other than broadcasting is called a copyright illustration. Here, I have used characters from Pure Princess to create two copyright illustrations, one a key visual or still and the other presented in poster format.

Theme

Date . . ()

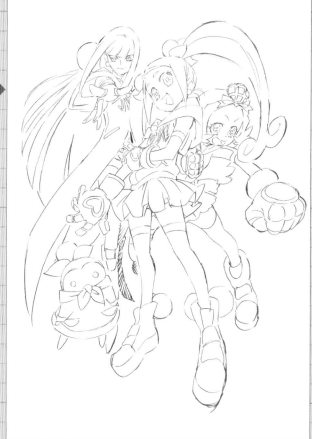

If it's a key visual of a work, all of the characters must be featured. I've drawn this one so that the bodies are easily seen vertically. While thinking about where the title and other elements will be placed afterward, I reconfigure the positioning. In reality, it is better to show more of the costumes and design details than I did here.

Theme

Date . . ()

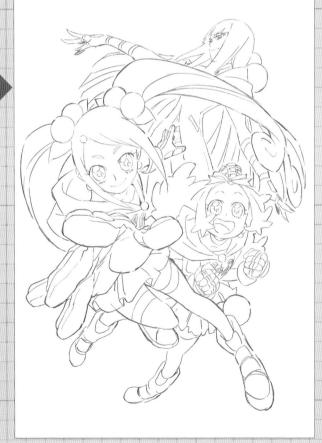

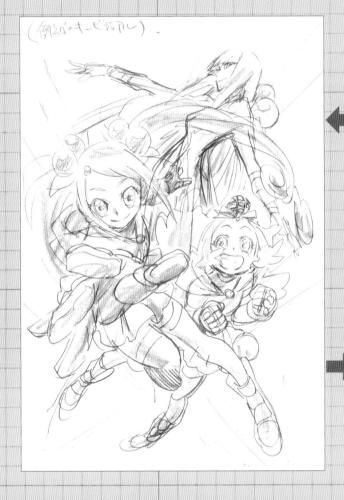

This is supposed to be a poster. I like to emphasize the gap or distance between the foreground and background. So that it looks as though the foreground is jumping out at the viewer, I've brought the character's hand to the front. In key visuals, I make sure the eyes are facing forward. Never have their hands folded behind their backs or have one hand concealed behind them.

Concept Art

Concept art shows the world you're creating or highlights characters' personalities and features. Here, I've tried to feature the characters' fighting and action styles: Martial Mandarin is skilled at punching, Mighty Melon is good at footwork, and Pure Mango defends with a giant glove.

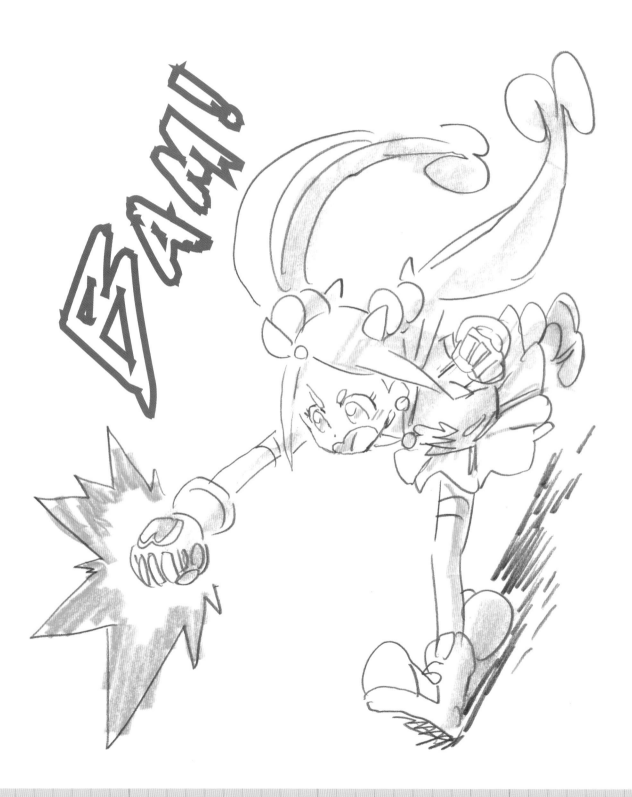

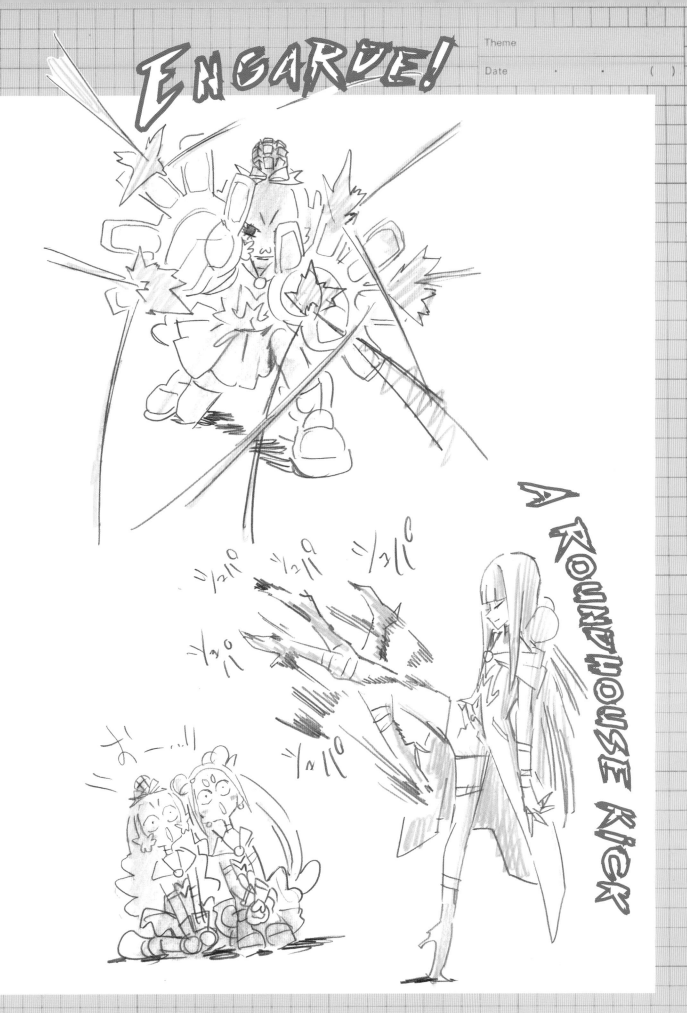

Drawing an Action Sequence

When you think about it, there are countless ways and directions your characters can move. Their action poses and positions are limitless. Here I show you how my own characters would actually look if they moved.

First (in frames 1 and 2), I've concealed Martial Mandarin's face. By doing this, in frames 3 to 7, I'm able to dynamically capture the process of her removing her hood so her face is revealed. After that, in frames 6 and 7, the villain moves to the left from her original position, and for the first time Martial Mandarin's full form is revealed. Here, I've drawn her performing a relatively routine action sequence: dodge, jump and punch! A character's strength can be shown by slowing the attacker's movements or distorting the character to create a sense of speed. It's a good idea to come up with many different ideas and then go with the strongest.

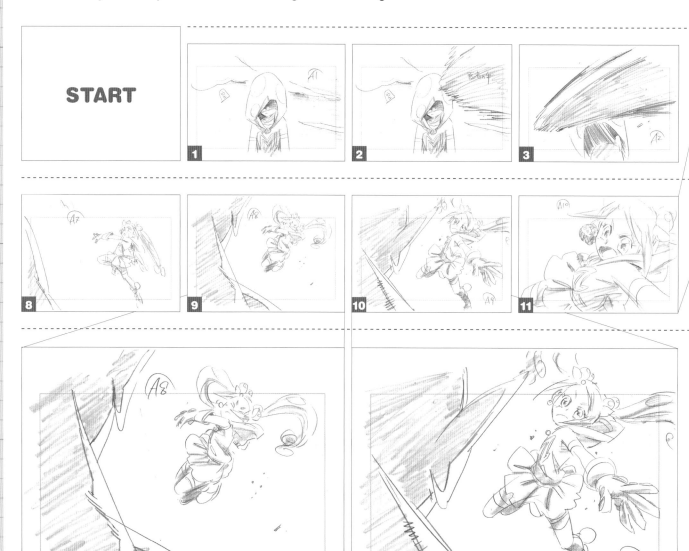

In frames 8 and 9, I've shown her summoning her strength while jumping. Here, her kicking leg and other leg are compactly crossed to compress the character's size. By doing this, it's possible to suggest a much bigger arc to the movement.

Looking at the enemy and taking a swing: as she's falling, depending on the camera angle, it makes her look bigger. By spreading the body, in comparison to the size of the character in frame 9, you can also show a powerful, well-defined movement.

Theme

Date · · ()

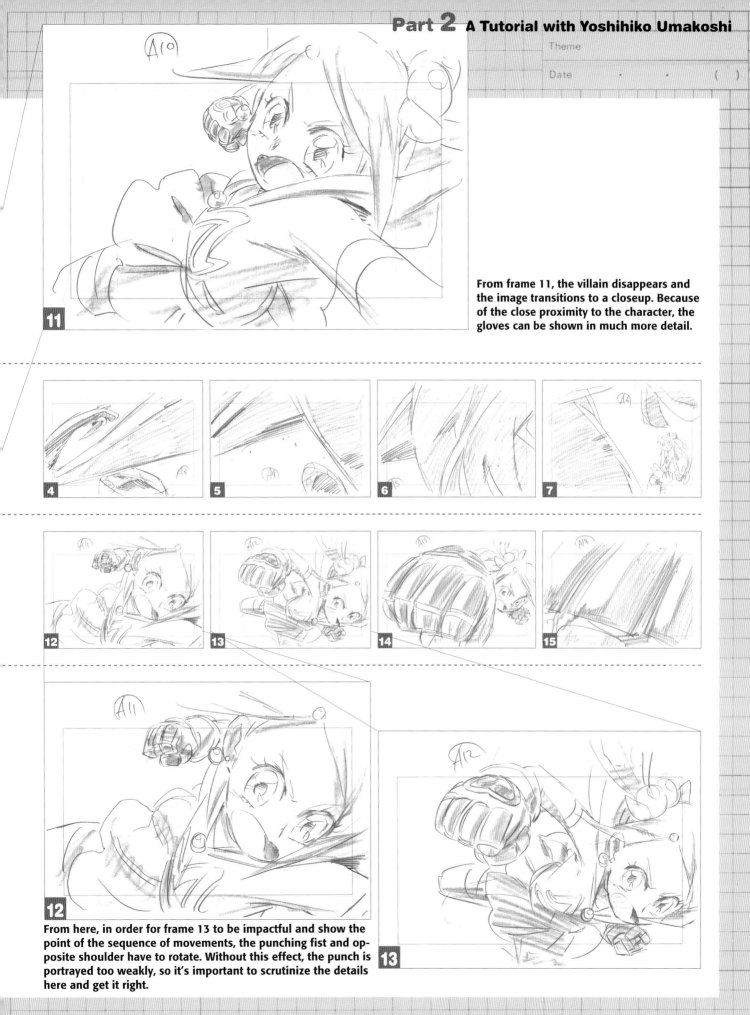

From frame 11, the villain disappears and the image transitions to a closeup. Because of the close proximity to the character, the gloves can be shown in much more detail.

From here, in order for frame 13 to be impactful and show the point of the sequence of movements, the punching fist and opposite shoulder have to rotate. Without this effect, the punch is portrayed too weakly, so it's important to scrutinize the details here and get it right.

Expert Advice

Women's Hand Gestures

The trick is to get rid of the lines that define the joints and bones, and instead add a line at a single point.

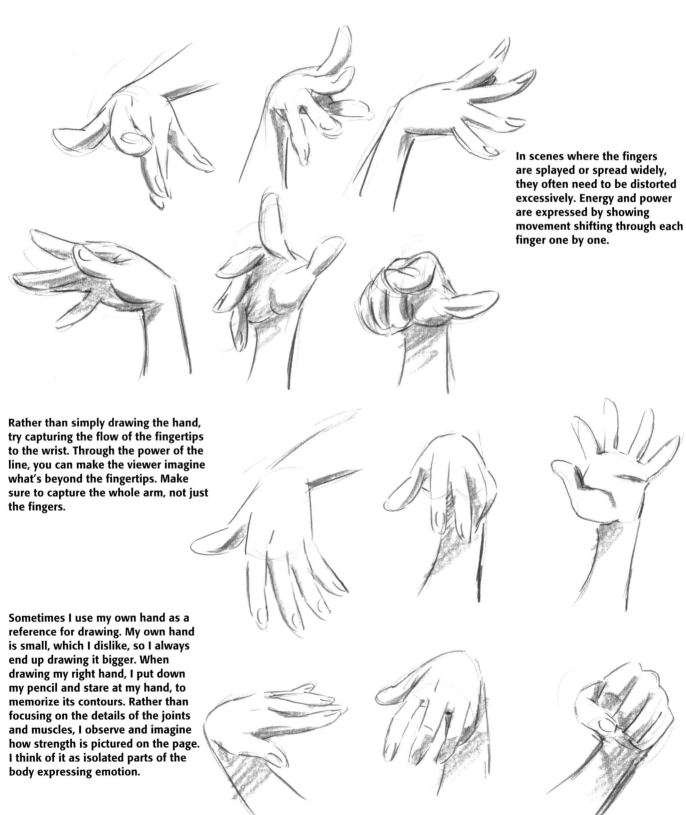

In scenes where the fingers are splayed or spread widely, they often need to be distorted excessively. Energy and power are expressed by showing movement shifting through each finger one by one.

Rather than simply drawing the hand, try capturing the flow of the fingertips to the wrist. Through the power of the line, you can make the viewer imagine what's beyond the fingertips. Make sure to capture the whole arm, not just the fingers.

Sometimes I use my own hand as a reference for drawing. My own hand is small, which I dislike, so I always end up drawing it bigger. When drawing my right hand, I put down my pencil and stare at my hand, to memorize its contours. Rather than focusing on the details of the joints and muscles, I observe and imagine how strength is pictured on the page. I think of it as isolated parts of the body expressing emotion.

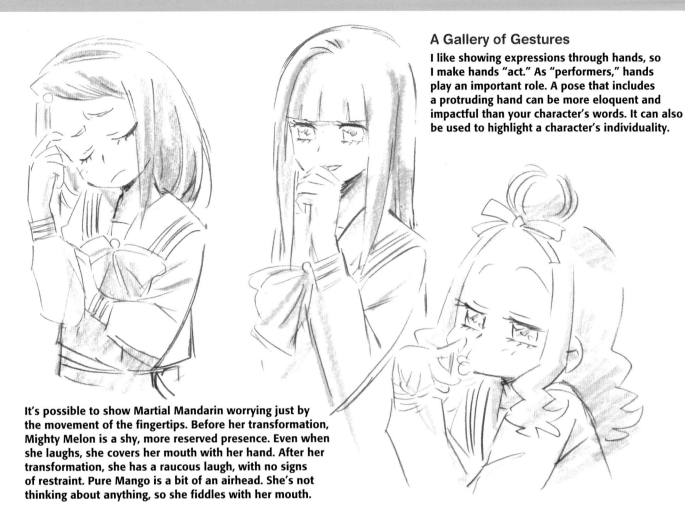

A Gallery of Gestures

I like showing expressions through hands, so I make hands "act." As "performers," hands play an important role. A pose that includes a protruding hand can be more eloquent and impactful than your character's words. It can also be used to highlight a character's individuality.

It's possible to show Martial Mandarin worrying just by the movement of the fingertips. Before her transformation, Mighty Melon is a shy, more reserved presence. Even when she laughs, she covers her mouth with her hand. After her transformation, she has a raucous laugh, with no signs of restraint. Pure Mango is a bit of an airhead. She's not thinking about anything, so she fiddles with her mouth.

Variations

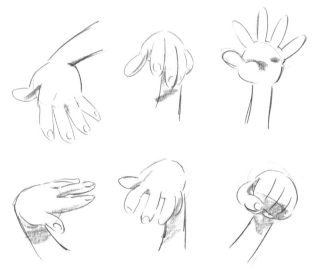

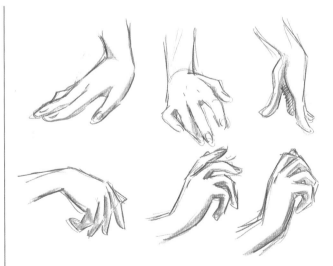

Even More Distorted Versions

By adding roundness, the form becomes softer and more feminine. In a comical scene, it's O.K. for limbs to become limp like noodles or to waft in the breeze. It's a technique that I learned from "Magical Doremi" director Junichi Sato and is designed so that anyone, even children, can draw it.

Realistic Versions

To draw realistic versions, it's necessary to be conscious of the joints. Even in the worldview of this original story, I don't go as far as drawing the knuckles, but I draw realistically to an extent for the male characters. Although it's not included in this example, in the case of the elderly— grandpas and grandmas—I do add knuckles in order to show their wrinkles.

INTERVIEW WITH YOSHIHIKO UMAKOSHI

Inspired by Yoshikazu Yasuhiko, which started him on the road to becoming an animator. Yoshihiko Umakoshi talks with a smile about how even as a new young professional "it was fun." But exactly how did he improve his skills? Let's learn some of his secrets.

Learning Animation as a Young Professional

—Please tell us about the first work that you were in charge of.

The *Saint Seiya*: *Knights of the Zodiac* Nordic Asgard compilation was the first. Copies of Shingo Araki's original pictures would come around, and it was my job to make them into a video. At the time, I didn't know about the most basic of basic technologies known as tapping (a tool that creates splits with reference to the overlapping position of the tapped holes of two pieces of paper), so I used to draw by slowly shifting each paper (lol). But that's not to say that I wasn't taught anything by anyone. For example, the character creator of *Mobile Suit Gundam Thunderbolt*, Hirotoshi Takaya, was the first to guide me in creating video. I was somehow blessed with a great mentor. When I went to Junichi Hayama's studio, when I was promoted to creating original motion pictures, I was mentored by the co-author of this book, Mr. Kagawa. It was only a few years, but I was very lucky. It was a lot later that I worked directly with Mr. Hayam. I was too late for *Fist of the North Star*, but I was able to do the video for the game's commercial.

—Can you tell us about the first original picture that you were in charge of?

Around this time I did the original video animation (OVA) for *Kyatto Ninden Teyandee* and a manga called *Maji!*. It was very difficult but at that time, I had no idea how to draw the layout or anything.

Muscly Men Are the Easiest Characters to Draw

—Which is easier to draw: male or female characters?

Male characters. It might be from Mr. Hayama's influence, but it feels good to draw muscles. They're fun to draw and to show that muscly characters are strong, but being completely one-note is boring. In fact, quite often the really muscly characters aren't actually all that strong.

--When talking about your work, what comes to mind is Pretty Cure and Magical Doremi.

In my own opinion, I'm not so good at female characters. It might come as a surprise to younger audiences who know me for *Pretty Cure* and *Magical Doremi*, but when I did *Marmalade Boy*, it was a real ordeal. The kind of good looking guys in Mr. Araki's *Saint Seiya: Knights of the Zodiac*, tend to be in the category that I find difficult, but getting used to it was a big advantage. Come to think of it now, the fact that it was the same people drawing *Magical Doremi*, *Saint Seiya: Knights of the Zodiac* and *Dangard Ace* is pretty amazing.

—Please tell us about the animators and writers that inspired you.

Yoshikazu Yasuhiko, Mr. Hayama, Mr Araki. Mr Hayama is someone who's always there, a special person (lol). I was also strongly influenced by the chiefs at Sunrise Inc. and Osamu Dezaki's work. So to speak, you could say that my generation was under the spell of the works of Yushiyuki Tomino!

—I heard that you become an animator after being inspired by Mr. Yasuhiko, but were you involved in robot-related works such as Gundam?

I like it and wanted to be a part of it, but when I actually did become involved, I realized, "this is too difficult!" and foremost, "this is impossible for me!" Automatons were drawn by professionals, so for me to mix with these people and draw them was difficult. When Hirotoshi Takaya was chief of *Brave Exkaiser*, I was able to do it, but I thought it was amazingly difficult. You wouldn't think *Mobile Suit Gundam Unicorn* was drawn by humans, there are so many lines!

From the Onset, It Was More Fun Than Hard Work

—Tell us about a time you struggled as an animator.

To be honest, I've never thought of it as hard work. When I was a newbie, I didn't sleep much and even when I wanted to sleep, sometimes I couldn't; but I don't remember struggling. It was fun even from the time I was doing videos! I fondly remember being scolded for taking on more pages than I could possibly complete (lol). I was in video for around a year and a half, I began to worry when I started on original miotion pictures. I can't say that I was immediately able to draw, but when doing video, there was a huge number of pages to get through. But I think the biggest factor was that I knew what I wanted to do. After seeing *Fist of the North Star*, I thought, "that's the kind of thing I want to draw," and they let me. I was also allowed to help with Masami Obari's *Metal Armor Dragonar*. Being able to be a part of animations that I liked was a big factor.

—How did you practice?

When I was younger, I practiced a lot. The first step is to copy pictures that you like. Up until now, all I have done is replicate pictures that I like. It's strange, but in fact I dearly wanted to keep the drawing by Mr. Hayama that's in the studio. But of course, it would be unacceptable to photocopy it. So I secretly traced it and took that home (lol). If I look back on it now, in terms of results, that was very good practice.

—When drawing a picture, in what sort of environment is it easiest to draw?

I draw while listening to music, listening to the radio or watching a movie. There's always sound. Whether I'm concentrating or not, I'm always listening to music. It's great to think I get to earn money just by drawing while listening to my favorite music (lol). I like listening to soundtracks. Not because there aren't vocals, I like the idea of being uplifted when listening. Also, if the timing works, I ask for the demo tape of the work and I like to listen to that too.

What to Do If You're an Aspiring Animator

—To expand one's repertoire, what should one do?

Watch lots of movies and animations. Because everything you see accumulates. I would recommend watching live-action closely, although it can be tiresome to watch something that you feel you have to watch. Whether it's animation or not, copying an image that you like is important. There are many people who spend their whole lives aspiring but aren't successful: technique, drawing, anatomy, there are too many skills to try to cover! So it's O.K. to have your own strengths and weaknesses. After all, drawing is something that every child does. Animation is just people making that drawing into work. So what really matters is how much you drew as a child, or when you were younger. But I think it's also possible to become an average animator part way through. If you take away the geniuses, there's a huge skill gap within those who specialize in this. It's unavoidable to have different strengths and weaknesses depending on the genre, and everyone has his or her own preferences, which I think is important. Also, I hope that everyone enjoys themselves as much as possible.

—What are you thankful for in being part of the animation world?

It's fun to make pictures move. I think that is fundamental to the animator. "I managed to make it move the way I wanted it to!" "I've managed to make it move like the piece I like so much!" These things make me happy. And when I watch a work that I helped on, and think, "that was interesting!" then I am even more satisfied. Also, depending on the way you look at it, I think in some ways, an animator is like an actor. I'm not a good-looking guy or girl, but if I depend on the characters that I draw, I can become anything I want!

—Have you ever watched a movie and thought, "I can use this?"

Yes. I personally like to watch action movies, so there aren't many instances where I can use something, but there's a lot of material that can be borrowed to use in a roundhouse kick. I'd like to do an action piece that features *bojutsu* or a wet cloth turned into a weapon like Jet Li's in *Once Upon a Time in China*. I always think about adding them.

—What inspires you when designing a costume?

I can't think of anything specific, but, for example, in this case, I used the idea of food. And I think American comics and movies also have a big impact. I only pick works that I like the design of and then read them fervently.

—What sort of work do you want to do in the future?

After all, I'd like to do an original animation. I vaguely have an idea of what I want to do. Partly because there's so much out there, but when I think about what I want to do, I'm uncertain. I don't mean to turn my back on the things I've worked on so far, but as there's a manual side to it, there's a part of me that would like to try something new. If I put it bluntly, if I am told to do it in "Umakoshi style," I'm of course very happy and I'm happy to put my back into it. On the other hand, if I'm asked to do something completely different, it might be difficult to do it. In that sense, maybe it's better to draw something that isn't manually laborious. When working as an animator, there are always places that don't give priority to the animator's "comfort level." I do feel a conflict regarding my work being criticized and being told to correct it, but I just tell myself that it's "that kind of work" and try not to get stressed. Of course, if all places were like that it would be awful. That's why while always trying to keep my own originality in my drawings, I try to match the constraints of the real world. After all, it's not possible to continue doing things that aren't fun and comfortable to do. Also, when I was younger, I was able to absorb information from the mentors and the outside world, but as I gained experience, there are parts of me that have become stubborn. It's difficult to adjust.

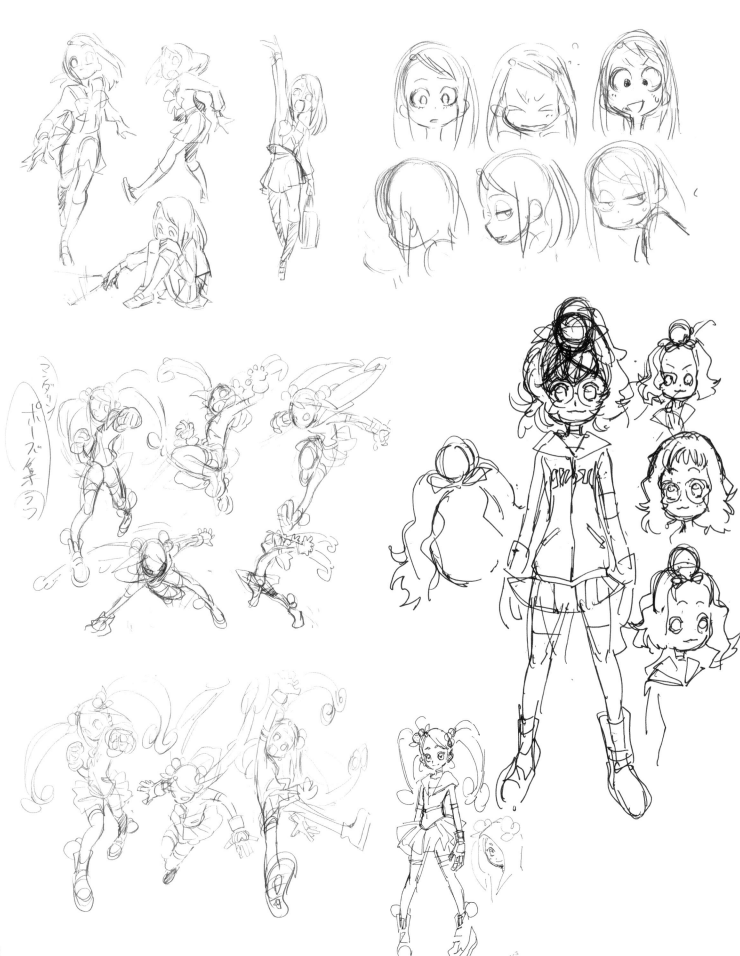

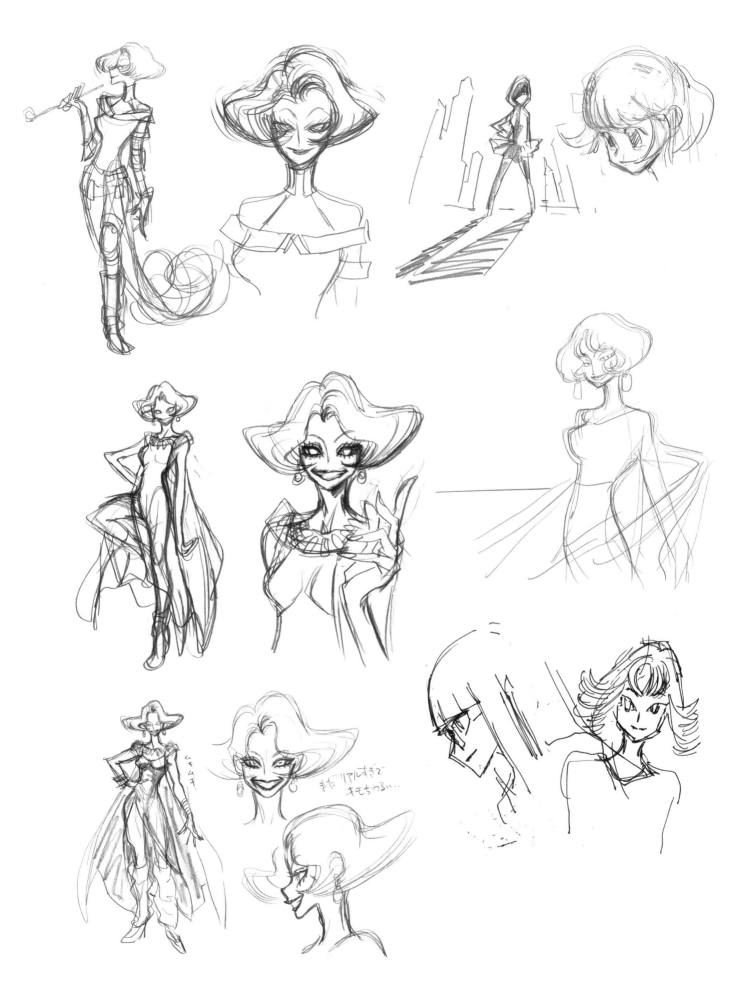

まだリアルすぎて
キモちわるい…

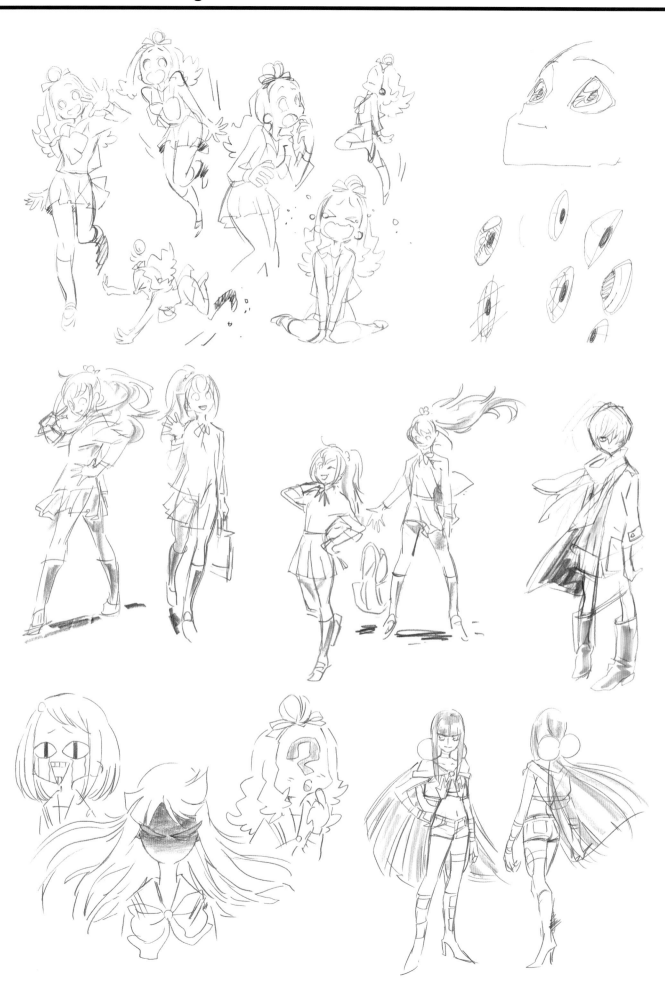

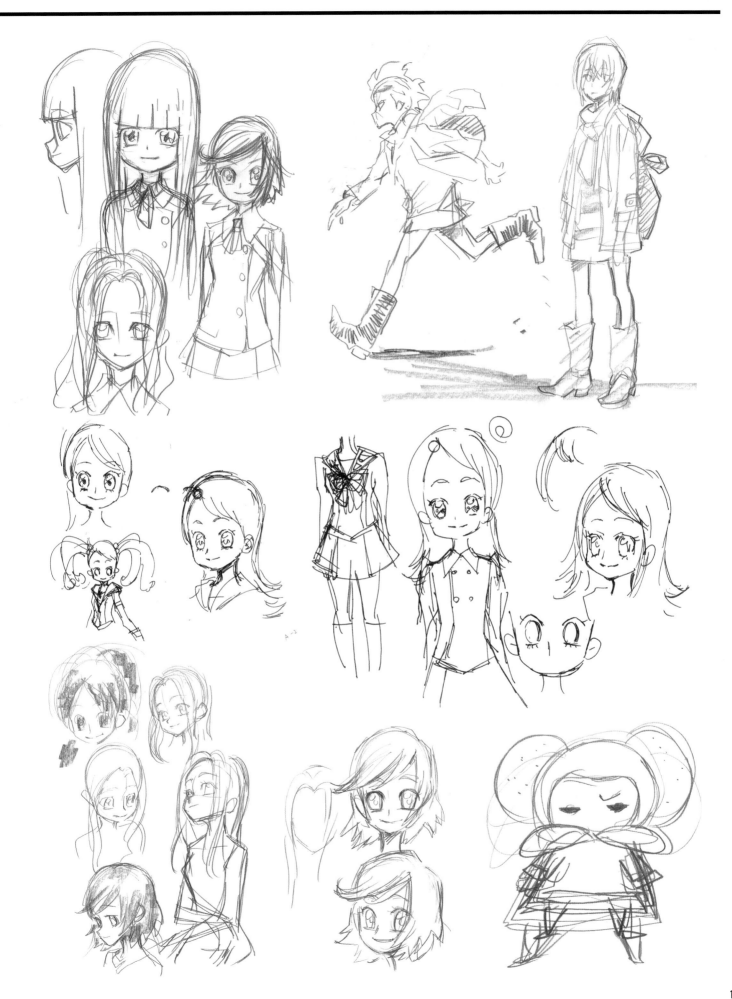

Hisashi Kagawa's Studio

I've been using this home workspace for around 10 years. As I used Toei Studios for my animation director work, I use this space for developing original works and other creative activities. It's an attic-like room where I can reach everything by hand and I can keep all kinds of things. My drawing desk is the one that I used at the studio by Sankisha, I bought it 10 years ago and have been using it since then. I use an old Mac Mini and a graphics tablet to add color, and sometimes I share on Twitter. Right next to me, I have a bed so that I can sleep whenever. It is like a mancave.

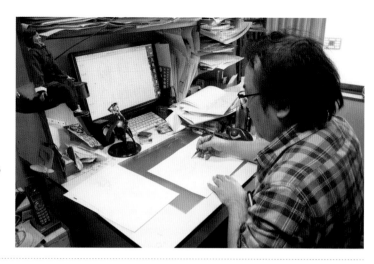

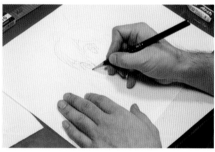

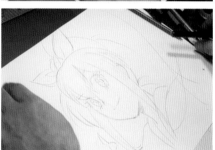

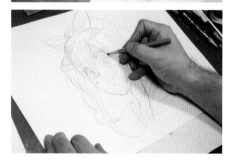

Pencils
I use the standard Mitsubishi B pencil. When the pencils get too short, I use instant adhesive to stick them together but it becomes unusable very quickly, so I use a pencil auxiliary axis.

Colored Pencils
I use the hard-core Mitsubishi Hard Lead Colored Pencils to show shadows. In contrast to ordinary colored pencils, these are hexagonal so they don't roll down the slope of the drawing desk.

Eraser
I recently found this Sakura Color Products Corporation eraser called "Arch." It's made of a hard material so it's easy to erase and easy to use.

Tap
I got this one from the studio, and I'm also using a standard one. When I move the paper, it's easy to use.

Brush
To wipe away erasures and so on, I use this drafting brush. When I entered vocational school, this was part of the complete set of tools. I've been using it now for over 30 years.

Original Eraser
Instead of an eraser, I use the tap holes of original picture paper. I use the horizontal holes and circular holes for different things. I have a tendency to lose erasers, but with these, that's not a concern!

Stopwatch
This stopwatch is one that I bought 25 years ago when I went from being a video person to an original motion picture person. Recently, I've started using the WariKen app that times to 1/24th of a second.

When I became the head of motion pictures, as a commemoration, Junichi Hayama tied string for me.

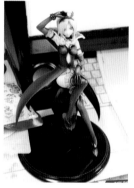

The Jackie Chan figures are a birthday present from around 20 years ago. I'm a fan of Shogo Hamada so I have a truck that I bought at a concert, and the control and radio of an "Ele Kata" (a Elecomi and Jin Katagiri duo), which are comforting.

Yoshihiko Umakoshi's Studio

Umakoshi's "Sea Breeze Studio" can be found in a Showa era house in a residential area. For the past six years, he's been sharing it with nine freelance animators. The name "Sea Breeze Studio" comes from animator Terumi Nishii, who shares the place and named it after the product Umakoshi's hometown is known for, Hakata Salt. Around his desk there are many figurines. He says, "I can't do it without the figurines. When I hit a mental block, they provide support. I buy them as documents." On other shelves, there are all kinds of hobby- and work-related things, such as American comics and DVDs.

The reason why I have a desk mat on top of my lightbox is to reduce the sound of the pencil touching the surface and to soften the writing pressure. I also add paper to soften the light filtering through. I borrowed this technique from the master Junichi Hayama.

Pencils
I don't have a preference, I just use the standard pencils that the staff buy. Recently, I use 3B-4B pencils. I prefer dark, soft lead pencils.

Eraser
I don't have a particular preference for the maker, I just use what the purchasing staff buys in bulk.

Feather Duster
I've been using this feather duster for around 15 years. Originally, the feather part was longer but over time, the feathers have worn away and become shorter. I don't mind!

Tap
This is the black type that was sold at Tokyo Designer Gakuin College. I've been using it for over 20 years so the black paint is beginning to peel.

Pencil Sharpener
I'm using an electric pencil sharpener by a maker called Debika. It allows you to sharpen to the end of the lead, so it's a recommended product for animators. I started using this around six months ago.

Bulldog Clip
A surprisingly well-used bulldog clip. I use it when shifting and fixing the drawing paper, to hold a stack of sheets between the ruler, or to hold together a stack of sheets.

Around his desk are numerous figurines from films and animations. Cobra is a muscular model which he liked so he bought it as a reference. The Coppesama from "HeartCatch PreCure!" is handmade by a fan.

from **Hisashi Kagawa**

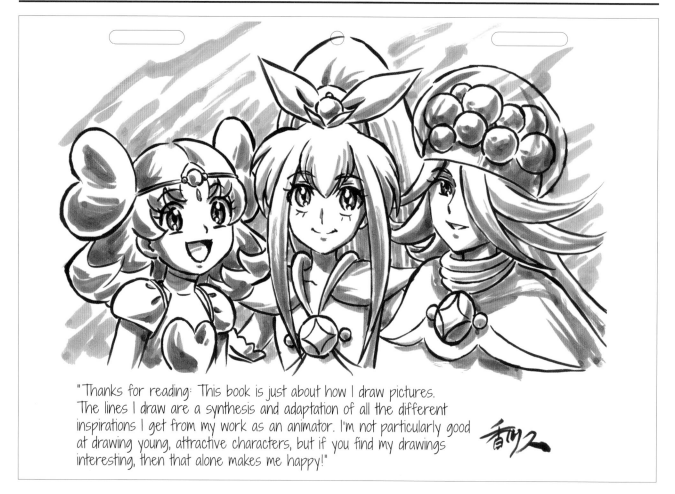

"Thanks for reading: This book is just about how I draw pictures. The lines I draw are a synthesis and adaptation of all the different inspirations I get from my work as an animator. I'm not particularly good at drawing young, attractive characters, but if you find my drawings interesting, then that alone makes me happy!"

Profile

After graduating from Osaka College of Art and Design, he joined Mush Onion Production, moving on to Studio Cockpit where he became animation director and head of character design for *Sailor Moon, Revolutionary Girl Utena, Fresh Pretty Cure!* and *Soul Eater*. Recently, he has been working on a wide range of things, including the character design for *Tiger Mask W*.

Sailor Moon Series (1992-1995, Animation Director)

Phantom Thief Jeanne (1999, Character Design, Animation Director)

Pokemon Three: The Movie (2000, Character Design, Animation Director)

Bomberman Jetters (2002-2003, Character Design, Animation Director)

Initial D Fourth Stage (2004, Animation Director, Original Picture)

Fist of the North Star: New Saviour Legend (2006, Character Design)

Soul Eater (2008, Animation Director)

Fresh Pretty Cure! (2009-2010, Character Design, Animation Director)

Toriko (2011-2014, Character Design, Chief Animation Director, Animation Director, Original Picture)

Come Back! Shuriken Sentai Ninninger: Ninnin Girls vs. Boys FINAL WARS (2016, Original Picture for animation)

Tiger Mask W (2016, Character Design)

"Books to Span the East and West"

Tuttle Publishing was founded in 1832 in the small New England town of Rutland, Vermont (USA). Our core values remain as strong today as they were then—to publish best-in-class books which bring people together one page at a time. In 1948, we established a publishing office in Japan—and Tuttle is now a leader in publishing English-language books about the arts, languages and cultures of Asia. The world has become a much smaller place today and Asia's economic and cultural influence has grown. Yet the need for meaningful dialogue and information about this diverse region has never been greater. Over the past seven decades, Tuttle has published thousands of books on subjects ranging from martial arts and paper crafts to language learning and literature—and our talented authors, illustrators, designers and photographers have won many prestigious awards. We welcome you to explore the wealth of information available on Asia at **www.tuttlepublishing.com.**

Published by Tuttle Publishing, an imprint of Periplus Editions (HK) Ltd.

www.tuttlepublishing.com

ISBN 978-4-8053-1584-2

KAGAWA HISASHI X UMAKOSHI YOSHIHIKO BATTLE HEROINE DRAWING & DESIGN TECHNIQUE
© 2017 GENKOSHA Co., Ltd
© Hisashi Kagawa
© Yoshihiko Umakoshi
English translation rights arranged with GENKOSHA CO. through Japan UNI Agency, Inc., Tokyo

English Translation © 2020 Periplus Editions (HK) Ltd

ISBN 978-4-8053-1584-2

Staff (Original Japanese edition)
Planning & Editing + Art Direction & Design Kenji Segawa (Kiligraph)
Editing & Writing Coordination Crenter K.K.
Character Setting Coordination Takatoka Shioaji
Editor Toshimitsu Katsuyama, Yasuke Hirayama

Printed in China 2202EP

25 24 23 22 10 9 8 7 6 5 4 3 2

Distributed by:

North America, Latin America & Europe
Tuttle Publishing
364 Innovation Drive
North Clarendon
VT 05759-9436 U.S.A.
Tel: (802) 773-8930
Fax: (802) 773-6993
info@tuttlepublishing.com
www.tuttlepublishing.com

Japan
Tuttle Publishing
Yaekari Building 3rd Floor
5-4-12 Osaki Shinagawa-ku
Tokyo 141 0032
Tel: (81) 3 5437-0171
Fax: (81) 3 5437-0755
sales@tuttle.co.jp
www.tuttle.co.jp

Asia Pacific
Berkeley Books Pte. Ltd.
3 Kallang Sector, #04-01
Singapore 349278
Tel: (65) 6741-2178
Fax: (65) 6741-2179
inquiries@periplus.com.sg
www.tuttlepublishing.com

from **Yoshihiko Umakoshi**

"I hope I can help aspiring animators in some way. It's a lot of fun making pictures move. Mr. Kagawa, thank you for your hard work."

Profile

After graduating from Tokyo Animator Technical College, he joined Studio Cockpit where he directed original picture development for the first time with **Super Bikkuriman**. With the 1994 original video animation (OVA) **Baki the Grappler**, he was the head of character design for the first time. With **HeartCatch PreCure!**, he received the 10th Tokyo Animation Award: Individual Category Character Design Award.

Marmalade Boy (1994-1995, Character Design, Animation Director)
Boys Over Flowers (1996-1997, Character Design, Animation Director)
Berserk (1997-1998, Character Design, Animation Director)
Magical Doremi Series (1999-2003, Character Design, Animation Director)
Zipang (2004-2005, Character Design, Animation Director)
Mushishi (2005-2006, Character Design, Animation Director)
Mushiking: The King of Beetles (2005-2006, Character Design)
Casshern Sins (2008-2009, Character Design, Chief Animation Director, Animation Director)
HeartCatch PreCure! (2010-2011, Character Design, Animation Director)
Saint Seiya Omega (2012, Character Design, Chief Animation Director, Animation Director)
Mushishi (2012, Character Design, Chief Animation Director, Animation Director)
Mushishi Sequel (2012, Character Design, Animation Director)
My Hero Academia (2017 to the present, Character Design)